TYPOGRAPHY

WATSON GUPTILL

PUBLICATIONS/NEW YORK

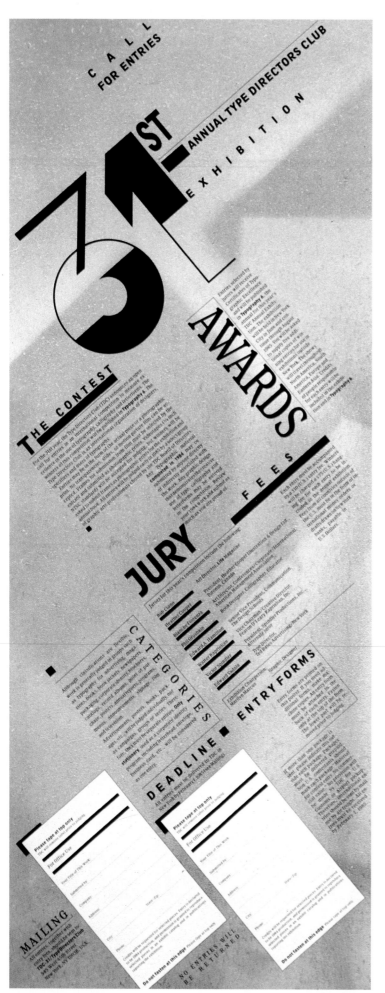

First published 1985 in New York
by Watson-Guptill Publications,
a division of Billboard Publications, Inc.,
1515 Broadway, New York, N.Y. 10036

Distributed in the United Kingdom by Phaidon
Press Ltd., Littlegate House, St. Ebbe's, Oxford

Distributed outside U.S.A. and Canada by
Fleetbooks, S.A.
% Feffer & Simons, Inc.
100 Park Avenue
New York, N.Y. 10017

ISBN 0-8230-5540-X

Manufactured in Japan
1 2 3 4 5 6 7 8 9/89 88 87 86 85

Edited by Susan Davis
Art direction by Olaf Leu
Page layout by Jay Anning
Photography by Dennis Williford
Graphic production by Hector Campbell
Composition by Trufont Typographers

CONTENTS

8-24-87

o.e.

CHAIRPERSON

MARILYN MARCUS
*Chairperson, TDC-31,
Graphic Designer,
New York*

The 3900 entries to the 31st annual competition of typographic excellence conducted by the Type Directors Club of New York City (TDC-31) were of consistently high quality, offering a great challenge to the judges. We were fortunate to have a distinguished panel: Bob Ciano, Blanche Fiorenza, Phil Grushkin, Ed Hamilton, Walter Kaprielian, Ed Vadala, and Kenn Waplington. Vic Spindler, TDC-30 Chairman, served as alternate juror.

Interest in the Type Directors Club competition grows each year. Most entries come from type directors and designers from the U.S.A. About 10 percent of the entries this year came from 18 other countries: Australia, Belgium, Brazil, Canada, Czechoslovakia, England, Finland, France, Israel, Italy, Japan, Luxembourg, Mexico, New Zealand, Scotland, Sweden, Switzerland, and West Germany. This marks a notable increase in international submissions over past years.

In the two-day judging, 209 pieces received a majority vote from the judges. Winners were selected for excellence in the use of typography and calligraphy, though type was often integrated with illustration, photography, and other graphic elements. The winning entries show a *variety* of contemporary design trends. To enhance the typography and calligraphy, we noted careful paper choice and fine printing with colors ranging from subtle to vibrant, although these factors were not considered in the judging. Occasionally, special effects were achieved through binding, folding, and even tearing!

The judging is always a rigorous, but exciting, event. With so many entries to arrange within categories, we are grateful for our energetic committee, which ably facilitated the process.

This year European designer Olaf Leu, TDC member from Frankfurt, Germany, coordinated the design for the TDC-31 show call for entry, certificate and invitation, as well as our annual publication, *Typography 6*.

We are grateful to New York photographer Dennis Williford for his color work on *Typography 6*. Dennis, along with Kim Sales, studio manager, gave each piece caring attention. Dennis specializes in commercial photography in the areas of still life and photo illustration.

As this show is viewed on its travels around the world as well as in this book, it will serve to applaud and encourage continued fine work in the field of typography and calligraphy.

MARILYN MARCUS

Marilyn Marcus serves as a board member of the Type Directors Club. In the past she has served as a juror and as Traveling Show Chairperson for TDC-29. Marilyn graduated from Cooper Union Art School and Yale University Art School with a B.F.A., studying fine art and graphic design. At Cooper Union she studied with George Salter and Paul Standard; at Yale, with Alvin Eisenman, Alvin Lustig and Josef Albers.

Starting out in the book field, thanks to Art Director Jerome Kuhl, she worked for Rinehart & Company designing sports, trade and then college textbooks. During the years as she was developing a knowledge of typography, Bernard Kress and Dr. Robert Leslie offered guidance and inspiration. She then worked for Harcourt Brace Jovanovich (HBJ) with Meyer Miller and became art director of college texts, specializing in English, foreign language, art, and math subjects. When HBJ relocated, Marilyn remained in New York, continuing as a freelance design consultant on books, brochures, and promotion. Her work has been presented in shows of the American Institute of Graphic Arts and the Printing Industries of America.

Marilyn is a member of two other typography-oriented organizations, The American Printing History Association and the Typophiles.

JUDGES

BOB CIANO
Art Director,
Life *Magazine,*
New York City

It is the constant. The one element that all designers must deal with in almost any problem. Yet typography is too often perfunctory, too often specified "set to fit." So it is indeed hopeful to all of us that this year's selections show designers who are much more than perfunctory in their use of type. Here is evidence of type used as communicator, art, design, and, most of all, as an expression of passion about transmitting ideas. The range of style and approach—from the " '85" on a shopping bag, to the letterspacing of "The Society of Publication Designers," to the exuberance of the "Oberlin!" handbooks—makes it obvious that typography is alive and well in 1985.

BOB CIANO

Bob Ciano is currently the Art Director of *Life* Magazine.

BLANCHE FIORENZA
Art Director, Corporate Conferences,
American Management Associations,
New York City

Based on my experience of evaluating competitions, the TDC 1985 judging was one of the most satisfying and rewarding! The overall quality of the entries was exceptionally high and it was a joy to see so much excellence and creativity.

Judging the show was hard work—physically and mentally. I found myself returning more than once for a reevaluation of many of the pieces. The procedures for judging were thoughtfully organized—allowing us to work in a quiet and calm atmosphere—and my special compliments to the staff for their help and efficiency.

It was a fine show. I was happy to be a part of it.

BLANCHE FIORENZA

Blanche Fiorenza is Art Director for Corporate Conferences of the American Management Associations (AMA). She also serves as curator of the AMA Corporate Art collection, and has conducted seminars on art and graphics for her company and outside groups.

A member of the Art Directors Club of New York, she is currently Assistant Secretary/Treasurer on its Executive Board as well as Vice-President of ADC Publications (Annual).

Born in Prague, she received her education at the New York Community College, New York University, and the New School. Her career spans 25 years in the graphics field as designer and art director for agencies, not-for-profit organizations, and publishers. Consultant and designer for a wide range of private clients, she also assists her husband who has his own design firm. Competitions she has judged include the Art Directors Club, Andy Awards, Japan ADC, Association of the Graphic Arts Awards.

She spends her leisure time traveling, cooking, and studying Romanesque art.

PHILIP GRUSHKIN

Freelance Book Designer,
Book Production Consultant,
Calligrapher & Educator,
New York City

While the judging took place many weeks ago, I recall that the show we picked was very good, very good indeed—a sparkling cross-section of printed material involved with letterform and typography. But what is also still remembered painfully, even after these many weeks, was the enormous quantity of material we had to evaluate. It was a staggering amount. It still amazes me that we looked at almost 4000 pieces in the two-day judging. For this, much thanks is due to the splendid teamwork and organization of the TDC staff.

If I can offer any suggestion at all, it would be to divide the show in half, giving each half a separate team of five jurors. It may be a bit tough to get ten jurors, but it's only three more than the norm for this present show. This proposal would dilute the pressure on the jurors to race through the enormous quantity of submissions. I certainly think it is worth a try.

PHILIP GRUSHKIN

Philip Grushkin is a freelance book designer, book production consultant, calligrapher, and educator. He was formerly vice-president and art director at Harry N. Abrams, Inc., where he designed the original edition of the highly acclaimed *History of Art* by H. W. Janson. He has lectured widely and served on juries for many book and calligraphic events.

Grushkin graduated from the Cooper Union Art School and, after service in World War II as a cartographer in the OSS, returned to Cooper Union, where he taught lettering, calligraphy, and graphic design for over 20 years. He has also directed the Book Design Workshop of the Radcliffe Publishing Procedures Course at Harvard Summer School and taught book design at New York University.

He is constantly involved in work-related travel to supervise special book projects in Europe, South America, and the Far East. Born in New York City, Philip Grushkin now lives in Englewood, New Jersey, where most of his home is now a uniquely equipped studio containing a photography lab and a letterpress print shop. He is a member of the Typophiles and the Grolier Club, and was a trustee of the American Printing History Association.

EDWARD A. HAMILTON

Senior Vice-President, Communications,
The Design Schools,
New York City

Bravo, Bravo, Bravo! This was an excellent competition conducted with great skill. The overwhelming number of quality entries left me with a very positive feeling about typographic design for print materials. It would almost indicate that designers of print material are feeling the challenge of video and computer graphics and are reacting with greater and greater degrees of imagination and quality.

While there were many very strong categories, a few areas were weak, namely, publication design, both magazine and newspaper. It is possible that the best designers in these fields are so busy that they don't have time to enter contests. I know for a fact that better work exists in publications than we saw in the judging rooms. Another category that caused me some concern was annual reports. There is so much repetition and look-alike qualities in annual reports that the effect is almost stultifying. I realize the limitations imposed on the designer in this very restricted field and occasionally a designer will break away from some of the familiar devices—and for that I give them great credit! They have learned how to work successfully with the corporate hierarchy.

It was rewarding to see that the Type Directors Club attracted almost 4000 submissions. It was exhausting for the judges to spend many hours over a two-day period, but it bodes well for the field of graphic design to see this huge response. On the whole, there were a great many handsome and distinctive pieces, which means there are good minds and top talents at work in many places in the 1980s.

EDWARD A. HAMILTON

Currently Senior Vice-President, Communications for The Design Schools, Edward A. Hamilton was previously Art Director of Time-Life Books and Design Director of Macmillan's School Division. The

TYPOGRAPHY

TYPOGRAPHY/ DESIGN	TYPOGRAPHIC SUPPLIER	STUDIO	CLIENT	PRINCIPAL TYPE	DIMENSIONS
Michael Mabry San Francisco, California	*Petrographics*	*Michael Mabry Design*	*Overseas Printing Corporation*	*Garamond Italic #3*	*9 × 9 in. 22.9 × 22.9 cm*

TYPOGRAPHY/ DESIGN	CALLIGRAPHER	TYPOGRAPHIC SUPPLIER	AGENCY/ STUDIO	CLIENT	PRINCIPAL TYPE	DIMENSIONS
Friedrich Don *Waiblingen,* *West Germany*	*Friedrich Don*	*Friedrich Don*	*Wagner Siebdruck*	*Wagner Siebdruck*	*Univers 48/* *Univers 58*	*27⅕ × 19⅓ in.* *69 × 49 cm*

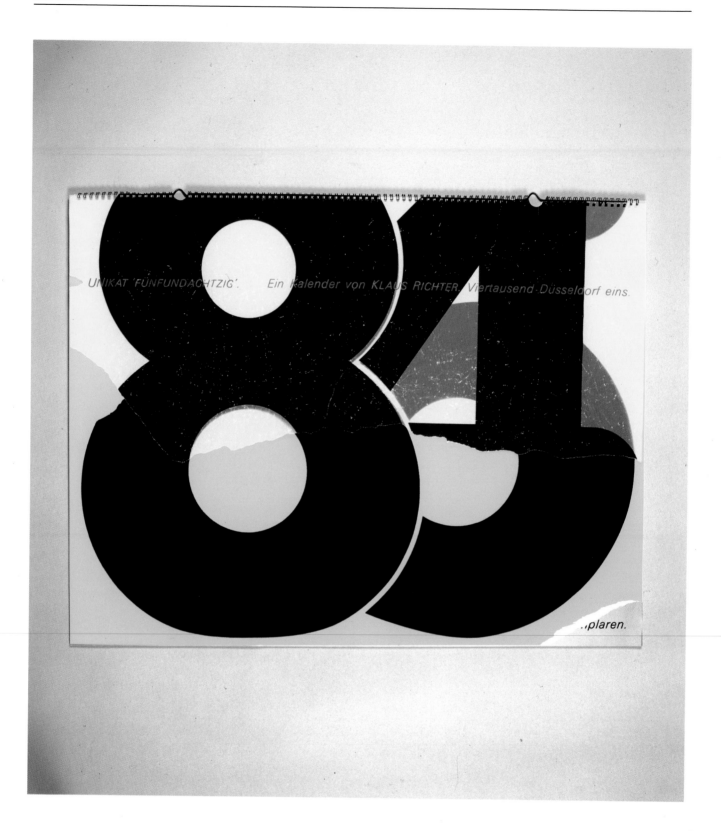

TYPOGRAPHY/ DESIGN	TYPOGRAPHIC SUPPLIER	STUDIO	CLIENT	PRINCIPAL TYPE	DIMENSIONS
Klaus Richter/ Angelika Guntermann Düsseldorf, West Germany	*Satzatelier Michael-G. Seffrin*	*Klaus Richter*	*Klaus Richter*	*VAG-Rundschrift/ Univers Kursiv Mager*	*31½ × 23⅗ in. 80 × 60 cm*

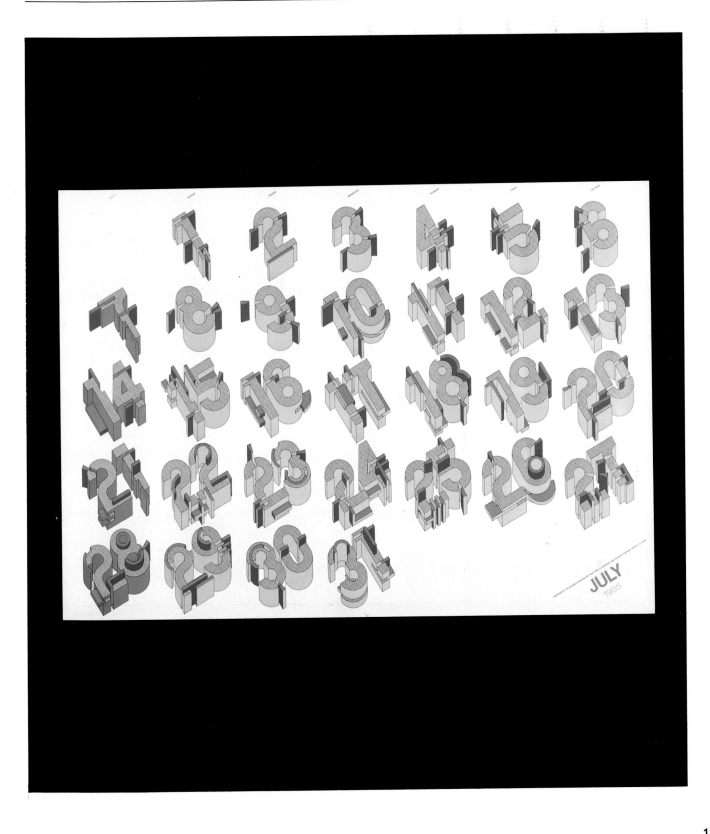

TYPOGRAPHY/ DESIGN	STUDIO	CLIENT	DIMENSIONS
Takenobu Igarashi Tokyo, Japan	*Igarashi Studio*	*The Museum of Modern Art, New York*	*28¾ × 40½ in. 73 × 103 cm*

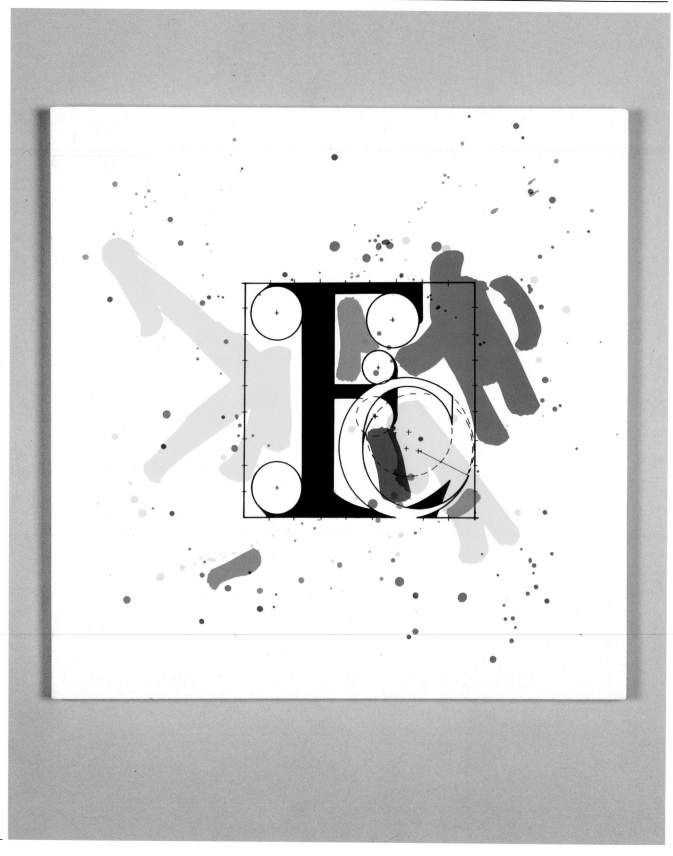

TYPOGRAPHY/ DESIGN	CALLIGRAPHER	TYPOGRAPHIC SUPPLIER	AGENCY/ STUDIO	CLIENT	PRINCIPAL TYPE	DIMENSIONS
Paschoal Fabra Neto São Paulo, Brazil	Paschoal Fabra Neto	Digital	Exclam Comunicacões	Exclam Comunicacões	Times Roman	10⅔ × 10⅔ in. 27 × 27 cm

TYPOGRAPHY/ DESIGN	TYPOGRAPHIC SUPPLIER	STUDIO	CLIENT	PRINCIPAL TYPE	DIMENSIONS
Steve Gibbs/ Don Sibley Dallas, Texas	Southwestern Typographics	Sibley/Peteet Design, Inc.	Trammell Crow Company	Palatino	12 × 6½ in. 30.5 × 16.5 cm

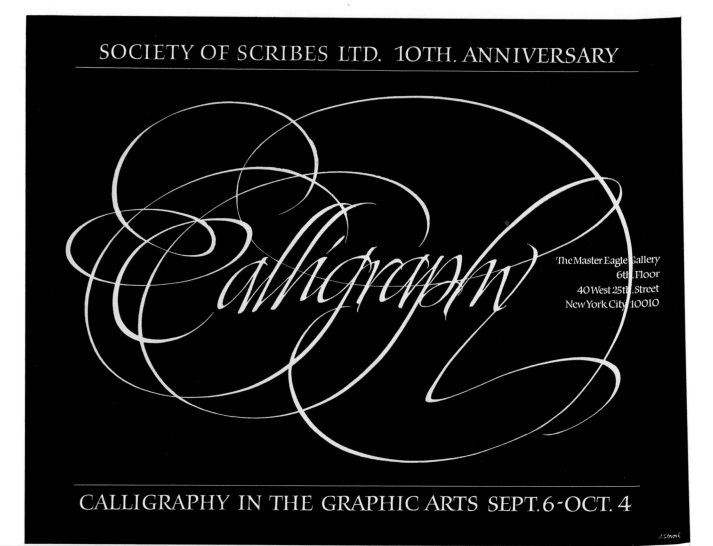

TYPOGRAPHY/ DESIGN	CALLIGRAPHER	STUDIO	CLIENT	DIMENSIONS
John Stevens Huntington Station, New York	John Stevens	John Stevens Calligraphy & Lettering Design	Society of Scribes/ Master Eagle Gallery	18 × 24 in. 45.7 × 61 cm

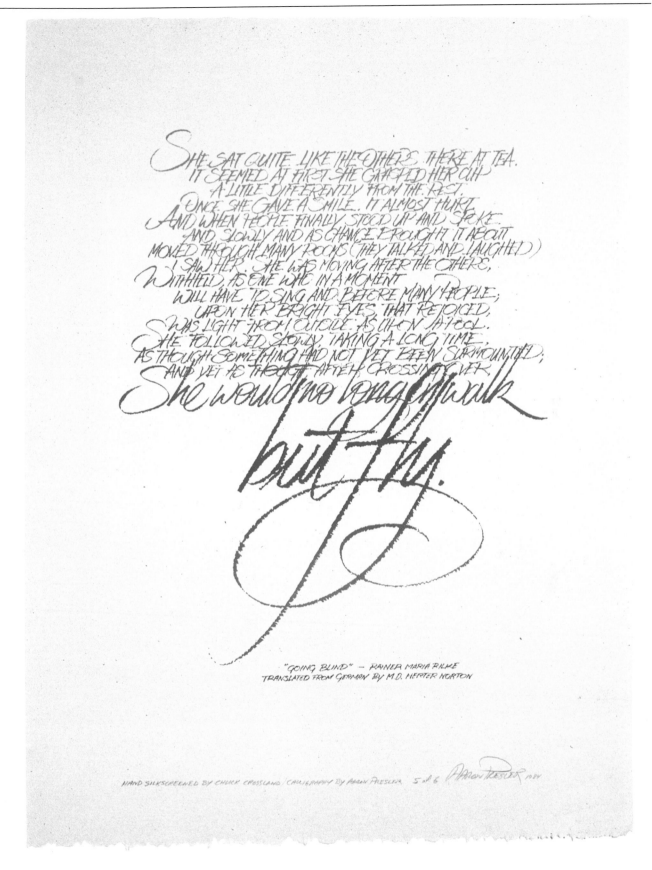

CALLIGRAPHER	STUDIO	CLIENT	DIMENSIONS			
Aaron Presler *Kansas City,* *Missouri*	*Art Partners*	*Hallmark Cards*	*20 × 26 in.* *50.8 × 66 cm*			

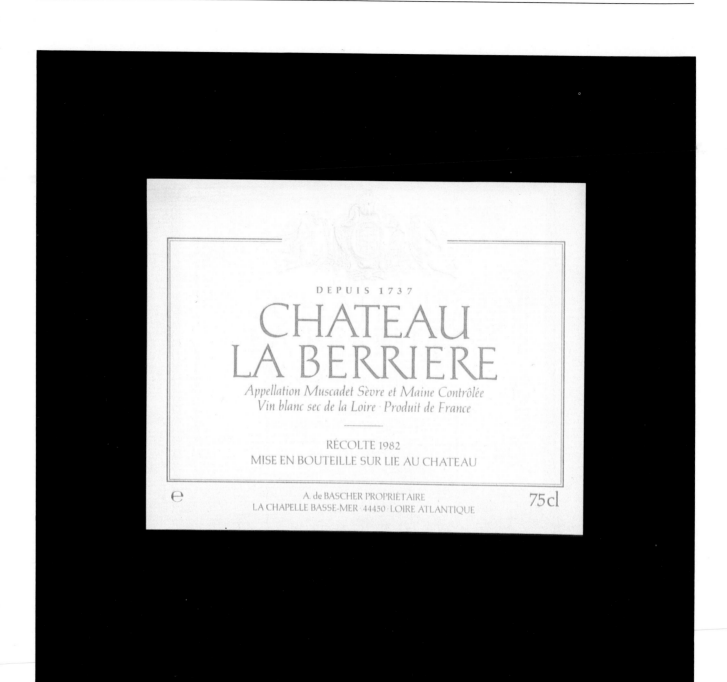

TYPOGRAPHY/ DESIGN	CALLIGRAPHER	TYPOGRAPHIC SUPPLIER	STUDIO	CLIENT	PRINCIPAL TYPE	DIMENSIONS
Xavier De Bascher Paris, France	Xavier De Bascher	Typo Gabor	Concept Groupe	Domaine de la Berriere	Michelangelo	3¾ × 4¾ in. 9.5 × 12.2 cm

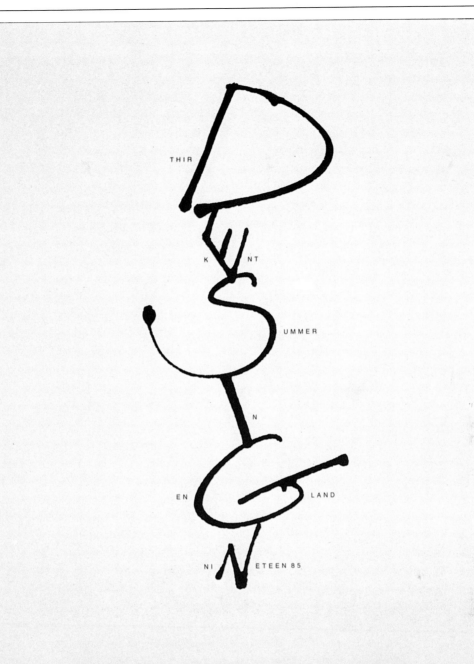

THIR

K NT

UMMER

N

EN LAND

NI ETEEN 85

The third annual Kent State and Pentagram Graphic Design Workshop will take place 5–23 August 1985 in London, England. The three-week programme is open to designers, design educators and students at graduate and post-graduate level.

Workshop directors are Professor j Charles Walker, Co-ordinator, Division of Design, Kent State University, and Mervyn Kurlansky, partner of Pentagram Design, London and New York. Faculty for the programme will also include London designers F H K Henrion and Michael Peters. Classroom assignments and discussions covering a wide range of design problems will be scheduled from Monday to Friday. Lectures from guest speakers, trips to museums and design studios, and informal gatherings are included in the workshop.

The cost of the workshop is $2200, which includes lodging in single or double room with breakfast, and special dinners. This payment also covers instructional materials, and various fees for transport, entry to museums, etc. on directed field trips. Air fares and ground transportation to and from London are not included. Up to six semester credit hours at graduate or undergraduate level may be obtained on application to Kent State University for an additional fee.

Costs have been calculated on the current dollar/sterling exchange rate. Participants will be notified of any change on acceptance. Fees will be final at that point. The costs of the programme may be considered as an educational expense in respect of income tax (see US Treasury Regulation Section 1.162–5).

Applications to attend the workshop must be received no later than 1 March 1985. For further information, contact Professor j Charles Walker, Director Graphic Design Workshops in Europe, 1520 South Blvd., Kent, Ohio 44240. Phone: (216) 673-0699/672-2192.

TYPOGRAPHY/ DESIGN	TYPOGRAPHIC SUPPLIER	AGENCY	CLIENT	PRINCIPAL TYPE	DIMENSIONS
Mervyn Kurlansky London, England	Opus Graphics	Pentagram Design	Kent State University	Helvetica	29½ × 18 in. 75 × 45.7 cm

TYPOGRAPHY/ DESIGN	CALLIGRAPHER	TYPOGRAPHIC SUPPLIER	CLIENT	DIMENSIONS
Erwin Fieger Castelfranco di Sopra, Italy	Erwin Fieger	Koelblindruck Baden-Baden, West Germany	Ottobach Repro GmbH, Rastatt, West Germany	19⅓ × 22 in. 49 × 56 cm

TYPOGRAPHY/ DESIGN	CALLIGRAPHER	TYPOGRAPHIC SUPPLIER	STUDIO	CLIENT	PRINCIPAL TYPE	DIMENSIONS
Steve Hodowsky New York City	Steve Hodowsky	Steve Hodowsky	Citibank Communication Design	New York Philharmonic Tour of Asia	Handwritten	31 × 19 in. 78.7 × 48.3 cm

TYPOGRAPHY/ DESIGN	CALLIGRAPHER	AGENCY	STUDIO	CLIENT	DIMENSIONS
Rick Cusick *Shawnee, Kansas*	*Rick Cusick*	*Rick Cusick/* *Richie Tankersley* *Cusick*	*Rick Cusick/Design*	*New York Society* *of Scribes*	*12 × 15⅝ in.* *30.5 × 39.7 cm*

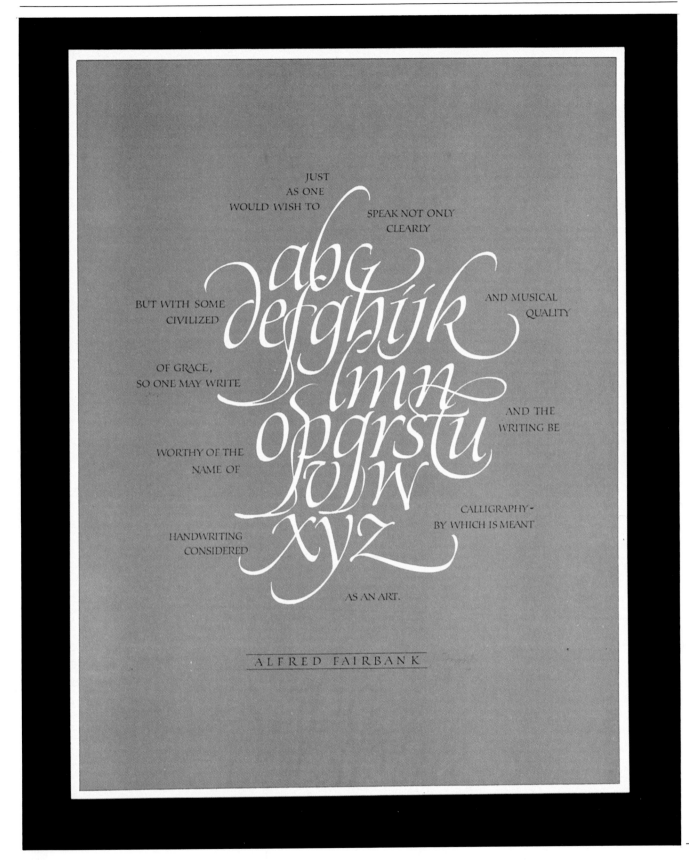

TYPOGRAPHY/ DESIGN	CALLIGRAPHER	STUDIO	CLIENT	PRINCIPAL TYPE	DIMENSIONS
John Stevens Huntington Station, New York	John Stevens	John Stevens Calligraphy Lettering Design	John Stevens Calligraphy Lettering Design	Calligraphy	8¾ × 11⅜ in. 22.2 × 28.9 cm

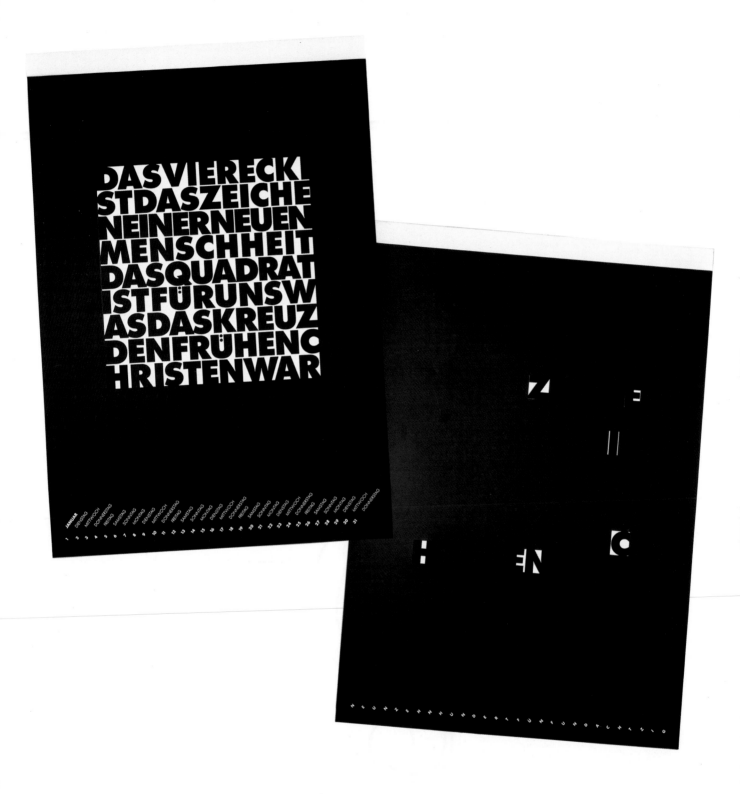

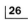

TYPOGRAPHY/ DESIGN	TYPOGRAPHIC SUPPLIER	CLIENT	PRINCIPAL TYPE	DIMENSIONS
Annette Höhne Dortmund, West Germany	Jöllenbeck & Schlieper	Schlieper & Co./ Jöllenbeck & Schlieper	Futura	19 × 27 in. 48 × 68.5 cm

TYPOGRAPHY/ DESIGN	CALLIGRAPHER	STUDIO	CLIENT	PRINCIPAL TYPE	DIMENSIONS
Manfred Sayer Stuttgart, West Germany	Manfred Sayer	Atelier Manfred Sayer	Johannes-Gutenberg-Schule, Stuttgart	Handlettering	16 × 22 in. 40.6 × 55.9 cm

Syntex Corporation 1984 Annual Report

Innovation, creativity & excellence in health-care will always be the hallmarks of Syntex.

Diagnostics

The diagnostics division designs, manufactures and markets systems to measure levels of therapeutic drugs, hormones, proteins, and substances of abuse in body fluids; and tests to detect disease.

Sales by the diagnostics division, which includes Syva, declined nine percent to $92.4 million in fiscal 1984, compared with $101.0 million during the previous fiscal year. The division reported an $18.9 million operating loss in fiscal 1984, compared with a $10.2 million operating profit in fiscal 1983.

The fiscal 1984 operating loss was caused by a significant decline in sales of therapeutic drug monitoring products. The loss also included inventory adjustments of $9.5 million. In addition, the company continued to invest heavily in research and development of new products and start-up costs for new businesses that represent major long-term opportunities in medical diagnostics. These include diagnostic tests for sexually transmissible diseases, products for cancer diagnosis and treatment, and non-instrumented diagnostic tests.

The diagnostics division developed and marketed a number of new enzyme-immunoassays for therapeutic drug monitoring tests in fiscal 1984. The company expanded its Emit therapeutic drug monitoring product line by introducing new assays and FDA-approved instrument applications during the year. A fluorescence immunoassay designed to monitor levels of digoxin, a cardioactive drug, was also introduced in fiscal 1984. The division also continued to market its complete line of assays to detect drugs of abuse during the fiscal year.

The Qst sample processor, the newest addition to Syva's line of diagnostic instruments, allows a technician to run a single test for an individual patient 24-hours a day, 7-days a week. Quantitative results are available within 90 seconds. Qst sales have grown steadily since its introduction in July 1983.

In addition to developing diagnostic tools for use in hospitals and clinical laboratories, Syntex also emphasizes the development of cost-effective diagnostic products for use outside hospital laboratories. The Emit/st drug detection system, for example, is a portable system that allows fast, qualitative identification of drugs of abuse. The system is widely employed

Syntex increased its investments in diagnostic research to develop potentially important cost-effective products that meet the changing needs of the diagnostics market.

Syva's MicroTrak Chlamydia trachomatis direct specimen test

16 17

TYPOGRAPHY/ DESIGN	CALLIGRAPHER	TYPOGRAPHIC SUPPLIER	STUDIO	CLIENT	PRINCIPAL TYPE	DIMENSIONS
Stephen Stanley/ Robert Conover San Francisco, California	Georgia Deaver	Spartan Typographers	Robert Conover Graphic Design	Syntex Corporation	Bembo	8½ × 11 in. 21.6 × 27.9 cm

Doch zum
Verherrlichen
bin ich geboren
gepflanzt in eine noch
unvollendete Welt
eine sprudelnde Quelle
Klage und Wind
werde ich sein und in ihm
auch Freude —
und die wird
erzählen. JAN ZAHRADNÍČEK

Aus ·Der Häftling Gottes· im Verlag Johann Wilhelm Naumann

CALLIGRAPHER	CLIENT	DIMENSIONS
Prof. Alfred Linz Nürnberg, West Germany	Verlag F. W. Naumann	12⅕ × 16¹/₁₆ in. 31 × 41 cm

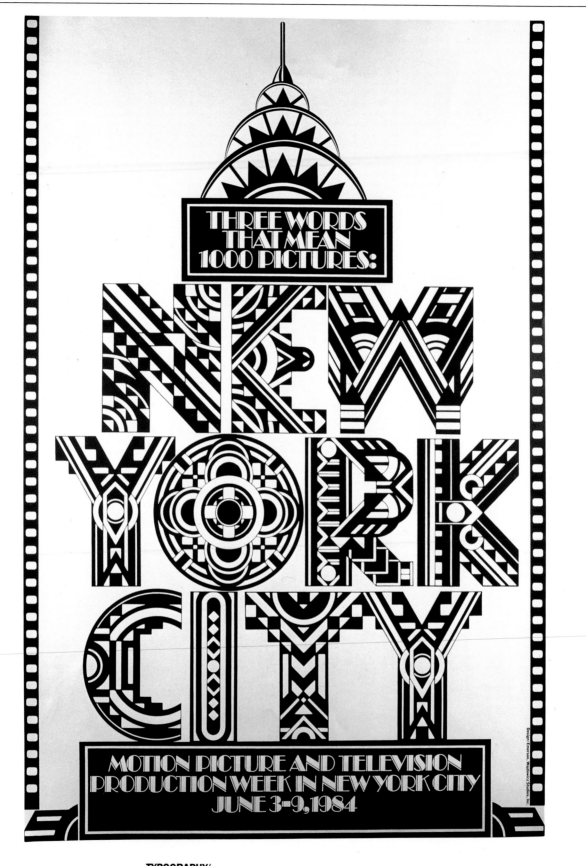

TYPOGRAPHY/DESIGN	CALLIGRAPHER	STUDIO	CLIENT	DIMENSIONS
Jurek Wajdowicz New York City	Emerson, Wajdowicz Studios, Inc.	Emerson, Wajdowicz Studios, Inc.	Mayor's Office of Film, Theatre & Broadcasting/New York Telephone	21½ × 32⅝ in. 54.6 × 82.8 cm

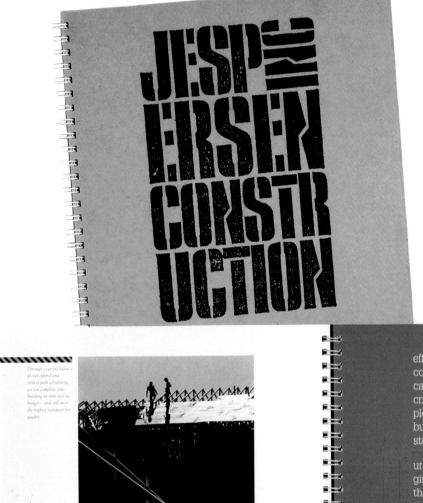

efforts of the developer, architect, and construction contractor. Through a careful balance of cost control and critical-path scheduling, we can complete your building on time and on budget — and still meet the highest standards for quality.

ur involvement in a project often begins when it is no more than an idea. At that stage, we can provide initial estimates for your budgeting purposes.

As the design is developed, we stay involved, helping to ensure that the design meets not only your construction budget, but also your budget for long-term maintenance. With our knowledge of construction and materials costs, you can make informed decisions about design options as well as marketable features and amenities.

Through a careful balance of cost control and critical-path scheduling, we can complete your building on time and on budget — and still meet the highest standards for quality

TYPOGRAPHY/ DESIGN	CALLIGRAPHER	TYPOGRAPHIC SUPPLIER	STUDIO	CLIENT	PRINCIPAL TYPE	DIMENSIONS
Blake Miller *Houston, Texas*	*Blake Miller*	*XL Typographers*	*Miller Judson and Ford, Inc.*	*Jesperson Construction Co.*	*Glypha*	*8 × 8 in.* *20.3 × 20.3 cm*

TYPOGRAPHY/ DESIGN	TYPOGRAPHIC SUPPLIER	STUDIO	CLIENT	PRINCIPAL TYPE	DIMENSIONS
Petrula Vrontikis Los Angeles, California	Photographix	P Vron Visual Communication Design	Design Student Association, California State University, Long Beach	Univers 58/ Univers 48	17 × 22 in. 43.2 × 55.9 cm

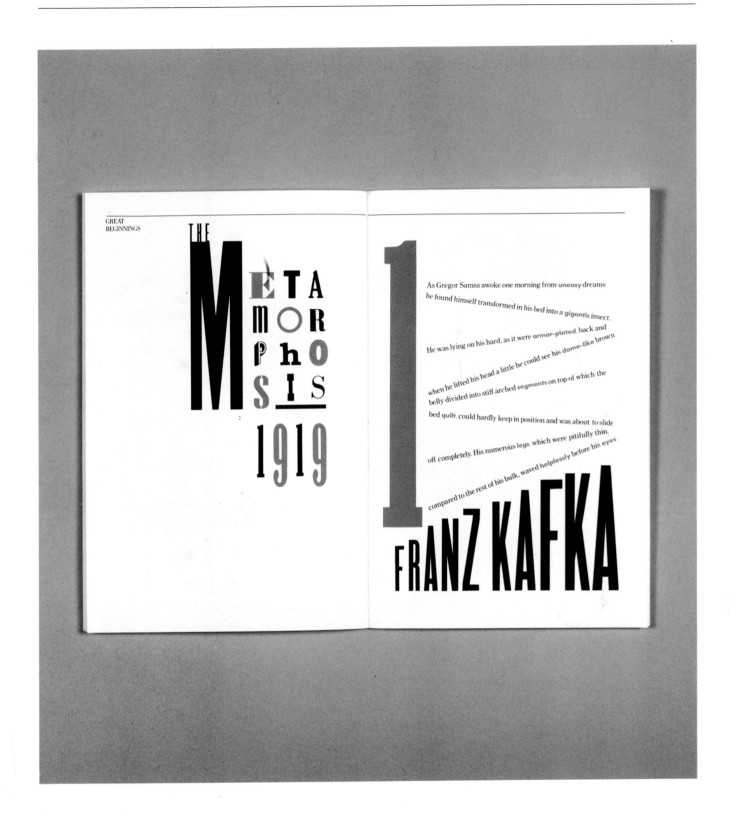

TYPOGRAPHY/ DESIGN	TYPOGRAPHIC SUPPLIER	AGENCY	STUDIO	CLIENT	PRINCIPAL TYPE	DIMENSIONS
Terry Koppel/ Paula Scher/ Richard Mantel New York City	Haber Typographers	Koppel & Scher	Koppel & Scher	Koppel & Scher	Bodoni	6 × 9 in. 15.2 × 22.9 cm

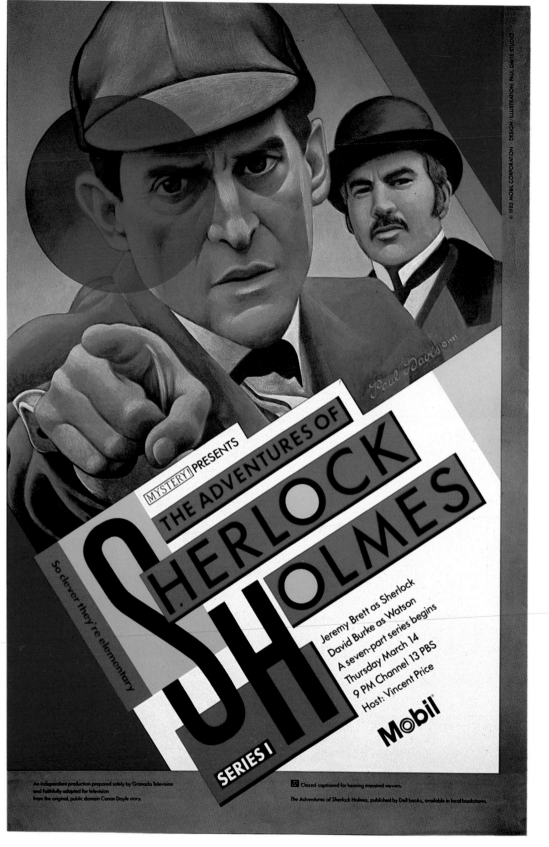

TYPOGRAPHY/ DESIGN	TYPOGRAPHIC SUPPLIER	STUDIO	CLIENT	PRINCIPAL TYPE	DIMENSIONS
Paul Davis/ Jose Conde New York City	Haber Typographers	Paul Davis Studio	Mobil	Futura	30 × 46 in. 76.2 × 116.8 cm

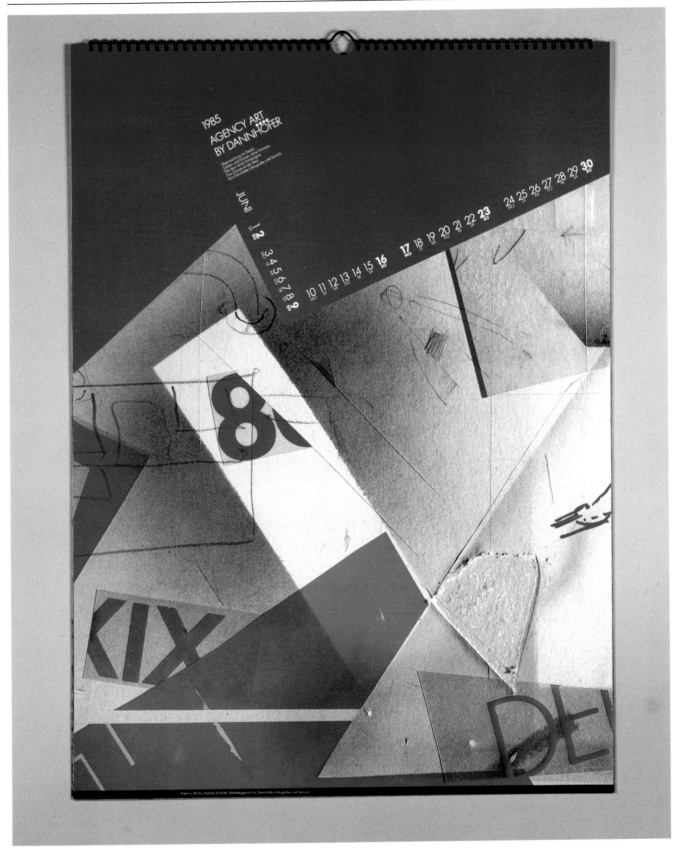

TYPOGRAPHY/ DESIGN	CALLIGRAPHER	AGENCY	CLIENT	PRINCIPAL TYPE	DIMENSIONS
Harald Schlüter Essen, West Germany	*Dannhoefer KG Heiligenhaus*	*Harald Schlüter Werbeagentur GmbH*	*Dannhoefer KG*	*Futura Book*	*20 × 27⅓ in. 51 × 69 cm*

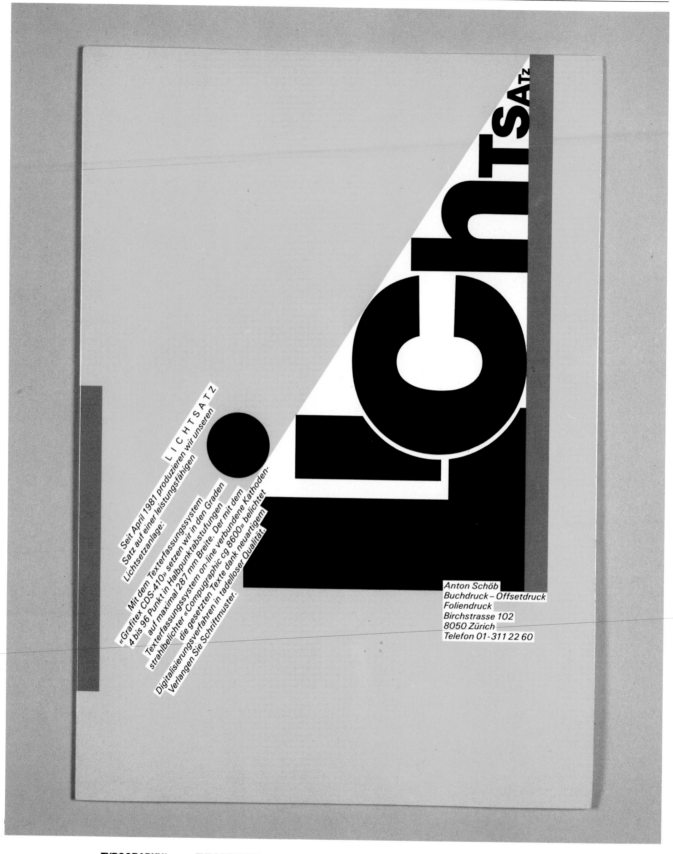

LICHTSATZ

Seit April 1981 produzieren wir unseren
Satz auf einer leistungsfähigen
Lichtsetzanlage:

Mit dem Texterfassungssystem
«Grafitex CDS-410» setzen wir in den Graden
4 bis 96 Punkt in Halbpunktabstufungen
auf maximal 287 mm Breite. Der mit dem
Texterfassungssystem on-line verbundene Kathoden-
strahlbelichter «Compugraphic cg 8600» belichtet
die gesetzten Texte dank neuartigem
Digitalisierungsverfahren in tadelloser Qualität.
Verlangen Sie Schriftmuster.

Anton Schöb
Buchdruck – Offsetdruck
Foliendruck
Birchstrasse 102
8050 Zürich
Telefon 01-311 22 60

TYPOGRAPHY/ DESIGN	TYPOGRAPHIC SUPPLIER	STUDIO	CLIENT	PRINCIPAL TYPE	DIMENSIONS
Rosmarie Tissi Zurich, Switzerland	Anton Schöb Buchdruck—Offset	Odermatt & Tissi	Anton Schöb Buchdruck—Offset	Helvetica Bold/ Univers Italic #56	12⅛ × 8⅝ in. 30.8 × 22 cm

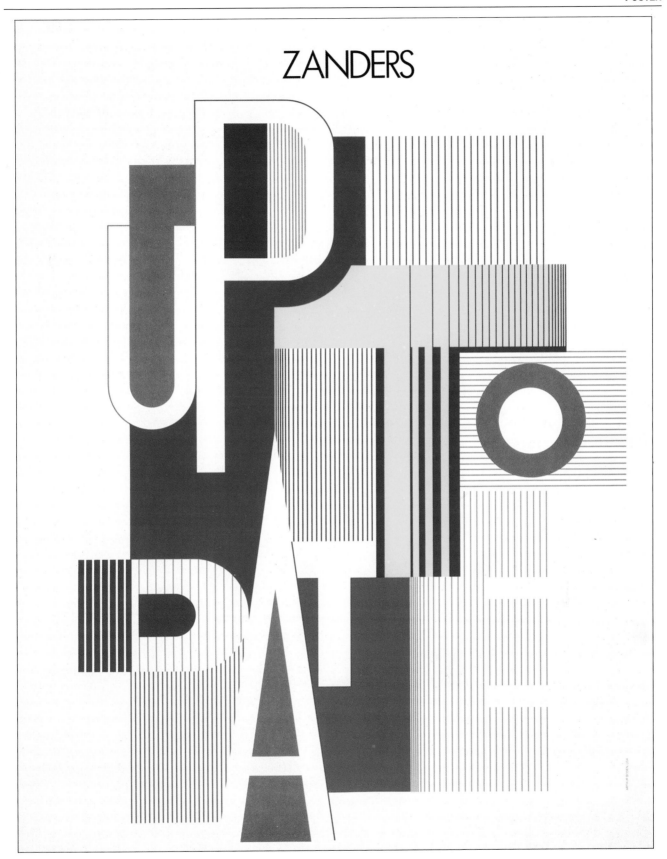

TYPOGRAPHY/ DESIGN	CALLIGRAPHER	CLIENT	PRINCIPAL TYPE	DIMENSIONS			
Arthur Boden Upper Saddle River, New Jersey	Arthur Boden	Zanders Feinpapiere AG, West Germany	Handlettering	19²/₃ × 27½ in. 50 × 70 cm			

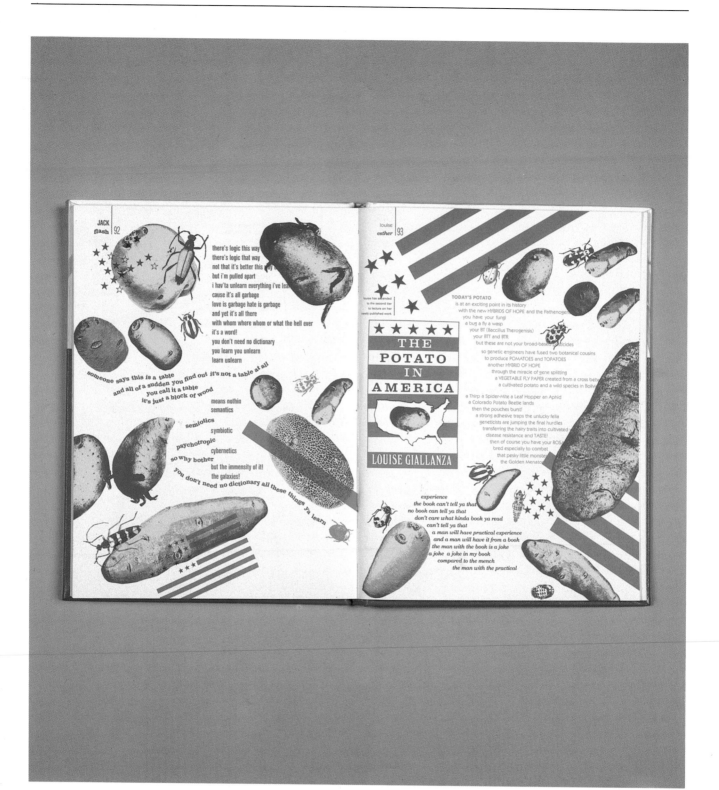

TYPOGRAPHY/ DESIGN	TYPOGRAPHIC SUPPLIER	STUDIO	CLIENT	PRINCIPAL TYPE	DIMENSIONS
Warren Lehrer *Purchase, New York*	*Warren Lehrer*	*Ear/Say*	*Ear/Say*	*24 type styles used*	*8¼ × 10¾ in.* *20.9 × 27.3 cm*

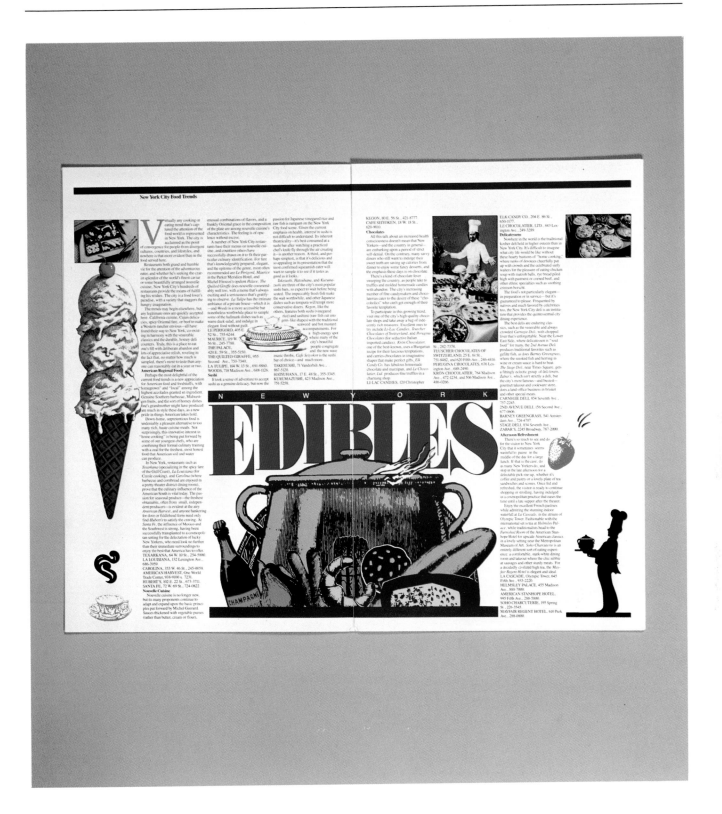

TYPOGRAPHY/ DESIGN	CALLIGRAPHER	TYPOGRAPHIC SUPPLIER	STUDIO	CLIENT	PRINCIPAL TYPE	DIMENSIONS
Vásken Kalayjian New York City	Vásken Kalayjian	Typographic Images	Glazer & Kalayjian, Inc.	Young Presidents	Times Roman	11¼ × 17½ in. 28.5 × 44.4 cm

TYPOGRAPHY/ DESIGN	CALLIGRAPHER	TYPOGRAPHIC SUPPLIER	STUDIO	CLIENT	PRINCIPAL TYPE	DIMENSIONS
Domenica Genovese Baltimore, Maryland	James Hackley	Typeworks	The North Charles Street Design Organization	Oberlin College	Times Roman/ Rockwell	8 × 10½ in. 20.3 × 26.7 cm

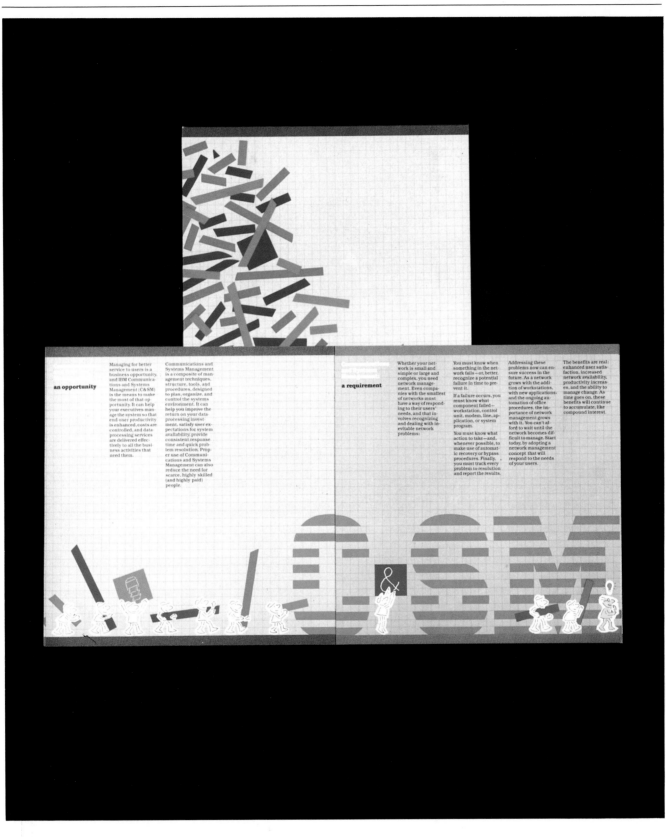

TYPOGRAPHY/ DESIGN	TYPOGRAPHIC SUPPLIER	AGENCY	STUDIO	CLIENT	PRINCIPAL TYPE	DIMENSIONS
Bob Paganucci New York City	Gerard Associates	Salpeter-Paganucci Inc.	Salpeter-Paganucci Inc.	IBM	Bookman	9 × 9 in. 22.9 × 22.9 cm

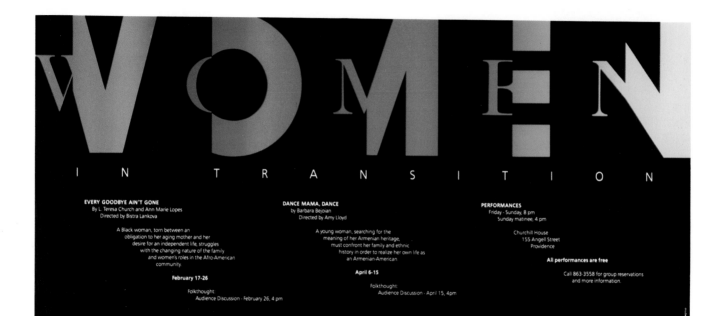

TYPOGRAPHY/ DESIGN	TYPOGRAPHIC SUPPLIER	STUDIO	CLIENT	PRINCIPAL TYPE	DIMENSIONS
Allen Wong Providence, Rhode Island	*Brown Designgroup/ Brown University*	*Brown Designgroup/ Brown University*	*Rites & Reason/ Brown University*	*Caslon #471/ Avant Garde Bold*	*20¾ × 9¾ in. 52.7 × 24.8 cm*

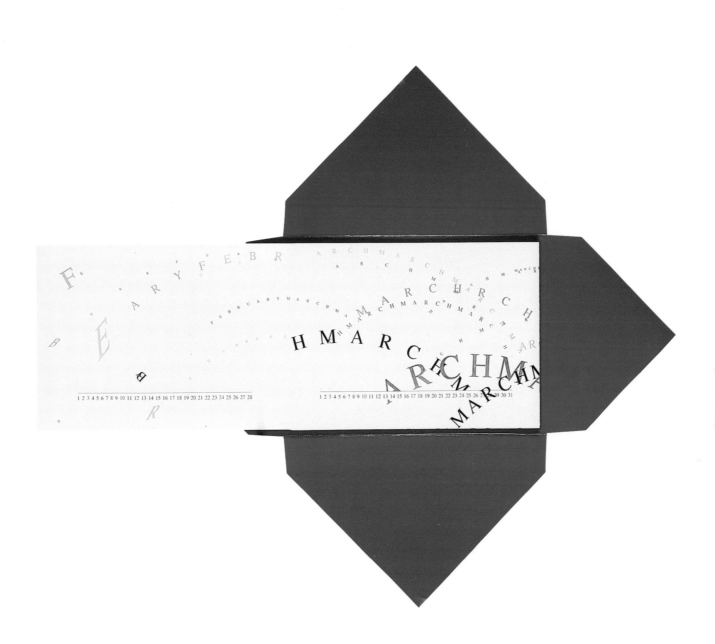

TYPOGRAPHY/ DESIGN	TYPOGRAPHIC SUPPLIER	STUDIO	CLIENT	PRINCIPAL TYPE	DIMENSIONS
Cleo Huggins Palo Alto, California	Adobe Systems Incorporated	Adobe Systems Incorporated	Adobe Systems Incorporated/ Liz Bond	Times Roman	8½ × 6¼ in. 21.6 × 15.8 cm

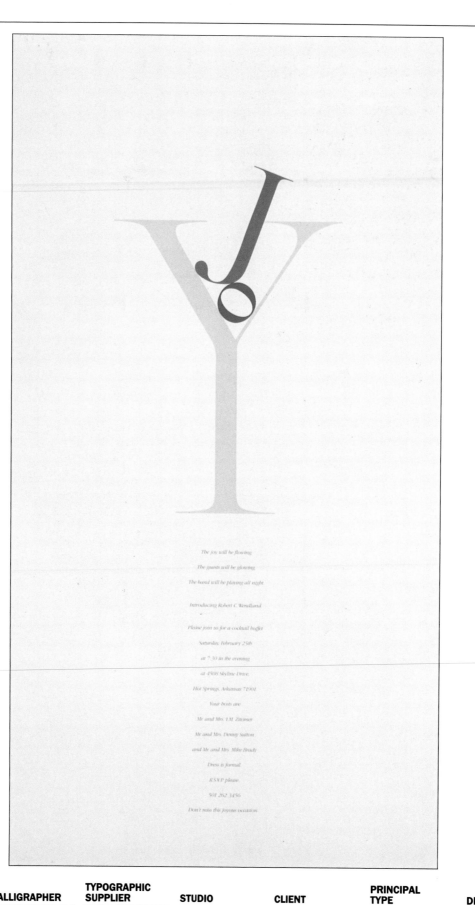

TYPOGRAPHY/ DESIGN	CALLIGRAPHER	TYPOGRAPHIC SUPPLIER	STUDIO	CLIENT	PRINCIPAL TYPE	DIMENSIONS
Vikki Foster/ Bob Dennard Dallas, Texas	Vikki Foster	Southwestern Typographics	Dennard Creative, Inc.	Pam & Rob Wendland	Garamond Light	11½ × 23 in. 29.2 × 58.4 cm

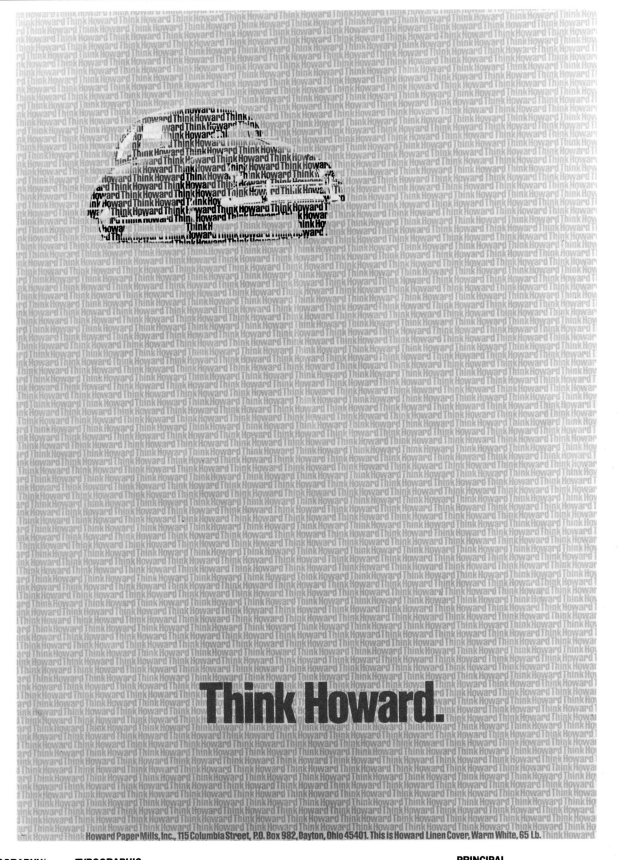

TYPOGRAPHY/ DESIGN	TYPOGRAPHIC SUPPLIER	AGENCY	STUDIO	CLIENT	PRINCIPAL TYPE	DIMENSIONS
Michael Grout Dayton, Ohio	Dayton Typographic Service, Inc.	Kircher Helton Collett Advertising	Hafenbrack Graphic Design	Howard Paper Mills, Inc.	Helvetica Extra Bold Condensed	21½ × 29½ in. 54.6 × 74.9 cm

Reprolaitos Ten Points Oy, Pursimiehenkatu 29 A, 00150 Helsinki 15, puh. 176008, tele 653870.

TYPOGRAPHY/ DESIGN	TYPOGRAPHIC SUPPLIER	AGENCY	CLIENT	PRINCIPAL TYPE	DIMENSIONS
Erkki Ruuhinen Helsinki, Finland	Valotyyppi	Erkki Ruuhinen Design	Reprolaitos Ten Points OY	News Gothic	23¹⁵/₁₆ × 34½ in. 60.8 × 87.6 cm

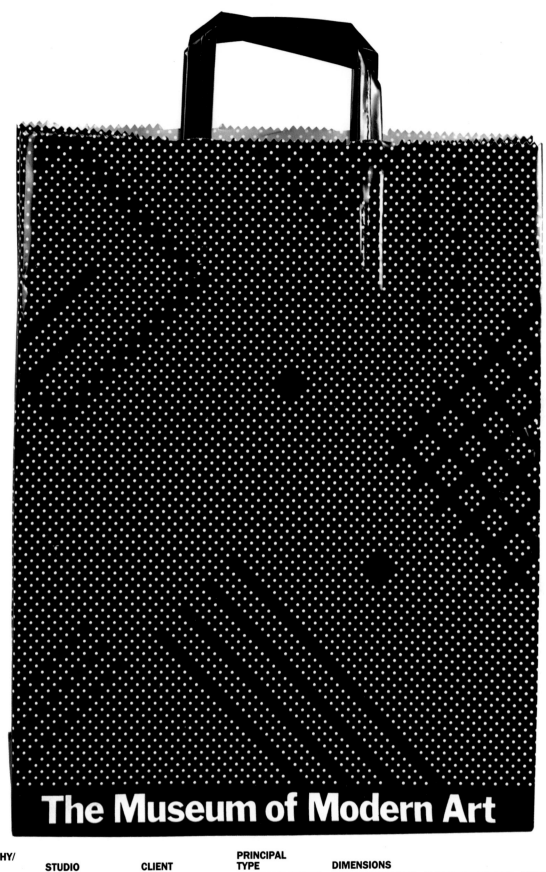

The Museum of Modern Art

TYPOGRAPHY/ DESIGN	STUDIO	CLIENT	PRINCIPAL TYPE	DIMENSIONS
Takenobu Igarashi Tokyo, Japan	Igarashi Studio	The Museum of Modern Art, New York	Franklin Gothic	7 × 13 × 16½ in. 17.8 × 33 × 41.9 cm

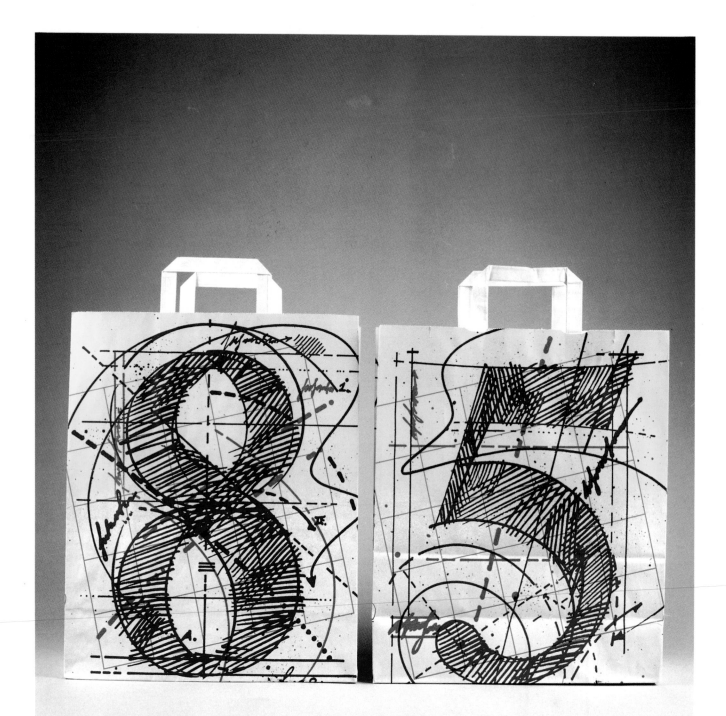

TYPOGRAPHY/ DESIGN	CALLIGRAPHER	STUDIO	CLIENT	PRINCIPAL TYPE	DIMENSIONS
Tim Girvin/ John Jay Seattle, Washington	*Tim Girvin*	*Tim Girvin Design, Inc.*	*Bloomingdale's*	*Handlettering*	*15¾ × 13 × 6 in. 39 × 33 × 15.2 cm*

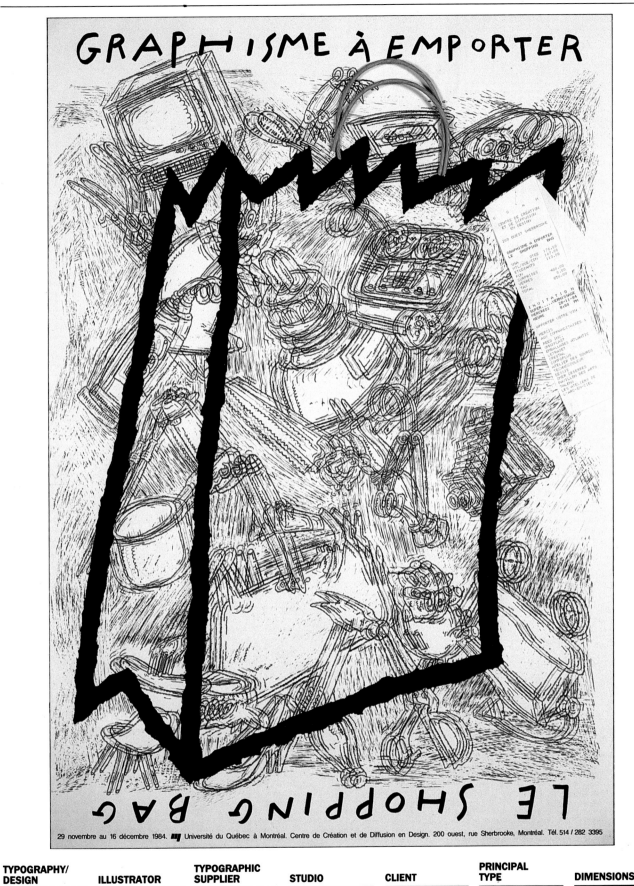

TYPOGRAPHY/ DESIGN	ILLUSTRATOR	TYPOGRAPHIC SUPPLIER	STUDIO	CLIENT	PRINCIPAL TYPE	DIMENSIONS
Frédéric Metz Montréal, Canada	Alain Pilon	Compoplus Inc.	Bretelle-UQAM	Centre de Création et de Diffusion en Design	Handlettering/ Helvetica/ Apple-Escape Normal	23¼ × 33 in. 59 × 83.8 cm

TYPOGRAPHY/ DESIGN	CALLIGRAPHER	TYPOGRAPHIC SUPPLIER	STUDIO	CLIENT	PRINCIPAL TYPE	DIMENSIONS
L.A.L.A. *New York City*	*Cristina Mascherpa* *Milan, Italy*	*Parsons* *Phototypographic* *Research Center*	*Parsons Publication* *Design Office*	*Parsons School of* *Design*	*Helvetica*	*9⅛ × 10 in.* *23.2 × 25.4 cm*

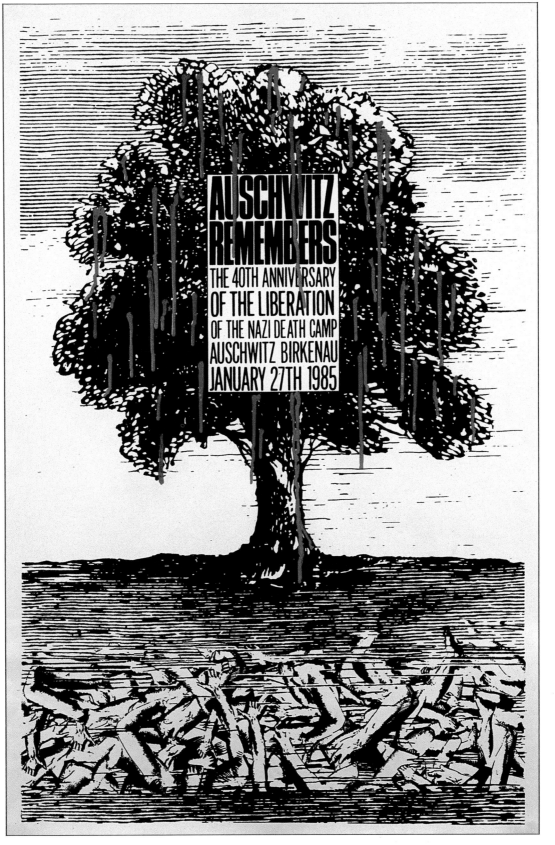

TYPOGRAPHY/ DESIGN	TYPOGRAPHIC SUPPLIER	AGENCY	STUDIO	CLIENT	PRINCIPAL TYPE	DIMENSIONS
Dianne Mill Elkins Park, Pennsylvania	Letraset USA Inc.	Art 270, Inc.	Art 270, Inc.	International Auschwitz Committee	Compacta Light	24 × 36¼ in. 61 × 92 cm

TYPOGRAPHY/ DESIGN	TYPOGRAPHIC SUPPLIER	CLIENT	PRINCIPAL TYPE	DIMENSIONS
Gunnar Collier Essen, West Germany	Jöllenbeck & Schlieper	University Essen/ Jöllenbeck & Schlieper	Century Headline/ Cable/Avant Garde	23²/₃ × 33¹/₄ in. 59.4 × 84.1 cm

TYPOGRAPHY/ DESIGN	TYPOGRAPHIC SUPPLIER	CLIENT	PRINCIPAL TYPE	DIMENSIONS		
Louise Fili New York City	Marvin Kommel Productions	Society of Publication Designers	Eagle Bold	23¼ × 16 in. 59 × 40.6 cm		

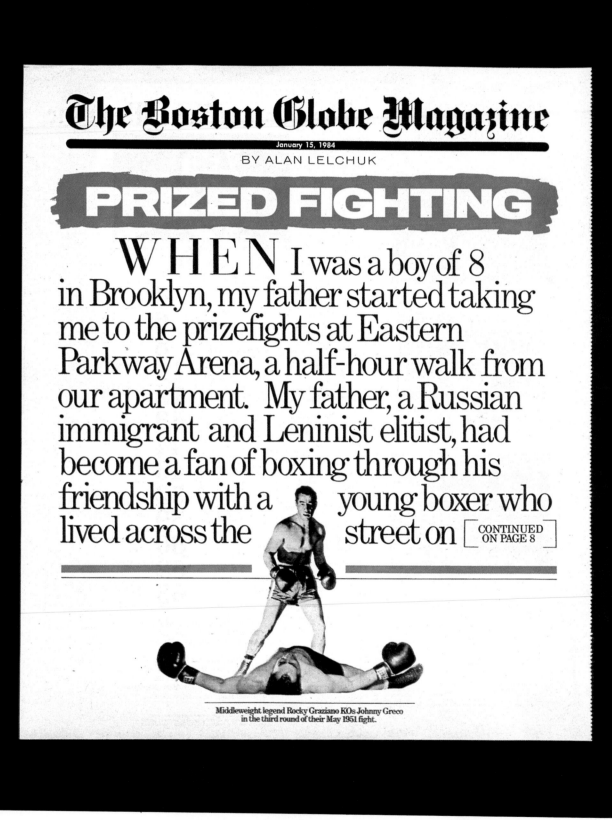

The Boston Globe Magazine

January 15, 1984

BY ALAN LELCHUK

PRIZED FIGHTING

WHEN I was a boy of 8 in Brooklyn, my father started taking me to the prizefights at Eastern Parkway Arena, a half-hour walk from our apartment. My father, a Russian immigrant and Leninist elitist, had become a fan of boxing through his friendship with a young boxer who lived across the street on

CONTINUED ON PAGE 8

Middleweight legend Rocky Graziano KOs Johnny Greco in the third round of their May 1951 fight.

TYPOGRAPHY/ DESIGN	TYPOGRAPHIC SUPPLIER	CLIENT	PRINCIPAL TYPE	DIMENSIONS
Ronn Campisi Boston, Massachusetts	Headliners of Boston	The Boston Globe Magazine	Venus Bold Extended/ Century Expanded	11 × 12¼ in. 27.9 × 31.1 cm

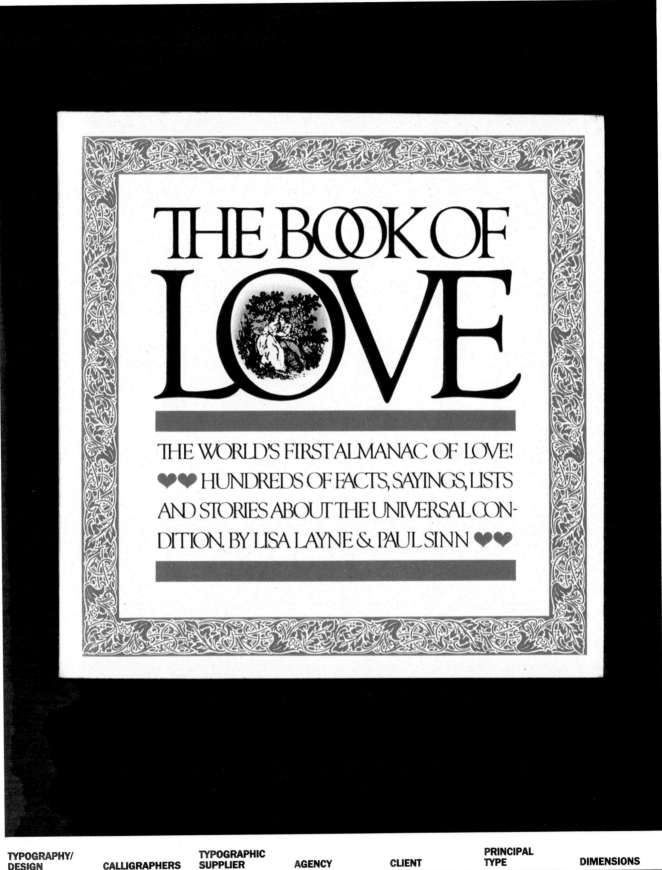

TYPOGRAPHY/ DESIGN	CALLIGRAPHERS	TYPOGRAPHIC SUPPLIER	AGENCY	CLIENT	PRINCIPAL TYPE	DIMENSIONS
Paul Sinn/ Mark Galarneau Palo Alto, California	Paul Sinn/ Mark Galarneau	Frank's Type	Galarneau & Sinn, Ltd.	Simon & Schuster	Goudy Old Style	5½ × 5½ in. 14 × 14 cm

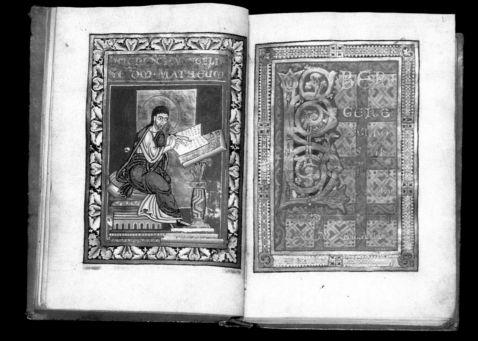

ILLUMINATED MANUSCRIPTS

THE J. PAUL GETTY MUSEUM

MALIBU · CALIFORNIA

TYPOGRAPHY/ DESIGN	TYPOGRAPHIC SUPPLIER	STUDIO	CLIENT	PRINCIPAL TYPE	DIMENSIONS
Patrick Dooley Los Angeles, California	Andresen Typographics	The J. Paul Getty Museum Design	The J. Paul Getty Museum	Bembo	20 × 30 in. 50.8 × 76.2 cm

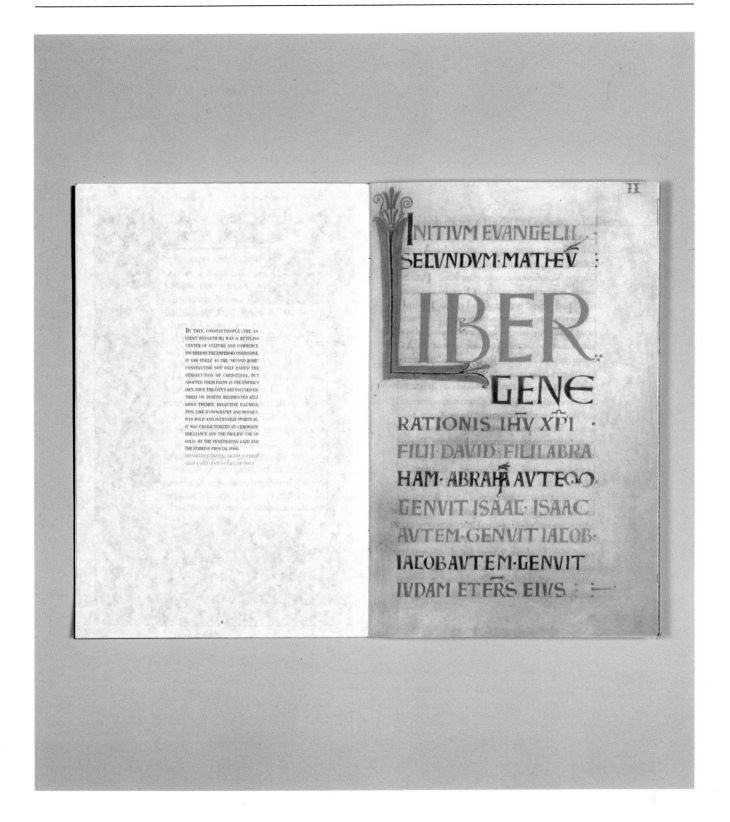

TYPOGRAPHY/ DESIGN	TYPOGRAPHIC SUPPLIER	STUDIO	CLIENT	PRINCIPAL TYPE	DIMENSIONS
B. Martin Pedersen/ Adrian Pulfer New York City	Boro Typographers	Jonson Pedersen Hinrichs & Shakery Inc.	Georgia Pacific	Century Book Condensed	8 × 12 in. 20.3 × 30.5 cm

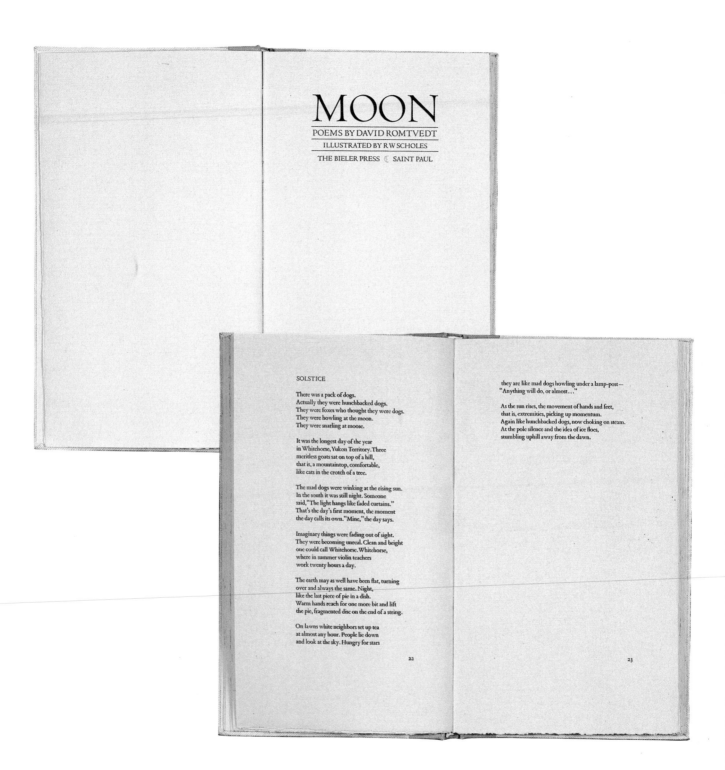

TYPOGRAPHY/ DESIGN	TYPOGRAPHIC SUPPLIER	CLIENT	PRINCIPAL TYPE	DIMENSIONS
Gerald Lange Minneapolis, Minnesota	*The Bieler Press*	*The Bieler Press*	*Bembo/ Centaur*	*6¼ × 10¼ in. 15.8 × 26 cm*

The Pulitzer Prize for Fiction 1953

ERNEST HEMINGWAY

THE

OLD MAN

AND

THE SEA

Illustrated by David Frampton

THE FRANKLIN LIBRARY · Franklin Center, Pennsylvania

slowing now and he was making the fish earn each inch of it. Now he got his head up from the wood and out of the slice of fish that his cheek had crushed. Then he was on his knees and then he rose slowly to his feet. He was ceding line but more slowly all the time. He worked back to where he could feel with his foot the coils of line that he could not see. There was plenty of line still and now the fish had to pull the friction of all that new line through the water.

Yes, he thought. And now he has jumped more than a dozen times and filled the sacks along his back with air and he cannot go down deep to die where I cannot bring him up. He will start circling soon and then I must work on him. I wonder what started him so suddenly? Could it have been hunger that made him desperate, or was he frightened by something in the night? Maybe he suddenly felt fear. But he was such a calm, strong fish and he seemed so fearless and so confident. It is strange.

Ernest Hemingway
80

"You better be fearless and confident yourself, old man," he said. "You're holding him again but you cannot get line. But soon he has to circle."

The old man held him with his left hand and his shoulders now and stooped down and

scooped up water in his right hand to get the crushed dolphin flesh off of his face. He was afraid that it might nauseate him and he would vomit and lose his strength. When his face was cleaned he washed his right hand in the water over the side and then let it stay in the salt water while he watched the first light come before the sunrise. He's headed almost east, he thought. That means he is tired and going with the current. Soon he will have to circle. Then our true work begins.

After he judged that his right hand had been in the water long enough he took it out and looked at it.

TYPOGRAPHY/ DESIGN	ILLUSTRATOR	TYPOGRAPHIC SUPPLIER	CLIENT	PRINCIPAL TYPE	DIMENSIONS
David Uttley/ Michael Mendelsohn Middlesex, New York	*David Frampton Richmond, New Hampshire*	*Progressive Typographers*	*The Franklin Library*	*Caslon*	*8 × 6⁹/₁₆ in. 20.3 × 15.7 cm*

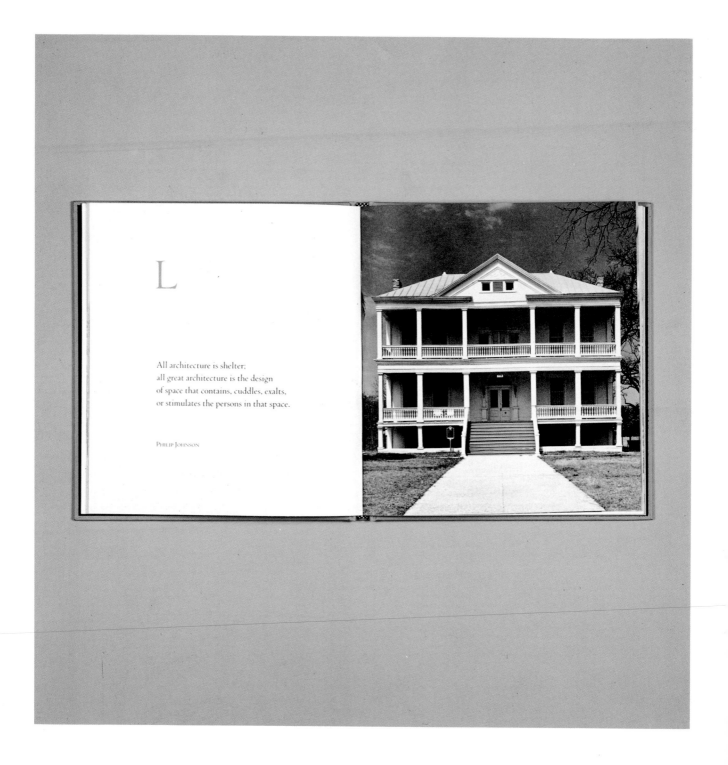

L

All architecture is shelter;
all great architecture is the design
of space that contains, cuddles, exalts,
or stimulates the persons in that space.

PHILIP JOHNSON

TYPOGRAPHY/ DESIGN	TYPOGRAPHIC SUPPLIER	STUDIO	CLIENT	PRINCIPAL TYPE	DIMENSIONS
Marc Alain Meadows/ Robert Wiser Washington, D.C.	*Harlowe Typography/ Phil's Photo Inc.*	*Meadows & Wiser*	*Preservation Press/ National Trust for Historic Preservation*	*Centaur*	*8¼ × 8¾ in. 20.9 × 22.2 cm*

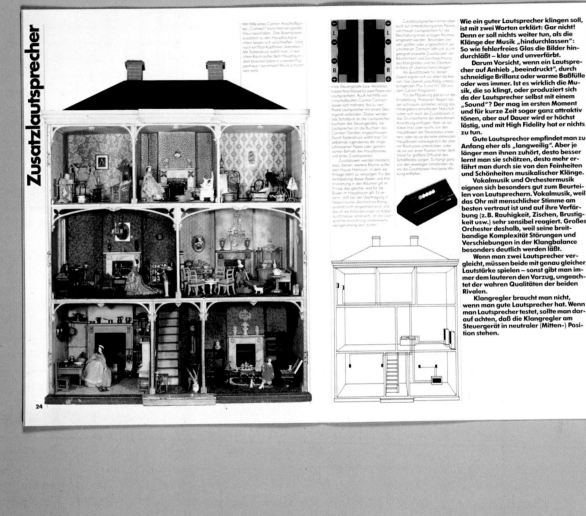

TYPOGRAPHY/ DESIGN	TYPOGRAPHIC SUPPLIER	STUDIO	CLIENT	PRINCIPAL TYPE	DIMENSIONS
Christof Gassner Frankfurt, West Germany	*Typo Knauer GmbH*	*Christof Gassner Grafik-Design*	*Canton*	*Futura*	*10½ × 14¼ in. 26.7 × 36.2 cm*

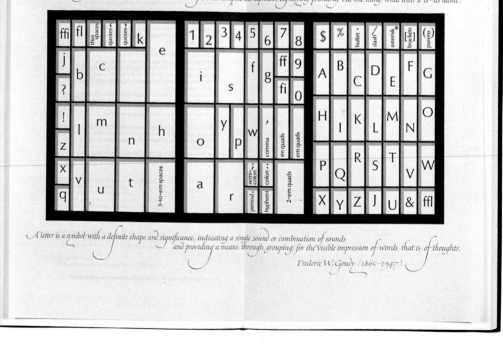

TYPOGRAPHY/ DESIGN	CALLIGRAPHER	TYPOGRAPHIC SUPPLIER	CLIENT	PRINCIPAL TYPE	DIMENSIONS
Hermann Zapf Darmstadt, West Germany	Hermann Zapf	Nagel Fototype GmbH	Technische Hochschule Darmstadt	Optima Roman	7 × 10¾ in. 17.8 × 27.3 cm

specie, steht, fertig. Ein unzureichender Proporz, daß die Sprachgeschichte Entwicklungen kennt, die, umgekehrt, irgendwann einmal ein Zusatz-H präsentieren und daran bis in die Gegenwart festhalten. Das mittelhochdeutsche Wort *eichen* ist so ein Beispiel, ab dem 14. Jahrhundert tritt immer häufiger ein H davor und wird schließlich obligatorisch. Dafür hat die *beidechse*, wie sie historisch in manchen Dialekten hieß, in der modernen Hochlautung ihr H abgestreift, und auch dem mittelhochdeutschen *helfenbein* hat man, endgültig erst im 17. Jahrhundert, seinen anlautenden Hauchlaut genommen.

Womit generell die Frage gestellt sei nach der zu vermutenden stark unterschiedlichen Wertigkeit des H in den Wortgliedern und nach seinen — möglicherweise in sprachgeschichtliche Regeln zu fassenden — Entwicklungsphasen.

Das ist ein Feld, auf dem Sicherheit, Wahrscheinlichkeit und Vermutung eng beieinander liegen.

sich der folgende Labial (das W also) noch rechtzeitig zum Vokal U wandelte. Auch in der Wortgeschichte gibt es lebenserhaltende Unfälle.

Etymologisch zweierlei H gibt es im In- und Auslaut unserer Sprache. Das eine geht, einmal mehr, auf ein indogermanisches K zurück. Althochdeutsch *zehan*, gotisch *taihun*, lateinisch aber *decem* ist so ein Fall — wobei das C als Stellvertreter für das eigentlich ‹gemeinte› K auftritt (wir erinnern uns der Bemerkungen zum Buchstaben C in unserer Alphabetpräsentation). Interessanter noch ist es in der Verbindung HT, in den meisten Fällen Ergebnis einer Assimilation aus Gutturale und Dentale. *Nahtan* heißt es altindisch, *nahts* gotisch und *naht* althochdeutsch. Über Jahrhunderte läßt sich dieses assimilierte HT in vielen Texten nachweisen. Erst mit dem Ausgang des Mittelhochdeutschen, mit dem Ende des 15. Jahrhunderts, ist es endlich zu CHT geworden. In unserem Fall also zur Schreibung *Nacht*.

CAPITALIS QUADRATA
3. BIS 4. JAHRHUNDERT.
CAPITALIS RUSTICA
5. BIS 6. JAHRHUNDERT.

UNZIALE,
8. JAHRHUNDERT.
HALBUNZIALE,
7. BIS 8. JAHRHUNDERT.

KAROLINGISCHE MINUSKEL,
9. JAHRHUNDERT.
GOTISCHE BUCHSCHRIFT,
MITTE 13. JAHRHUNDERT.

gedrückt wird. Wie wenig man sich in der Anfangszeit dieses Gebrauchs des H sicher war, belegt die Orthographie. Nicht immer steht es nach, häufig auch vor dem zu längenden Vokal. *Jahr* und *jhar* gibt es genau so wie die Schreibungen *naht* und *rhat*. Erst mit der immer stärkeren Bedeutung des Drucks gewinnt die Buchstabenfolge Festigkeit.

Nachklänge dieser Unsicherheit aber finden wir bis ins 20. Jahrhundert hinein in Schreibungen wie *Thür* und *Thor*, die — in der lautlichen Umschrift — für *Tür* und *Tohr* stehen. Aber auch in sinnlosen Analogiebildungen wie *Theil* und *Thier*. Weshalb sensible Beobachter sprachhistorischer Logik wie die Brüder Grimm

beitet. Aber auch ALBRECHT DÜRER hatte in Italien aus der Anschauung Grundlagen für den strengen Aufriß von Versalien gewonnen und in die vorbildhaft verbindliche Form eines Lehrbuchs eingebracht.

Wenn wir uns all diesen frühen Versuchen verpflichtet fühlen, nach empirischen Forschungen zu den Proportionen des menschlichen Körpers und, darum hergeleitet, zu den ‹richtigen› Maßen in der Architektur auch die Schrift in einen formalen Kanon einzubeziehen — wenn wir uns all dem noch heute verpflichtet wissen, so bleibt das bestehen, was auch dieser Jahresausgabe zu ihrer Existenz verhalf: Form als Auftrag, als übertragene und übernommene Verantwortung.

TYPOGRAPHY/ DESIGN	CALLIGRAPHER	TYPOGRAPHIC SUPPLIER	STUDIO	CLIENT	PRINCIPAL TYPE	DIMENSIONS
Hermann Rapp Weilrod/Hessen, West Germany	Hermann Rapp	Scangraphic Dr. Böger GmbH	Bölling, Offizin für Prägedruck	Bölling, Offizin für Prägedruck	Garamond Simoncini/Antiqua	7⅔ × 11¾ in. 18.7 × 29.8 cm

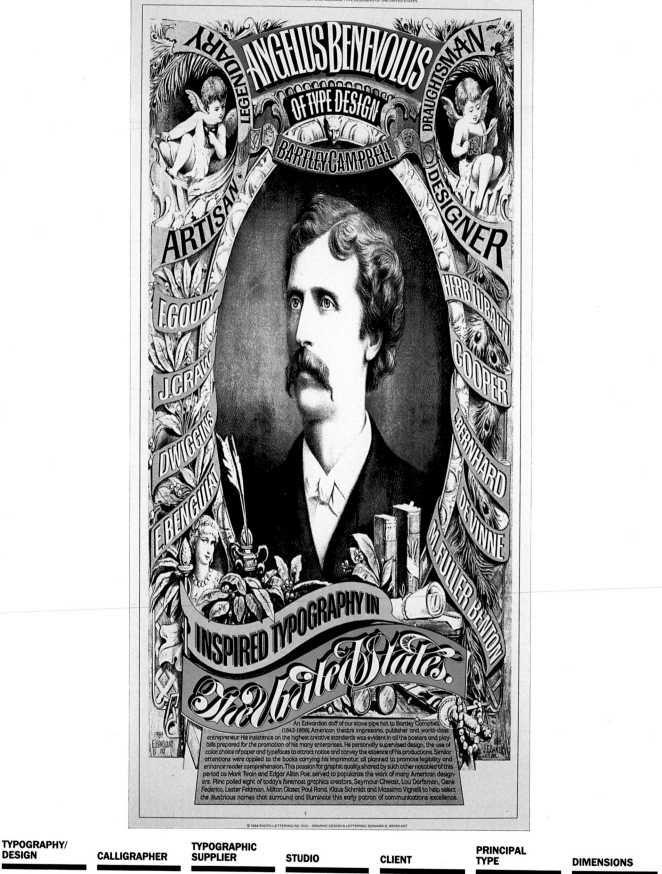

TYPOGRAPHY/ DESIGN	CALLIGRAPHER	TYPOGRAPHIC SUPPLIER	STUDIO	CLIENT	PRINCIPAL TYPE	DIMENSIONS
Ed Benguiat New York City	Ed Benguiat	Photo-Lettering, Inc.	Photo-Lettering, Inc.	Plinc	Handlettering	16 × 32 in. 40.6 × 81.3 cm

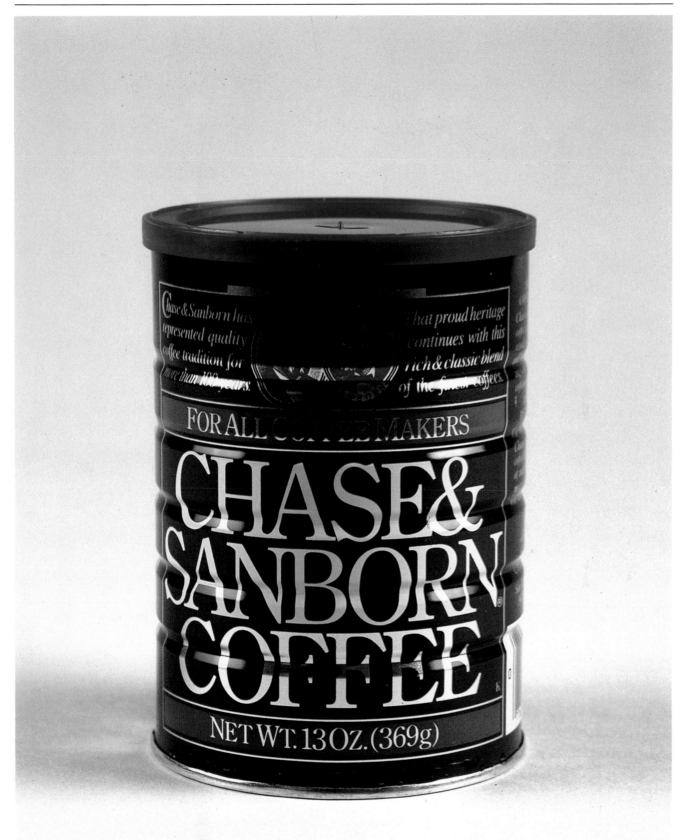

TYPOGRAPHY/ DESIGN	CALLIGRAPHER	TYPOGRAPHIC SUPPLIER	STUDIO	CLIENT	PRINCIPAL TYPE	DIMENSIONS
James Nevin/ Nicholas Sidjakov/ Jerry Berman San Francisco, California	Jock Campbell **ILLUSTRATOR** David Stevenson	Spartan Typography	Sidjakov Berman & Gomez	Hills Bros. Coffee, Inc.	Century Old Style (handlettered & modified)	Height: 5½ in./14 cm Circumference: 12¼ in./31.1 cm

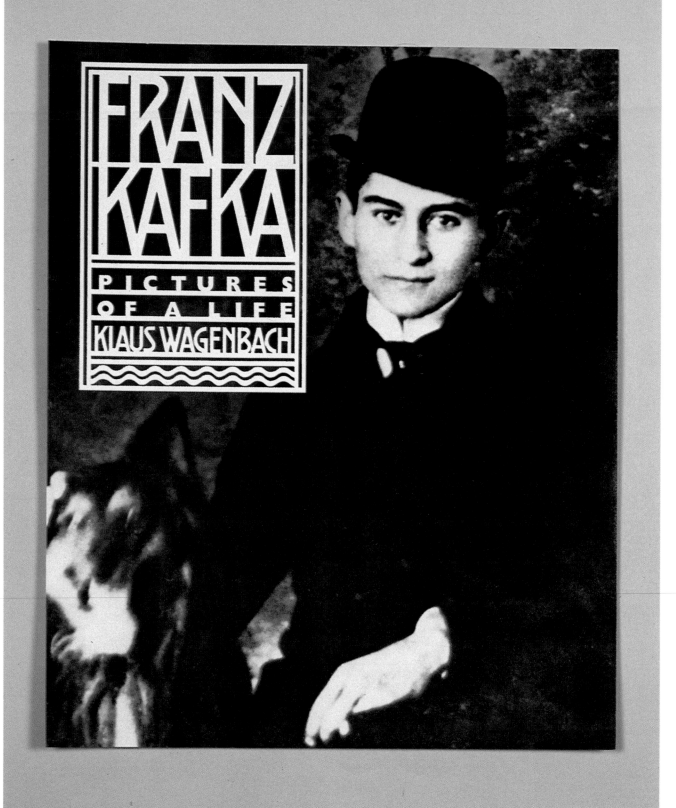

FRANZ KAFKA
PICTURES OF A LIFE
KLAUS WAGENBACH

TYPOGRAPHY/ DESIGN	LETTERING	TYPOGRAPHIC SUPPLIER	AGENCY	CLIENT	PRINCIPAL TYPE	DIMENSIONS
Louise Fili New York City	Tony Di Spigna	Haber Typographers	Pantheon Books	Pantheon Books	Handlettering	8¼ × 10¾ in. 21 × 27.3 cm

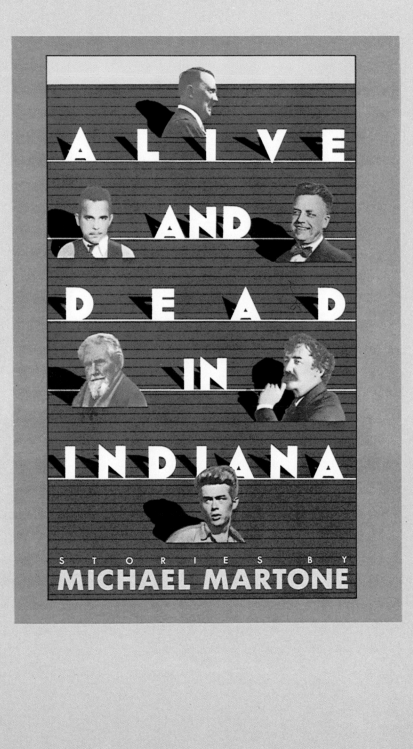

TYPOGRAPHY/ DESIGN	HANDLETTERING	CLIENT	DIMENSIONS
Fred Marcellino *New York City*	*Fred Marcellino*	*Alfred A. Knopf*	*5¼ × 8⁹/₁₆ in.* *13.3 × 20.8 cm*

TYPOGRAPHY/ DESIGN	TYPOGRAPHIC SUPPLIER	STUDIO	CLIENT	PRINCIPAL TYPE	DIMENSIONS
B. Martin Pedersen/ Adrian Pulfer New York City	*Boro Typographers*	*Jonson Pedersen Hinrichs & Shakery Inc.*	*Georgia Pacific*	*Futura Bold Condensed*	*8 × 12 in. 20.3 × 30.5 cm*

TYPOGRAPHY/ DESIGN	TYPOGRAPHIC SUPPLIER	STUDIO	CLIENT	PRINCIPAL TYPE	DIMENSIONS
B. Martin Pedersen/ Adrian Pulfer New York City	Boro Typographers	Jonson Pedersen Hinrichs & Shakery Inc.	Georgia Pacific	Futura Bold Condensed	8 × 12 in. 20.3 × 30.5 cm

TYPOGRAPHY/ DESIGN	TYPOGRAPHIC SUPPLIER	STUDIO	CLIENT	PRINCIPAL TYPE	DIMENSIONS
B. Martin Pedersen New York City	Boro Typographers	Jonson Pedersen Hinrichs & Shakery Inc.	Georgia Pacific	Futura Bold Condensed	8 × 12 in. 20.3 × 30.5 cm

America is a land of wonders, in which everything is in constant motion and every change seems an improvement ■

— *Alexis De Tocqueville*

TYPOGRAPHY/ DESIGN	TYPOGRAPHIC SUPPLIER	STUDIO	CLIENT	PRINCIPAL TYPE	DIMENSIONS
Brian Boyd *Dallas, Texas*	*Typographics*	*Richards, Brock, Miller, Mitchell & Associates*	*Criterion Financial Corp.*	*ITC Cheltenham Condensed*	*7½ × 11 in.* *19 × 28 cm*

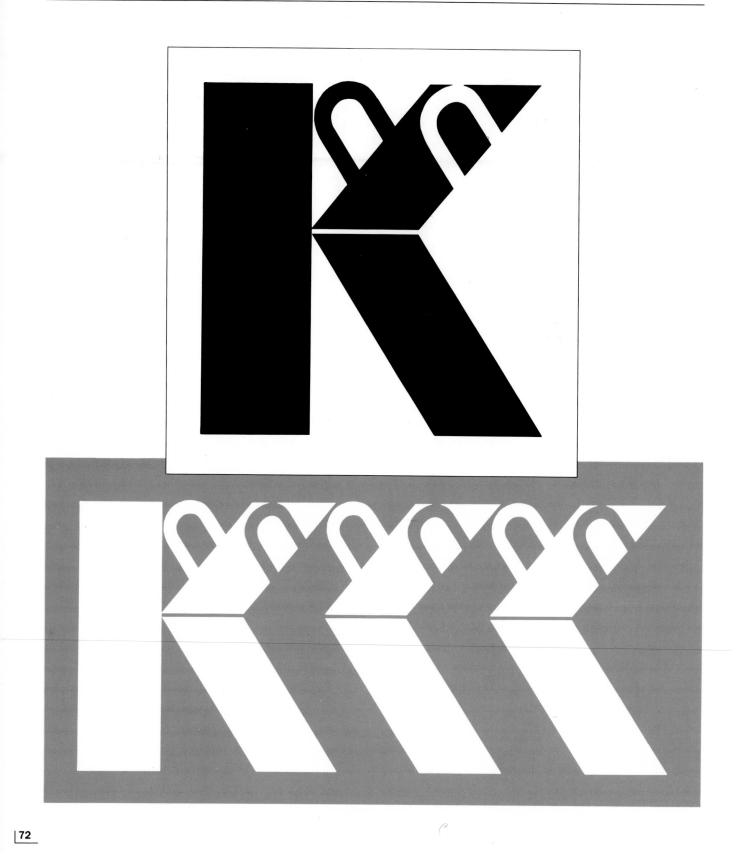

TYPOGRAPHY/ DESIGN	**AGENCY**	**STUDIO**	**CLIENT**
Samuel Kuo *Brooklyn, New York*	*KCSM* *Communications*	*KCSM* *Communications*	*Pratt Institute*

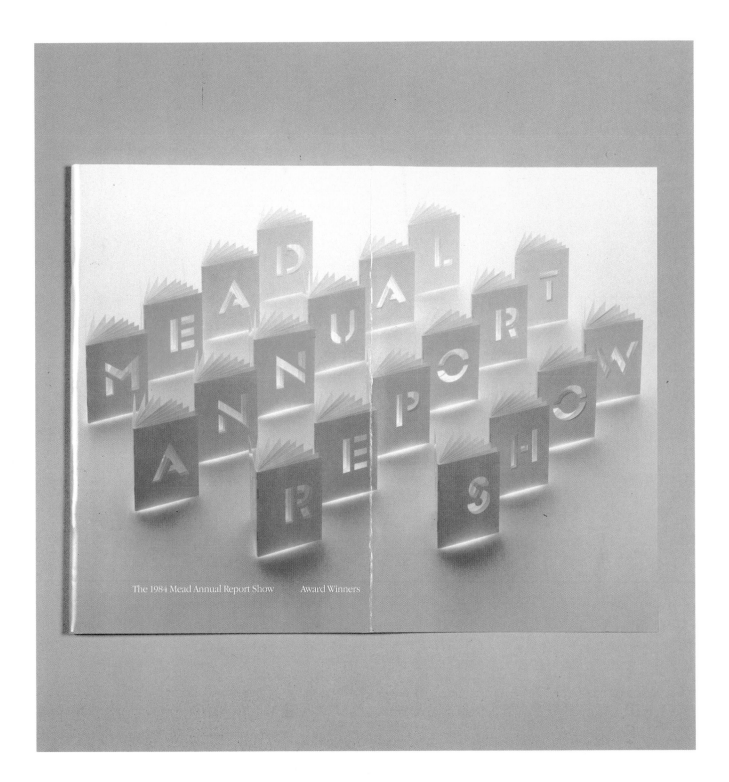

The 1984 Mead Annual Report Show Award Winners

TYPOGRAPHY/DESIGN	TYPOGRAPHIC SUPPLIER	AGENCY	STUDIO	CLIENT	PRINCIPAL TYPE	DIMENSIONS
Robert Cipriani Boston, Massachusetts	Typographic House	Cipriani Advertising, Inc.	Cipriani Advertising, Inc.	Mead Paper Corporation	ITC Garamond Bold	8½ × 12½ in. 21.6 × 31.8 cm

TYPOGRAPHY/ DESIGN	TYPOGRAPHIC SUPPLIER	AGENCY	CLIENT	PRINCIPAL TYPE	DIMENSIONS
Susan Hochbaum New York City	*Peat Marwick Mitchell*	*Pentagram Design*	*Peat Marwick International*	*Times Roman*	*8½ × 11 in. 21.6 × 27.9 cm*

VAN CLEEF

ECONOMICS. Although investments abound, truly good opportunities are rare. Before proceeding with a project, Van Cleef spends as much time as necessary analyzing the market factors which may affect investment performance. Careful consideration is given to downside risk, as well as to upside potential.

Van Cleef invests only when there is an opportunity to add value. We are not passive investors, waiting for external factors such as inflation to bring about economic gain. Our objective is to accelerate the appreciation process by making improvements in the project, its financing or its management.

STRUCTURE. The economic prospects for any investment, no matter how good, can be undermined by the wrong structure. Large front-end fees and excessive start-up costs can divert investor dollars and drive up the effective price of an asset. Inequitable sharing of cash flow, tax benefits and appreciation can convert profitable operating results into marginal returns. Misplaced benefits to the developers and managers can affect motivation and create disincentives. Because Van Cleef ties its success to the investors' success, it pays special attention to eliminating these problems.

TYPOGRAPHY/ DESIGN	TYPOGRAPHIC SUPPLIER	AGENCY	CLIENT	PRINCIPAL TYPE	DIMENSIONS
Marilyn G. Lurie Chicago, Illinois	Typographic Resource	Burson · Marsteller	Van Cleef & Arpels, Inc.	Bodoni	5½ × 11 in. 14 × 27.9 cm

TYPOGRAPHY/ DESIGN	TYPOGRAPHIC SUPPLIER	AGENCY	CLIENT	PRINCIPAL TYPE	DIMENSIONS
Erkki Ruuhinen Helsinki, Finland	*Valotyyppi*	*Erkki Ruuhinen Design*	*Haavikko & Pietiläinen & Co. OY*	*Bodoni Old Face*	*Various*

SAN FRANCISCO SYMPHONY

THE PERMANENT FUND

TYPOGRAPHY/ DESIGN	TYPOGRAPHIC SUPPLIER	AGENCY	CLIENT	PRINCIPAL TYPE	DIMENSIONS
Leslee Avchen Minneapolis, Minnesota	Type House/ Duragraph	Leslee Avchen Design	The San Francisco Symphony	Sabon	8½ × 11 in. 21.6 × 27.9 cm

Controlled,
consistent
inking

Computerized,
color-correct
inking

One of the main advantages of the Royal Zenith 40″ Planeta Super Variant is its ability to quickly reach and maintain optimum ink feeding. In just a few sheets, this press can achieve an even ink flow across the entire cylinder. It produces consistent, high-quality work throughout any length press run.

Precise inking. The Royal Zenith 40″ Planeta's inking unit has four form rollers — each a different diameter to minimize ghosting and to distribute the ink. Four vibrator rollers spread the ink film with a smooth and even motion.

In addition, ink form vibrator rollers are coated with a special wear-resistant substance to improve ink accep-

tance. Dust-proof bearings help to ensure trouble-free roller rotation.

Controlled inking. The Royal Zenith 40″ Planeta has a simple control that adjusts the ink form vibrator rollers from minimum to maximum vibration — making split fountain layouts much easier on all units. Press operators can easily adjust to difficult front-to-back layouts due to a 360° timing of the ink form vibrator rollers relative to the plate cylinders. Full calibration also makes resetting easy.

A technological breakthrough. The optional Varicontrol remote inking system provides optimum efficiency...from one central location. Varicontrol is a state-of-the-art inking control system. It combines microprocessor control and a single-blade inking unit. Varicontrol assures uniform, high-quality and color-correct inking without costly trial and error.

With the optional Varicontrol system, the press operator controls all required inking functions from one central console. Specially developed software determines individual inking zones, as well as overall inking quality. Eliminating of ink zones for smaller sheets, inking selected sheet widths and adjusting the fountain blade are also software controlled.

In most cases, only one command is needed to initiate most functions. And since all adjustments are made from one central location, press operators save time moving from unit to unit.

Consistent densities. With the Varicontrol system, ink density is easily set to match approved customer proof sheets. Once optimum ink density is attained, it can be maintained and consistently repeated over and over again—reducing makeready and stock waste.

Push-button recall. A push of a button lets press operators recall jobs when necessary. This Varicontrol feature is especially valuable with split shifts. For example, the night shift can wash up even though a job hasn't been

completed. In the morning, the day shift can recall the job immediately from the memory storage unit.

Manual backup. In the event of an electronic malfunction in the Varicontrol system, the 40″ Planeta has a manual override system so production can continue without interruption.

Dampening and wash-up. The Royal Zenith 40″ Planeta is available with a five-roller, fountain-type continuous alcohol dampening system that distributes liquid across the plate evenly and reliably. Distribution is metered. Fountain rollers are adjustable. Liquid circulation and return filtering are automatic. For quick changes, the chromed distribution roller is easily removed from its cone bearings.

A factory-installed inker wash-up machine with a spring-loaded doctor blade is standard equipment on the press. The drop-away ink fountain blade makes cleaning easy.

TYPOGRAPHY/ DESIGN	TYPOGRAPHIC SUPPLIER	AGENCY	STUDIO	CLIENT	PRINCIPAL TYPE	DIMENSIONS
Lou Fiorentino Brooklyn, New York	CTT Typografix, Inc.	Fiorentino Reinitz Leibe	Fiorentino Reinitz Leibe	Royal Zenith	Univers 75/ Univers 45	6½ × 12 in. 16.5 × 30.5 cm

■ PARIS: Fast, Flexible, Easy to Use

PARIS is today's most successful example of a system that harnesses state-of-the-art computer technology to store, retrieve and help manage museum collections information.

PARIS can help solve the enormously time-and-labor-intensive problem of managing curatorial data. For the first time, museums—with the support of Control Data consultants—can create a central data base containing comprehensive objective and subjective information on every item in their collections.

This information can be quickly and easily accessed by staff members unfamiliar with computerized processes. Information can be updated or amplified by assigned personnel with equal speed and ease.

Information in the data base can also be shared through the system's powerful network capabilities with other museums and scholars around the world.

The security features of the system allow museums to restrict access to sensitive information—such as insurance value, purchase price, the name of the donor of an object or any other information they do not wish to make public.

The development of PARIS presents the museum community with another very important benefit. By freeing creative museum personnel from many of the routine, time-consuming collection maintenance tasks, PARIS gives curators, archivists, museum librarians, and others on the administrative staff time to use their energy and expertise for more productive pursuits within their own fields.

■ From Art to Zoology

The fast, flexible PARIS system has been successfully used to document and manage many different collections of both natural and man-made treasures.

Antiquities

Botany

Coins and Medals

Decorative Arts

Earth Science

Ethnography

Fine Arts

Herpetology

History

Ichthyology

Mammalogy

Military and War Memorial Artifacts and Art

Ornithology

Page Four

Page Five

TYPOGRAPHY/ DESIGN	TYPOGRAPHIC SUPPLIER	STUDIO	CLIENT	PRINCIPAL TYPE	DIMENSIONS
Pamela Hovland Minneapolis, Minnesota	*Type House*	*Krogstad Design Associates*	*Control Data Corporation*	*Sabon*	*7½ × 11½ in. 19.1 × 29.2 cm*

NOWHERE IN THE SECOND WORLD HAS SUCH AN ACUTE COMPREHENSION OF BUSINESS BEEN OBTAINED THROUGH SO LITTLE PRACTICAL EXPERIENCE WORKING ONLY AT RELAXING, THE FRENCH TAKE PRIDE IN BEING EVEN LESS PRODUCTIVE THAN THE ITALIANS.

IF THE VISITOR TO THIS SMALL CORNER OF THE CONTINENT CAN OVERLOOK THE FIRST PERIOD OF SOPHISTICATED HUMOUR COMMONLY MISINTERPRETED AS RUDE AND INSULTING BEHAVIOR AT YOUR EXPENSE, PERMIT YOURSELF THE EXTENSION OF YOUR STAY LONG ENOUGH TO WITNESS A MODERN PHENOMENON, THE FRENCH AT WORK. DEPENDING ON THE SEASON, THIS MAY REQUIRE THAT YOU CHECK OUT OF YOUR HOTEL AND BUY A HOUSE, BUT IS WELL WORTH THE AMOUNT YOU'LL LOOSE ON THE RESALE.

A SENSE OF HISTORY AND IT'S PRESERVATION IS EXPRESSED IN EVERY ASPECT OF LIFE RIGHT DOWN TO THE MOST MODEST HOMES. ARCHITECTURAL STYLE WHICH CONTRADICTS CONTEMPORARY DIRECTION AND TASTE, BECOMING AFTER A VERY LONG WHILE, UNIQUELY FRENCH.

FOR A FIRSTHAND DEMONSTRATION, TRY ENTERING ANY ONE OF THE MANY BANKS FOUND TO BE OPEN ON WEDNESDAY IN PARIS NEAR THE OPERA BETWEEN TWO-THIRTY AND THREE-FIFTYFIVE.

LOOKING AS THOUGH YOU COULDN'T SPEAK FRENCH AND EVEN IF YOU DID YOU WILL BE EXTENDED THE COURTESY OF BEING MADE TO WAIT IN CONSECUTIVE LINES UNTIL CLOSING TIME. CALL FOR THE MANAGER, CALL YOUR MOTHER, THE DISTANCE WILL BE THE SAME.

COMING FROM ANYWHERE ELSE IN THE WORLD YOU WOULD HAVE MISTAKEN THE POLITE, COURTIOUS MANNER OF THE TELLER FOR A BAD INTERPRETATION OF MIME BUT YOU ARE WRONG YET AGAIN.

THIS IS A COUNTRY OF PRIDE WHICH PREFERS TO DO NO BUSINESS AT ALL THAN TO SEE SO MANY FRENCH FRANCS EXCHANGED FOR SO LITTLE OF ANYTHING ELSE.

IL FAUT EGALEMENT TROUVER LE TEMPS D'OBSERVER LES FRANÇAIS AU TRAVAIL. PRENEZ LA PEINE DE QUITTER VOTRE HOTEL. ESSAYEZ MEME DE VOUS TROUVER UNE PETITE MAISON DANS LES ENVIRONS. IL FAUT PRENDRE LE TEMPS NECESSAIRE A L'APPRECIATION DE CE PEUPLE ET DE CE PAYS, ET L'INVESTISSEMENT IMMOBILIER SERA LARGEMENT COMPENSE LORS DE LA REVENTE.

UNE LONGUE EXPERIENCE A CONDUIT LE FRANCAIS A UNE COMPREHENSION AIGUE DES AFFAIRES. LE FRANCAIS PARAIT A L'AISE LORSQU'IL TRAVAILLE, ET FIER D'AVOIR UNE PRODUCTIVITE AUTREMENT PLUS IMPORTANTE QUE LES ITALIANS, OU TOUT AUTRE PAYS PERIPHERIQUE. LEUR SYSTEME BANCAIRE EST PARTICULIEREMENT BIEN ORGANISE, VOUS TROUVEREZ AISEMENT UNE BANQUE OUVERTE PRATIQUEMENT TOUTE LA SEMAINE, ET MEME PRES DE L'OPERA L'APRES-MIDI.

LESQUELS NE S'OFFENSERONT GUERE DE VOS GESTES DE MIME MAL INTERPRETES. LA FIERTE DU FRANÇAIS POUR SON PAYS EST TELLE QU'IL PREFERERA NE FAIRE AUCUNE AFFAIRE AVEC VOUS PLUTOT QUE DE VOUS PRENDRE DES SOUS GAGNES A LA SUEUR DE VOTRE FRONT.

SACHANT QUE VOUS NE PARLEZ PAS UN TRAITRE MOT DE FRANÇAIS. ILS VOUS DEMANDERONT SOUVENT DE SORTIR DE LA QUEUE POUR VOUS SERVIR PERSONNELLEMENT. LE DIRECTEUR D'UNE BANQUE, LORSQU'ON A BESOIN DE LUI PARLER, SAIT FAIRE PREUVE D'UN SENTIMENT PRESQUE MATERNEL. DANS NUL AUTRE ENDROIT DU MONDE VOUS NE TROUVEREZ DES EMPLOYES PLUS COURTOIS ET POLIS.

	TYPOGRAPHIC			PRINCIPAL	
TYPOGRAPHY/ DESIGN	**TYPOGRAPHIC SUPPLIER**	**STUDIO**	**CLIENT**	**PRINCIPAL TYPE**	**DIMENSIONS**
Robert Adamski Paris, France	*FACE*	*Eclectic Design*	*Select Magazine*	*Univers*	*13¹/₁₀ × 9⁷/₁₆ in. 33.5 × 24 cm*

THIS IS NOT DUMMY COPY. IT IS MEANT TO BE READ. IT IS NOT A SUBSTITUTE FOR THE FINAL COPY WHICH WILL BE INSERTED AT A LATER DATE, BUT THE ACTUAL COPY WHICH HAS BEEN WRITTEN SPECIFICALLY FOR THIS AD. THIS AD WAS SET BY PHOTO-LETTERING, INC. THAT'S RIGHT, WE SET TYPE! IN FACT, MANY PEOPLE DON'T REALIZE THAT PHOTO LETTERING, INC. HAS BEEN SETTING TEXT SINCE THE LATE 60'S. OVER THE LAST FOURTEEN YEARS WE HAVE UPGRADED AND GREATLY EXPANDED OUR TEXT SETTING FACILITIES AND CAPABILITIES. NOW, WITH AN EVER-GROWING LIBRARY OF OVER 700 TEXT FACES INCLUDING EVERY ITC TEXT FACE, WE ARE SETTING COMPLETE ADS. (WE HAVE BEEN FOR YEARS!) WE ALSO DO COMPLETE MECHANICALS OF ADS—HEADLINES, TEXT SETTING, CLIENT'S ART, ETC. WE'VE REALIZED THAT FOR MANY YEARS WE HAVE BEEN KNOWN FOR OUR HEADLINES, PHOTO-EFFECTS, AND EVEN OUR SPECTRAKROME "ONE-OF-A-KIND" COLOR PREVIEW PRINT PROCESS; AND WE ARE PROUD OF THAT REPUTATION. SOME OF OUR SPECIAL PHOTO-EFFECTS ARE UNPARALLELED ANYWHERE IN THE WORLD. BUT EQUALLY IMPORTANT TO US IS THE FAST GROWING KNOWLEDGE THAT PHOTO-LETTERING, INC. IS A COMPETITIVE "TYPOGRAPHER" WITH COMPETITIVE TEXT SETTING FOR ALL OF YOUR TEXT COMPOSITION NEEDS. THIS IS NOT DUMMY COPY. IT IS MEANT TO BE READ. IT IS NOT A SUBSTITUTE FOR THE FINAL COPY WHICH WILL BE INSERTED AT A LATER DATE, BUT THE ACTUAL COPY WHICH HAS BEEN WRITTEN SPECIFICALLY FOR THIS AD. THIS AD WAS TYPESET BY PHOTO-LETTERING, INC., YOUR ONE STOP, FULL SERVICE TYPOGRAPHER. 216 EAST 45TH STREET, NEW YORK CITY, NEW YORK 10017. TELEPHONE 212-490-2345.

SET IN TIMES ROMAN SEMI-CONDENSED LIGHT 9706. AN EXCLUSIVE PHOTO-LETTERING FACE.

TYPOGRAPHY/ DESIGN	CALLIGRAPHER	TYPOGRAPHIC SUPPLIER	STUDIO	CLIENT	PRINCIPAL TYPE	DIMENSIONS
Tom Vasiliow Ridgefield Park, New Jersey	Ed Benguiat New York City	Photo-Lettering, Inc.	Photo-Lettering, Inc.	Photo-Lettering, Inc.	Times Roman Semi-Condensed Light	7 × 10 in. 17.8 × 25.4 cm

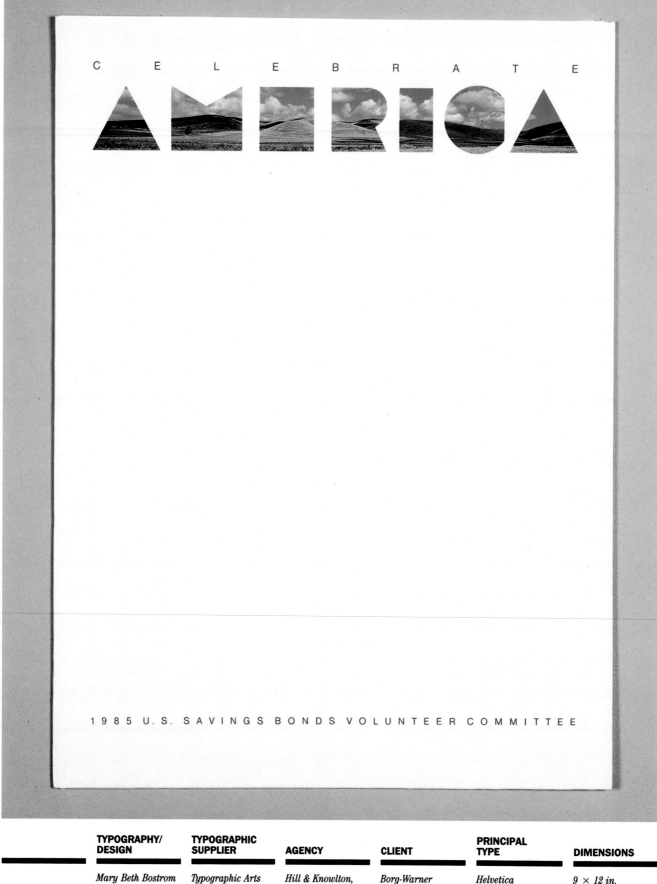

TYPOGRAPHY/ DESIGN	TYPOGRAPHIC SUPPLIER	AGENCY	CLIENT	PRINCIPAL TYPE	DIMENSIONS
Mary Beth Bostrom Cybul Chicago, Illinois	*Typographic Arts*	*Hill & Knowlton, Inc.*	*Borg-Warner*	*Helvetica*	*9 × 12 in. 22.9 × 30.5 cm*

P R O S P E R I T Y

mericans have been buying government bonds in one form or another since 1776. Whether to finance the Revolutionary War, to buy and develop new territory, or to build the first railroads and canals, bonds have given the American people a way to contribute to the nation's growth and prosperity. U.S. Savings Bonds were first introduced in 1941 to promote broad public participation in government financing. With guaranteed rates of return, Savings Bonds were designed to protect small savers, many of whom had experienced unexpected losses during the Depression. Today's Savings Bonds may be one of the best investment opportunities ever offered Americans, since Bonds now earn interest at high, market-based rates, while still providing the safety, convenience, and tax advantages they have always had. In addition, an investment in U.S. Savings Bonds provides a less tangible advantage. There is great pride in ownership, in the knowledge that one is contributing to the health and well-being of the country. Buying Bonds is an investment in America's future.

TYPOGRAPHY/ DESIGN	TYPOGRAPHIC SUPPLIER	AGENCY	CLIENT	PRINCIPAL TYPE	DIMENSIONS	
Mary Beth Bostrom Cybul Chicago, Illinois	Typographic Arts	Hill & Knowlton, Inc.	Borg-Warner	Times Roman/ Helvetica	11 × 8½ in. 27.9 × 21.6 cm	

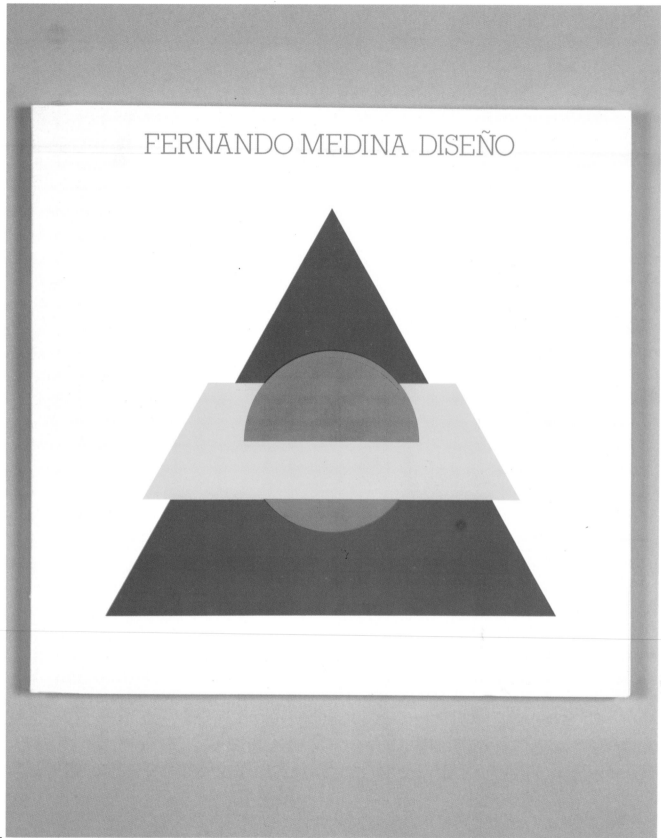

TYPOGRAPHY/ DESIGN	TYPOGRAPHIC SUPPLIER	AGENCY	STUDIO	CLIENT	PRINCIPAL TYPE	DIMENSIONS
Fernando Medina *Montreal, Canada*	*Letra*	*Fernando Medina* *Design*	*Fernando Medina* *Design*	*Fernando Medina* *Design*	*Rockwell Light*	*8²/₃ × 8¹/₄ in.* *22 × 21 cm*

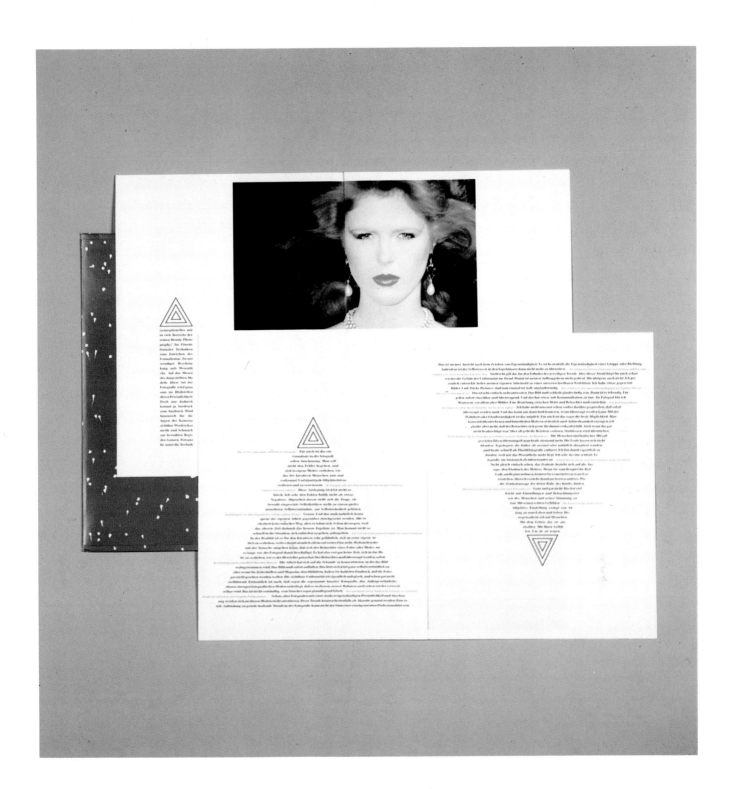

TYPOGRAPHY/ DESIGN	TYPOGRAPHIC SUPPLIER	STUDIO	CLIENT	PRINCIPAL TYPE	DIMENSIONS
Friedrich Meyer Düsseldorf, West Germany	RZA Werberealisierung GmbH	RZA Werberealisierung GmbH	Gunter H. Kremer	Walbaum Buch Bold	12⅕ × 9⅖ in. 31 × 24 cm

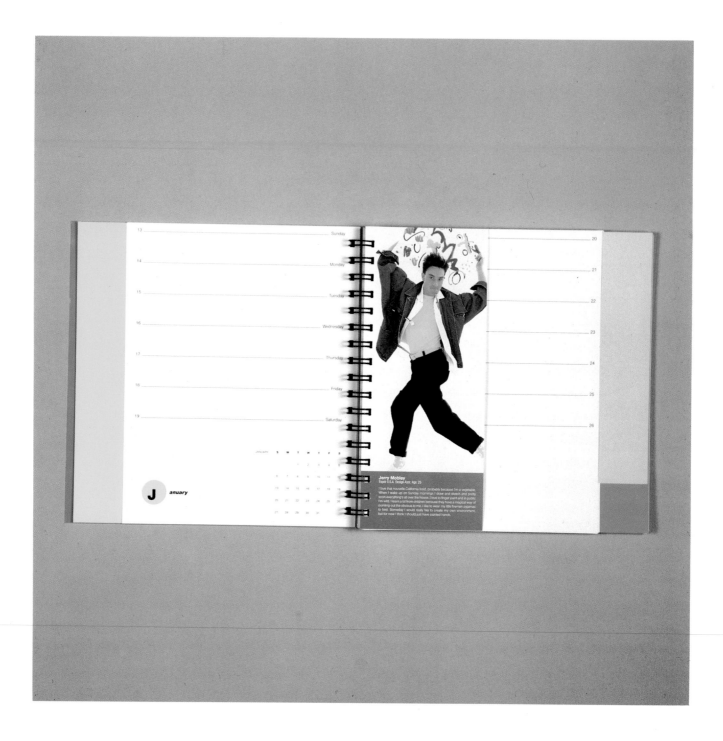

TYPOGRAPHY/ DESIGN	TYPOGRAPHIC SUPPLIER	STUDIO	CLIENT	PRINCIPAL TYPE	DIMENSIONS
Tamotsu Yagi San Francisco, California	*Display Lettering & Copy*	*Esprit Graphic Design Studio*	*Esprit De Corp*	*Helvetica*	*9 × 9 in. 22.9 × 22.9 cm*

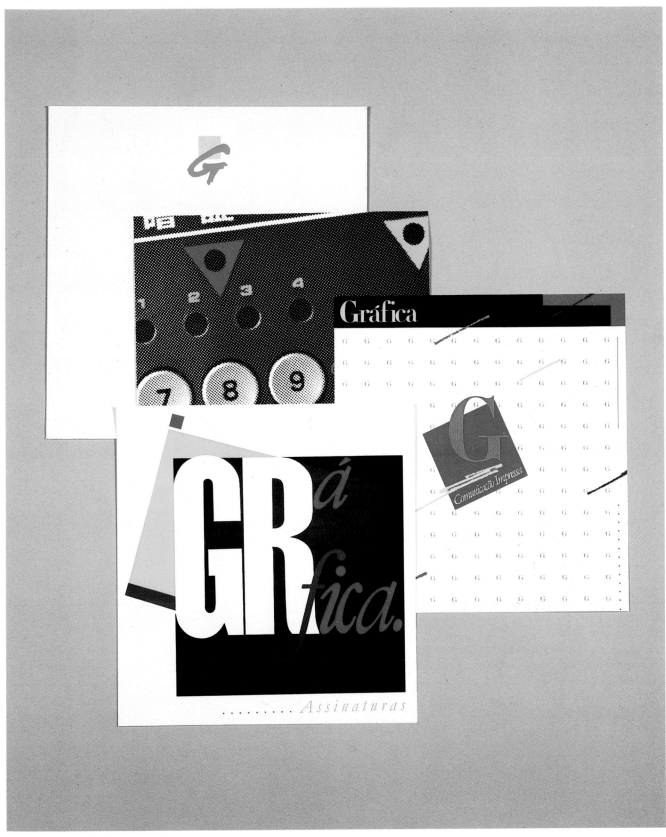

TYPOGRAPHY/ DESIGN	TYPOGRAPHIC SUPPLIER	STUDIO	CLIENT	PRINCIPAL TYPE	DIMENSIONS
Oswaldo Miranda (Miran) Curitiba, Brazil	Kingraf	Miran Studio	Gráfica	Helvetica Extra Condensed/ Garamond/ ITC Modern	10¼ × 10⅔ in. 26 × 27 cm

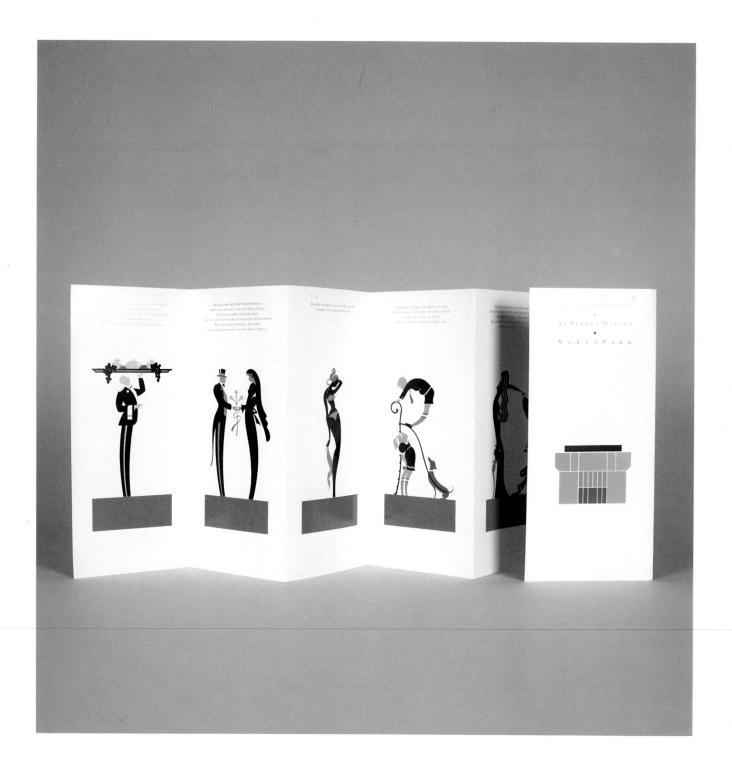

TYPOGRAPHY/ DESIGN	TYPOGRAPHIC SUPPLIER	STUDIO	CLIENT	PRINCIPAL TYPE	DIMENSIONS
Don Sibley *Dallas, Texas*	*Southwestern* *Typographics*	*Sibley/Peteet* *Design, Inc.*	*Neiman Marcus*	*Electra*	*11 × 5 in.* *27.9 × 12.7 cm*

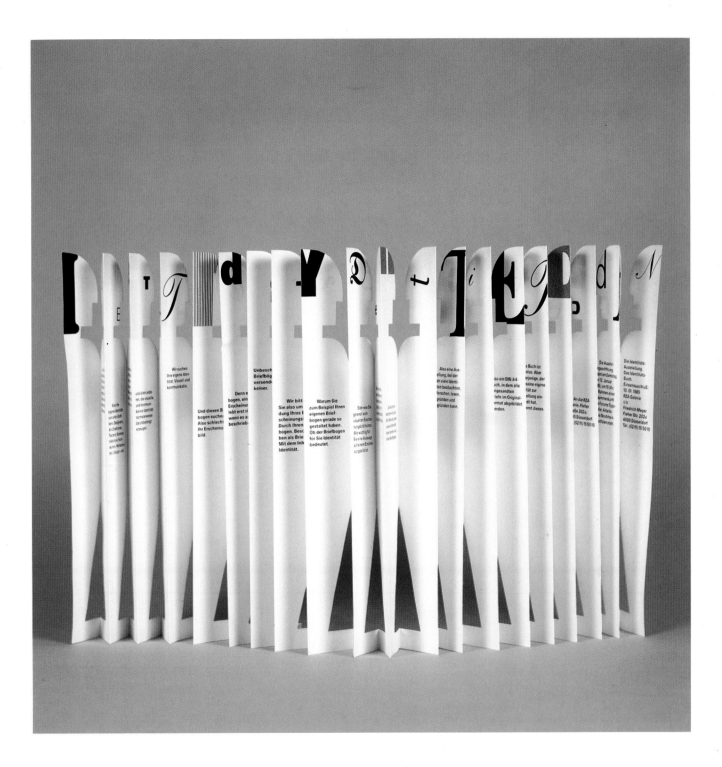

TYPOGRAPHY/ DESIGN	TYPOGRAPHIC SUPPLIER	STUDIO	CLIENT	PRINCIPAL TYPE	DIMENSIONS
Friedrich Meyer Düsseldorf, West Germany	*RZA Werberealisierung GmbH*	*RZA Werberealisierung GmbH*	*Forum Typografie*	*Univers Bold*	*9²⁄₃ × 51¹⁄₁₀ in. 23.5 × 130 cm*

SYMPHONY 10K RUN

ENTRY FORMS AVAILABLE AT:
RUN HEADQUARTERS, 4901 LBJ, SUITE 111
PHIDIPPIDES LUKE'S LOCKER YMCA
OSHMAN'S AEROBICS CENTER

FOR INFORMATION CALL: 960-6064, 361-6493 OR
387-9365 MEMBER: INSIDE RUNNING'S GRAND PRIX
OF RACES SUPPORTED BY: DALLAS TIMES HERALD
⊕ SUNBELT SAVINGS BUD LIGHT ADIDAS

MARCH 2, 1985 9 A.M. DALLAS CITY HALL PLAZA 10 KILOMETER RUN 5 KILOMETER RUN ½ KILOMETER FUN RUN WHEELCHAIR DIVISION

TYPOGRAPHY/ DESIGN	CALLIGRAPHER	TYPOGRAPHIC SUPPLIER	STUDIO	CLIENT	PRINCIPAL TYPE	DIMENSIONS
Tom Hough Dallas, Texas	Tom Hough	Southwestern Typographics/ Dallas Times Herald (in-house)	Dallas Times Herald Promotion Department	Dallas Symphony Orchestra	Bauer Text Initials/ Novarese Book	37 × 11¼ in. 94 × 28.5 cm

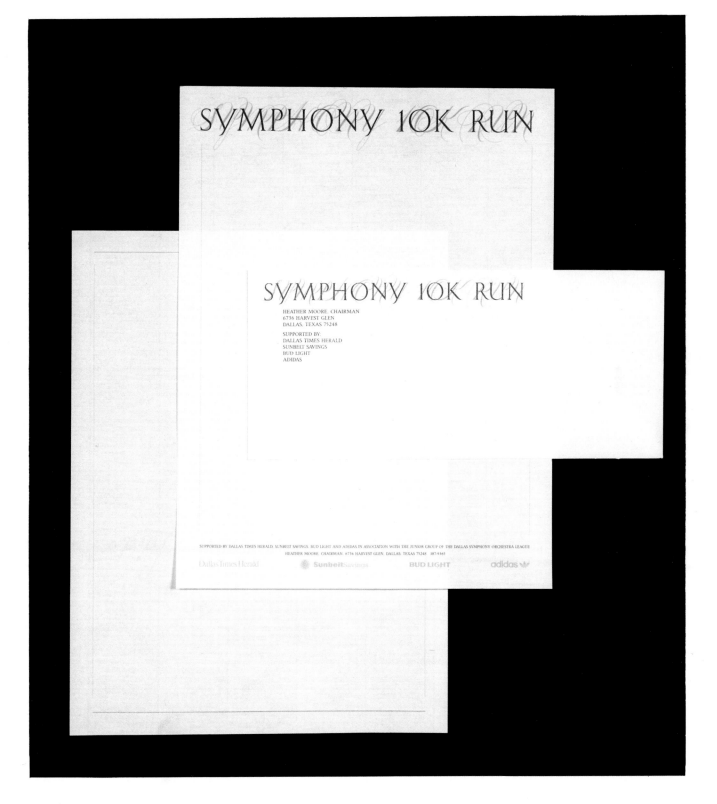

TYPOGRAPHY/ DESIGN	CALLIGRAPHER	TYPOGRAPHIC SUPPLIER	STUDIO	CLIENT	PRINCIPAL TYPE	DIMENSIONS
Tom Hough *Dallas, Texas*	*Tom Hough*	*Southwestern Typographers/ Dallas Times Herald (in-house)*	*Dallas Times Herald Promotion Department*	*Dallas Symphony Orchestra*	*Bauer Text Initials/ Maximal Light*	*8½ × 11 in.* *21.6 × 27.9 cm*

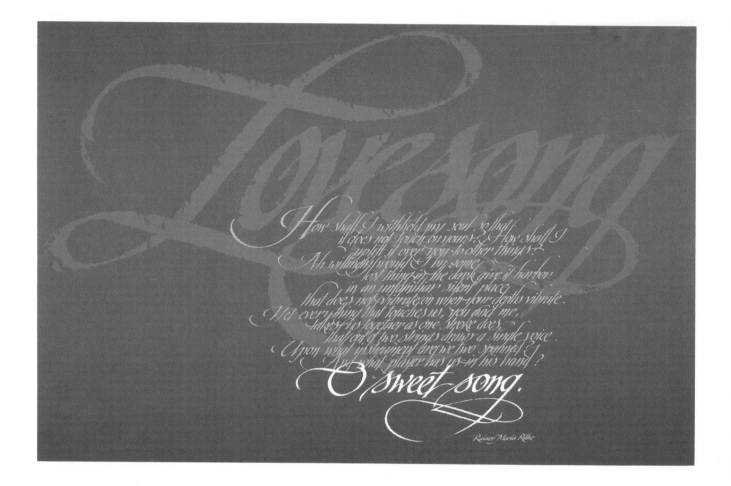

CALLIGRAPHER	STUDIO	CLIENT	DIMENSIONS
Aaron Presler			
Kansas City,
Missouri | Art Partners | Hallmark Cards | 22 × 32 in.
55.9 × 81.3 cm |

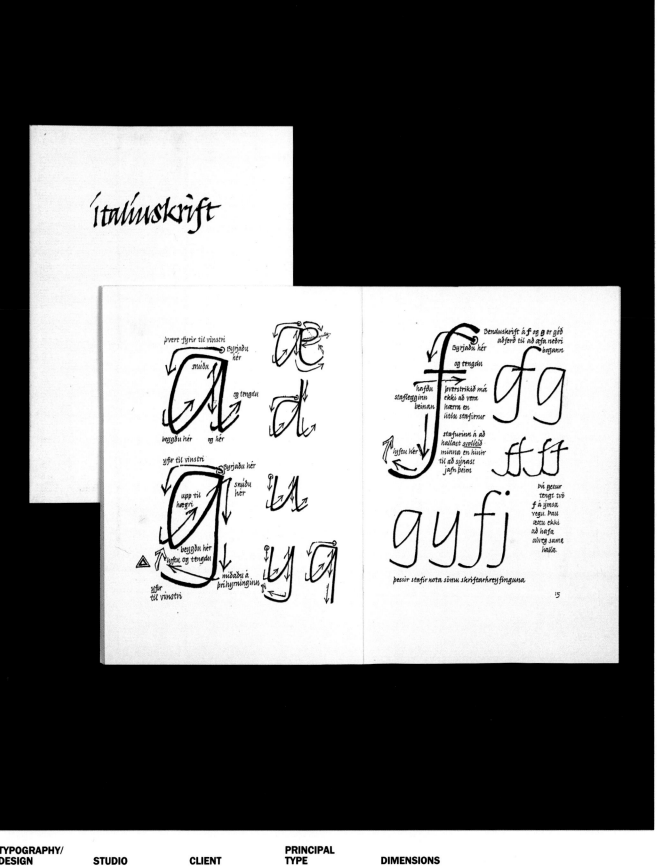

TYPOGRAPHY/ DESIGN	STUDIO	CLIENT	PRINCIPAL TYPE	DIMENSIONS
Gunnlaugur SE *Briem* *London, England*	*Second Hand Press*	*Working Party* *on Experimental* *Teaching of* *Italic Handwriting,* *Iceland*	*Handwritten*	*5¹³/₁₆ × 8¹/₄ in.* *14.8 × 20.9 cm*

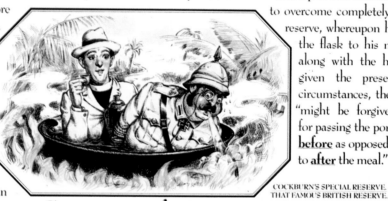

EVEN WHEN spreading the word, the missionary Denzel P. Symmering was said to be more *reserved* than a table at the Ritz.

Nevertheless, the Ayuli tribe – who had already been converted by the Gas Board – had him for dinner one night, along with an extremely well-seasoned Prussian explorer named Störmtrauzer.

Alas, never having been formally introduced, the two men sat through the soup in uncomfortable silence until Denzel suddenly remembered his hip flask of Cockburn's Special Reserve port.

One sip of this enabled our hero to overcome completely his own reserve, whereupon he offered the flask to his neighbour, along with the hope that, given the present circumstances, they "might be forgiven for passing the port **before** as opposed to **after** the meal."

Symmering in hot water.

COCKBURN'S SPECIAL RESERVE. THAT FAMOUS BRITISH RESERVE.

TYPOGRAPHY/ DESIGN	TYPOGRAPHIC SUPPLIER	AGENCY	STUDIO	CLIENT	PRINCIPAL TYPE	DIMENSIONS
Joanne Chevlin/ Maggie Lewis London, England	Character Phototypesetting	J. Walter Thompson	J. Walter Thompson	Cockburns Port	Bernhard Modern	10⅘ × 23⅘ in. 27.5 × 60.5 cm

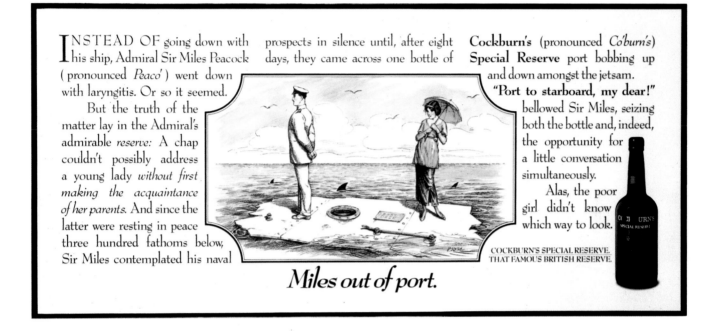

INSTEAD OF going down with his ship, Admiral Sir Miles Peacock (pronounced *Peaco'*) went down with laryngitis. Or so it seemed.

But the truth of the matter lay in the Admiral's admirable *reserve:* A chap couldn't possibly address a young lady *without first making the acquaintance of her parents.* And since the latter were resting in peace three hundred fathoms below, Sir Miles contemplated his naval prospects in silence until, after eight days, they came across one bottle of

Cockburn's (pronounced *Co'burn's*) **Special Reserve** port bobbing up and down amongst the jetsam.

"Port to starboard, my dear!" bellowed Sir Miles, seizing both the bottle and, indeed, the opportunity for a little conversation simultaneously.

Alas, the poor girl didn't know which way to look.

COCKBURN'S SPECIAL RESERVE.
THAT FAMOUS BRITISH RESERVE.

Miles out of port.

TYPOGRAPHY/ DESIGN	TYPOGRAPHIC SUPPLIER	AGENCY	STUDIO	CLIENT	PRINCIPAL TYPE	DIMENSIONS
Joanne Chevlin/ Maggie Lewis London, England	*Character Phototypesetting*	*J. Walter Thompson*	*J. Walter Thompson*	*Cockburns Port*	*Bernhard Modern*	*10⅘ × 23⅘ in. 27.5 × 60.5 cm*

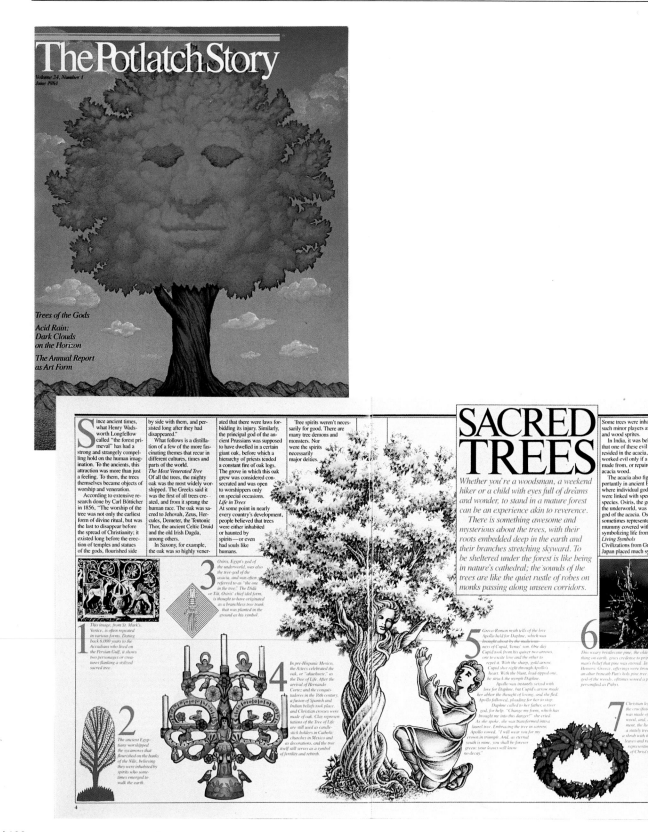

TYPOGRAPHY/ DESIGN	TYPOGRAPHIC SUPPLIER	STUDIO	CLIENT	PRINCIPAL TYPE	DIMENSIONS
Kit Hinrichs/ Lenore Bartz San Francisco, California	Spartan Typographics	Jonson Pedersen Hinrichs & Shakery Inc.	Potlatch Corporation	Times Roman	8½ × 11 in. 21.6 × 27.9 cm

INTENSIVE PROPERTY MANAGEMENT STRATEGY

Although timber is a natural resource, we're leaving nothing to nature. Once we acquire the timberland tracts, our objective is to maintain the quality level or improve it by using professional forest management techniques which maximize tree growth and bring trees to merchantable size even faster.

This is key to Timberfund's active management program. Our tracts will be intensively managed by major forest products companies on a full-time, on-site basis. In consultation with Equitable's timberland advisors, these forest managers will be responsible for the daily physical management of our tracts. Their practical forest experience in operating millions of timberland acres, combined with decades of investments in research and development, will prove invaluable in protecting and enhancing our timber crop and properties.

Forest management begins even before the seedlings are planted. Focusing on volume production and resistance to disease, forest genetics has played a major role in developing healthier and faster growing pine species. Since the start of the southern pine genetics program in the 1950s, total volume gains by progeny from the first seed orchard have ranged from 12 to 14 percent, while predictions are even higher for the second and third generation seed orchards—as much as 30 percent greater than the growth from natural seedlings.

Though the survival of young seedlings depends in part on inherent genetic qualities, careful site preparation and planting methods greatly contribute to their chances for survival and growth. In fact, a pine plantation in unprepared land will have few survivors, if any, because of weed competition.

Forest genetics develops healthier and faster growing pines. A branch from an outstanding, mature pine—chosen for superior height and straightness—is grafted to a vigorous seedling.

The resulting sapling is then transplanted into a seed orchard. A harvest of pine cones with superior seeds begins in about eight years.

Seeds from these cones are planted, and the seedlings grow into what are commonly called "super pines."

4

5

TYPOGRAPHY/ DESIGN	TYPOGRAPHIC SUPPLIER	STUDIO	CLIENT	PRINCIPAL TYPE	DIMENSIONS
Bennett Robinson/ Bob Hartman New York City	Set-To-Fit	Corporate Graphics Inc.	The Equitable Life Assurance Society of the U.S.	Bembo	7½ × 13½ in. 19 × 34.3 cm

15

WHY IT TAKES TYPESETTING OPERATIONS TO INSERT JUST ONE LITTLE WORD OF COPY IN YOUR AD. **1.** THE CHANGE IS PHONED IN. **2.** IT'S ENTERED ON A TIME SHEET AND JOB TICKET. **3.** THEN IT'S SENT TO THE COMPOS- ING ROOM. **4.** THE OPERATOR INTERRUPTS THE JOB ON WHICH HE'S WORKING. **5.** HE MAKES A VARIETY OF MACHINE ADJUST- MENTS AND BRINGS THE ORIG- INAL SETTING UP ONTO THE SCREEN. **6.** HE INSERTS THE NEW WORD INTO THE PARA- GRAPH AND SETS A SLUG LINE FOR IDENTIFICATION. **7.** THE CORRECTED COPY IS THEN RUN OUT. **8.** THE EXPOSED FILM IS DEVELOPED, FIXED, WASHED, AND DRIED IN A SEPARATE AU- TOMATIC PROCESSOR. **9.** THE CORRECTED COPY IS THEN SENT TO A STRIPPER, WHO MUST LOCATE THE ORIGINAL FILM MECHANICAL TO BE ADJUSTED. **10.** HE FINDS THE FILM MECHANICAL AND PLACES IT ON HIS LIGHT TABLE, INSERTS THE CORRECTION AND SENDS THE FORM TO THE PROOFING DEPARTMENT. **11.** THE FILM IS PROOFED ONCE, AND THEN SENT TO A READER TO CHECK THE CORRECTNESS OF THE NEW COPY. **12.** THEN BACK TO THE PROOFING DEPARTMENT, WHERE THE CORRECT NUMBER OF REVISED PROOFS ARE PULLED. **13.** THE FILM ME- CHANICAL IS RETURNED TO ITS ORIGINAL AND CORRECT LOCA- TION IN STORAGE. **14.** TIME RECORDS FOR BILLING PUR- POSES ARE ENTERED. **15.** THE REVISED PROOFS ARE SENT BY MESSENGER TO THE AGENCY.

DESIGN BY ROBERT WAKEMAN

TYPOGRAPHY/ DESIGN	TYPOGRAPHIC SUPPLIER	AGENCY	CLIENT	PRINCIPAL TYPE	DIMENSIONS
Robert Wakeman New York City	TypoGraphic Innovations, Inc.	N W Ayer, Inc.	Robert Wakeman	ITC Isbell	16 × 20 in. 40.6 × 50.8 cm

ENDOWED
BOOK FUNDS
AT
HARVARD
UNIVERSITY

*This bookplate identifies each volume that the
Library buys with income from Harvard's first endowed book fund,
which was established in 1774 by Thomas Hollis of Lincoln's Inn.
Among eighteenth-century benefactors whom the University
gratefully remembers, Hollis is unique because his gift is
still helping to build the remarkable library without which
Harvard would not be Harvard.*

THOMAS HOLLIS, Esqᴿ ℱᴿˢ

HARVARD COLLEGE LIBRARY

*It might be misleading to write of **the Harvard
Library** without explaining that the Harvard University Library is
really a federation of nearly one hundred libraries.*

THE RANGE
OF
CHOICES

Funds that are designated simply for
the acquisition and conservation of
library materials are very welcome;
when money can be used at the dis-
cretion of the Library, it helps to
maintain balance in collection-build-
ing and to meet changing needs of
scholarship. There are few subjects,
however, in which endowed book
funds are not desirable to insure
continuing support for systematic
collecting. There has very rarely been
any difficulty in using a fund to good
advantage in accordance with the
preferences or priorities stated by
its donor.

Some of its units are primarily for
undergraduate use; these include the
house libraries, the Cabot Science
Library, Hilles, and Lamont. Others
serve the graduate professional schools
of Business Administration, Design,
Divinity, Education, Government,
Law, Medicine, and Public Health.
Major collections for engineering
and for the sciences are maintained
by research institutions and depart-
ments of the Faculty of Arts and Sci-
ences. This faculty is also responsible
for the College Library, including
physically separate libraries for An-
thropology, Fine Arts, and Music, as
well as the central research collection.
The latter, with headquarters in the
Widener building, is primarily a
library for languages and literatures,
history, and social sciences; it in-
cludes Judaica, Middle Eastern, and
Slavic departments, but materials in
the East Asian languages are a re-
sponsibility of the Harvard-Yenching
Library. Houghton Library houses
the central collection of rare books
and manuscripts.

Conservation by the
AARON AND CLARA GREENHUT RABINOWITZ FUND
established by the Tudor Foundation, Inc.

HARVARD COLLEGE LIBRARY

in honor of

ARCHIBALD CARY COOLIDGE
1866 – 1928

Professor of History
Lifelong Benefactor and
First Director of This Library

Harvard College
Library

Susan Morse Hilles
Fund

EX LIBRIS

A gift to the
Ukrainian Collections from
the Library of
BOHDAN AND NEONILA
KRAWCIW

Harvard College Library

TYPOGRAPHY/ DESIGN	TYPOGRAPHIC SUPPLIER	STUDIO	CLIENT	PRINCIPAL TYPE	DIMENSIONS	
Jean Evans Cambridge, Massachusetts	*Wrightson Typographers*	*Jean Evans Designs*	*Harvard University Library*	*Baskerville*	*8 × 7¹⁵/₁₆ in. 20.3 × 20.2 cm*	

TYPOGRAPHY/ DESIGN	CALLIGRAPHER	TYPOGRAPHIC SUPPLIER	AGENCY/STUDIO	CLIENT	PRINCIPAL TYPE	DIMENSIONS
Simha Fordsham/ Nancy Leung/ Jonas Tse Toronto, Canada	Jonas Tse	Cooper & Beatty	Olympia & York Developments Limited	320 Park Avenue/ 59 Maiden Lane/ 125 Broad Street/ New York	Century Old Style	8½ × 11 in. 22 × 28 cm

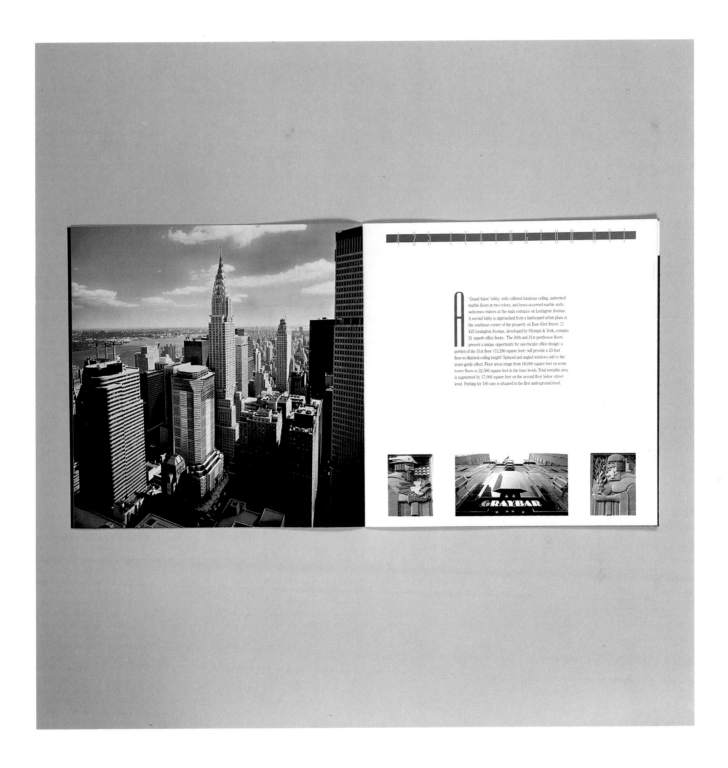

TYPOGRAPHY/ DESIGN	TYPOGRAPHIC SUPPLIER	AGENCY	STUDIO	CLIENT	PRINCIPAL TYPE	DIMENSIONS
Simha Fordsham/ Jonas Tse/ Nancy Leung Toronto, Canada	*Cooper & Beatty*	*Olympia & York Developments Limited*	*Olympia & York Developments Limited*	*425 Lexington Avenue New York*	*Empire/ Century Old Style (SCT)*	*13 × 13 in. 33 × 33 cm*

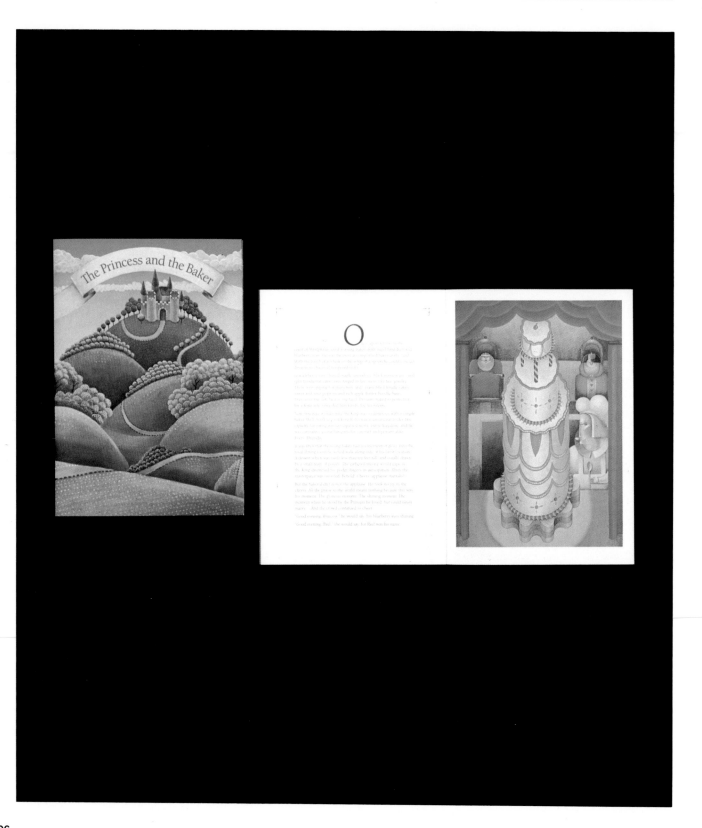

TYPOGRAPHY/ DESIGN	TYPOGRAPHIC SUPPLIER	AGENCY	STUDIO	CLIENT	PRINCIPAL TYPE	DIMENSIONS
Robin Ayres Dallas, Texas	Chiles & Chiles Graphic Services	The Richards Group	Richards, Brock, Miller, Mitchell & Associates	The March of Dimes Gourmet Gala	Berkeley Old Style	6¾ × 9½ in. 17.1 × 24.1 cm

TYPOGRAPHY/ DESIGN	TYPOGRAPHIC SUPPLIER	AGENCY	STUDIO	CLIENT	PRINCIPAL TYPE	DIMENSIONS
Rogério Martins/ Sérgio Liuzzi Rio de Janeiro, Brazil	Rainer Rio Artes Gráficas	Globo TV (House agency)	Cantão 4 Projeto Gráfico	Fundação Roberto Marinho	Romic Bold/ Helvetica Light	8¾ × 8⅛ in. 22.2 × 20.6 cm

The key to innovation, from a middle
manager at a high-tech company:
"You just gotta have a high tolerance
for crazy people. And let them get on
with it. Not spend millions of dollars,
but do a little something, try the idea.
You gotta listen to the crazy people."

The Emerging New: Looking for high returns through
high value-added products and services ffrom ice cream to
computer software to specialty steel); focusing on the revenue
line – Total Customer Satisfaction through sustained, superior
service and quality.

The Old: Naysaying and complex incentive schemes.

The Emerging New: Cheerleading, contests, hoopla and
celebration... and a high-volume outpouring of non-monetary
forms of compensation.

The Old: Management by constant committee meetings;
management constrained by fat staffs.

The Emerging New: Managing by Wandering Around;
managing with lean staff, or virtually no staff at all, at the
corporate center.

Our Creed and Promise:
Always a Strategic Focus

Our last five years of work have made it clear. Winning in the
marketplace – chicken, steel or computers – comes from an obses-

Market forces ...

TYPOGRAPHY/ DESIGN	CALLIGRAPHER	TYPOGRAPHIC SUPPLIER	STUDIO	CLIENT	PRINCIPAL TYPE	DIMENSIONS
Julia Kasle/ Steven Jacobs Palo Alto, California	Jane Anderson	Drager and Mount	Steven Jacobs, Fulton and Green	The Tom Peters Group	Times Roman Italic	8½ × 8½ in. 21.6 × 21.6 cm

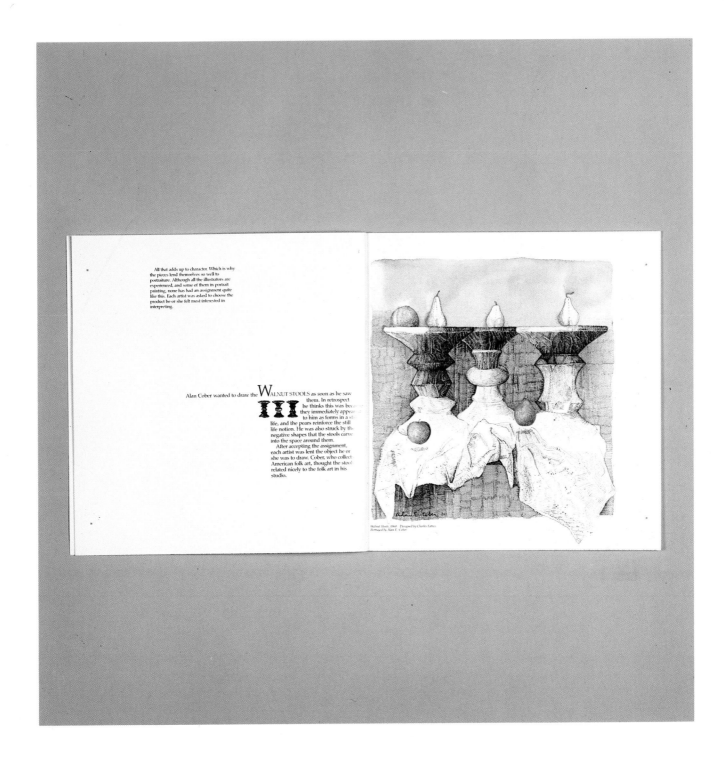

All that adds up to character. Which is why
the pieces lend themselves so well to
portraiture. Although all the illustrators are
experienced, and some of them in portrait
painting, none has had an assignment quite
like this. Each artist was asked to choose the
product he or she felt most interested in
interpreting.

Alan Cober wanted to draw the WALNUT STOOLS as soon as he saw
them. In retrospect
he thinks this was because
they immediately appeared
to him as forms in a still
life, and the pears reinforce the still
life notion. He was also struck by the
negative shapes that the stools carve
into the space around them.

After accepting the assignment,
each artist was lent the object he or
she was to draw. Cober, who collects
American folk art, thought the stool
related nicely to the folk art in his
studio.

Walnut Stools, 1960. Designed by Charles Eames
Portrayed by Alan E. Cober

TYPOGRAPHY/ DESIGN	TYPOGRAPHIC SUPPLIER	AGENCY	CLIENT	PRINCIPAL TYPE	DIMENSIONS
Barbara Loveland Zeeland, Michigan	Type House, Inc.	Corporate Communications Design & Development	Herman Miller, Inc.	Palatino	10 × 10 in. 25.4 × 25.4 cm

TYPOGRAPHY/ DESIGN/ CALLIGRAPHER	PHOTOGRAPHER	TYPOGRAPHIC SUPPLIER	STUDIO	CLIENT	PRINCIPAL TYPE	DIMENSIONS
Craig Fuller Del Mar, California	Marshall Harrington	Thompson Type	Crouch & Fuller, Inc./ Design Group West	The Meridian Company, Ltd.	Gill Sans	11 × 11 in. 27.9 × 27.9 cm

CONCORD ASSETS GROUP

Individual wealth in this country has frequently been accumulated through the ownership of real property. In the past, large-scale real estate holdings were the purview of the very wealthy. Fortunately, this is no longer true.

Real estate investments are becoming important to a growing segment of the American public, as they try to stem the effects of both inflation and increasing taxation on their incomes.

At the same time, the federal government of the United States has used provisions of the tax code to stimulate private investment into a number of business areas which are important to the American economy. To this end, tax incentives have been created to direct private investment capital into real estate.

As part of a diversified portfolio, real estate investments offer a combination of tax benefits, capital appreciation, cash distribution and capital gain.

Advantage to limited partners in a partnership arrangement is provided through limitations to their liability, which cannot exceed the amount of investment. And the collective force of a group of investors allows participation in real estate at a much larger scale than each investor might be capable of individually.

Both the needs and opportunities in today's economic environment have created an atmosphere where many successful Americans recognize the value of real estate holdings as one of the most effective tools available in tax and estate planning.

The Concord Assets Group, Inc., a fully integrated real estate organization, has earned a reputation for developing outstanding limited partnership investment opportunities.

TYPOGRAPHY/ DESIGN	TYPOGRAPHIC SUPPLIER	STUDIO	CLIENT	PRINCIPAL TYPE	DIMENSIONS
Richard J. Whelan New York City	Characters Typographers, Inc.	The Whelan Design Office Inc.	Concord Assets Group, Inc.	Aldus	9 × 12 in. 22.9 × 30.5 cm

illustrious occupant, renowned
photographer Mathew B. Brady.
Brady's appointment
book listed names like
Abraham Lincoln, Andrew
Jackson, and 16 other
presidents, James Fenimore
Cooper, Dolly Madison,
George A. Custer and a host
of other American and
international dignitaries.
Upon walking into the
gallery, visitors were greeted
by 14 portraits. Brady's
finishing and mounting
rooms were upstairs from
this, and on the top floor, his
studio lay strewn with
cameras, lenses and the like.
A skylight allowed Brady
to adjust the light upon
the countenances of hundreds
of famous personalities.
When President-elect
Lincoln arrived at the studio
to have his official portrait
taken in 1861, he said, "We
know each other...Brady and
the Cooper Union speech made
me President." Subsequent

One of the two Michael
John Angel paintings
commissioned by Sears,
this view shows Sears
House as it appeared
in the late 19th Century.

TYPOGRAPHY/ DESIGN	TYPOGRAPHIC SUPPLIER	AGENCY	CLIENT	PRINCIPAL TYPE	DIMENSIONS
Kathleen Sullivan Kaska Chicago, Illinois	Master	Burson · Marsteller	Sears, Roebuck and Company	Garamond Light Condensed Italic	7 × 11 in. 17.8 × 27.9 cm

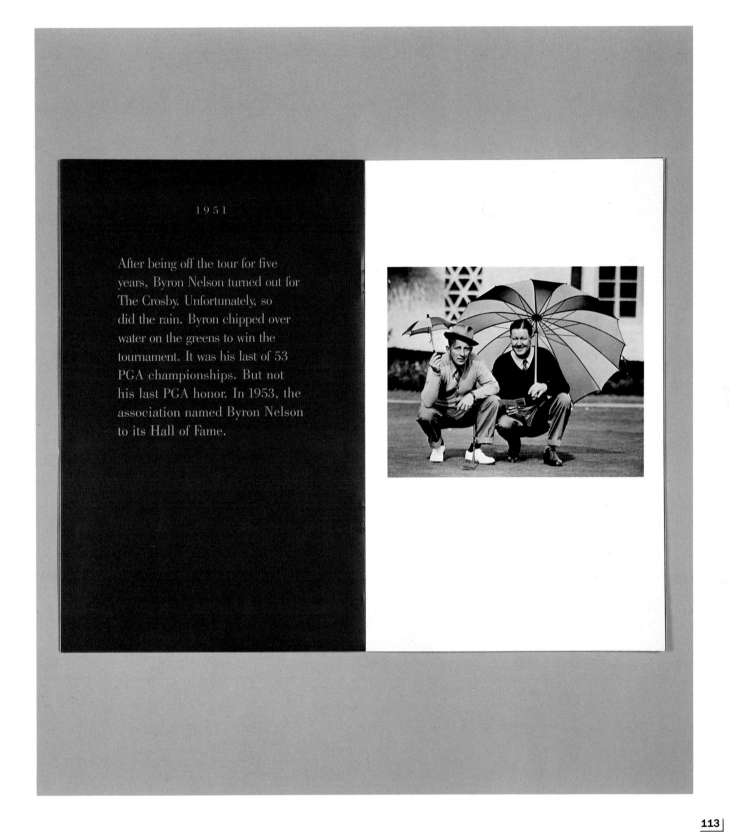

1951

After being off the tour for five years, Byron Nelson turned out for The Crosby. Unfortunately, so did the rain. Byron chipped over water on the greens to win the tournament. It was his last of 53 PGA championships. But not his last PGA honor. In 1953, the association named Byron Nelson to its Hall of Fame.

TYPOGRAPHY/ DESIGN	TYPOGRAPHIC SUPPLIER	AGENCY	STUDIO	CLIENT	PRINCIPAL TYPE	DIMENSIONS
D.C. Stipp Dallas, Texas	Typographics	The Richards Group	Richards, Brock, Miller, Mitchell & Associates	Abilene Christian College	Bodoni	7 × 11 in. 18 × 28 cm

Managing Wealth

AT THE MERCANTILE

FOR TWELVE DECADES

WE AT THE MERCANTILE

HAVE BEEN HELPING

SUCCESSFUL PEOPLE

BUILD AND WISELY

EMPLOY THEIR WEALTH.

TYPOGRAPHY/ DESIGN	TYPOGRAPHIC SUPPLIER	AGENCY	CLIENT	PRINCIPAL TYPE	DIMENSIONS
Claude Skelton/ Amy Knoell Baltimore, Maryland	Phil's Photo/ BG Composition	The Barton-Gillet Co.	Mercantile Trust Company	Torino Roman/ Manchester/ Century Old Style	8 × 11 in. 20.3 × 27.9 cm

THE WORK OF THE DANA-FARBER CANCER INSTITUTE

AT THE EDGE OF DISCOVERY

TYPOGRAPHY/ DESIGN	TYPOGRAPHIC SUPPLIER	AGENCY	CLIENT	PRINCIPAL TYPE	DIMENSIONS
Claude Skelton Baltimore, Maryland	BG Composition	The Barton-Gillet Co.	Dana-Farber Cancer Institute	Franklin Gothic/ Garamond/ Helvetica Ultra Condensed	11 × 15 in. 27.9 × 38.1 cm

Typecolor

The copy has been written, the artwork is finished, the layout has taken shape, the headline typeface has been chosen. Now for the body text. In addition to the type-face that will be chosen, what color will it be? Color?

You could choose to have it printed in any color imaginable to go with the design. In fact, there's been a trend for printing the text in one color, with the sentences that are to stand out printed in another color, and it can look great.

But the color referred to at the outset is the type that is to be printed in black.

Generally, today's typefaces released from the noted typeface companies are released in four or five different weights. Light, book, medium, bold and black. In type specimen books, there are blocks of body text settings in these various weights. A good type specimen book will show the typefaces set solid, and with added leading *(extra space between the lines)*. This can have an effect on the color.

When looking at these blocks of text, one begins to see various shades of grey, ranging from very light grey to almost solid black. The shade of grey will depend upon the design of the typeface.

Now, getting back to the question, which color will you choose?

Designers and art directors who are concerned about the typecolor have various reasons for choosing different weights of body text.

One way which has been used with good success is the different percentage values found in a screen tint scale. This works best when it is on a clear piece of film.

Lay this next to the artwork, headline type, or photographs *(color, or black & white halftones)*, and see what shade works best. Then find in the type specimen book the typeface to be used, and choose the weight that matches the screen value that looked the best.

When using this method, it has often been found that the darker weights of the body text look better with line drawings and lighter halftones. *(Light line drawings get lost next to very thin lightweight body text.)* On the other hand, lighter body text looks best next to darker artwork, and halftones.

Those who design magazine formats generally use a medium weight type-face for the body text, because they deal with all kinds of artwork and photographs.

The secret is to get viewers so involved in reading the material and enjoying the layouts that they don't mind the pieces being in black and white. This, of course, is important when the budget does not allow for color. Color?

The body text. What color will it be?

TYPOGRAPHY/ DESIGN	TYPOGRAPHIC SUPPLIER	AGENCY	CLIENT	PRINCIPAL TYPE	DIMENSIONS
Robert Wakeman New York City	TypoGraphic Innovations, Inc.	N W Ayer, Inc.	Robert Wakeman	ITC Novarese Bold Italic/ ITC Berkeley Old Style	20 × 16 in. 50.8 × 40.6 cm

117

TYPOGRAPHY/ DESIGN	TYPOGRAPHIC SUPPLIER	AGENCY	CLIENT	PRINCIPAL TYPE	DIMENSIONS
Robert Wakeman New York City	Stallone Typography Services, Inc.	N W Ayer, Inc.	Robert Wakeman	ITC Galliard	20 × 16 in. 50.8 × 40.6 cm

Colin Forbes, Pentagram Design Ltd., New York.

In Texas. Wednesday, May 2, 1984 at the Westin Hotel, Galleria, Dallas. Cocktails (cash bar) 6:00 p.m. program at 7:00 p.m. Members free, non-members $5.00. Students, with I.D. $1.00

TYPOGRAPHY/ DESIGN	TYPOGRAPHIC SUPPLIER	AGENCY	STUDIO	CLIENT	PRINCIPAL TYPE	DIMENSIONS
Chris Rovillo Dallas, Texas	Chiles & Chiles Graphic Services	The Richards Group	Richards, Brock, Miller, Mitchell & Associates	Dallas Society of Visual Communications	Torino	23½ × 27½ in. 59.7 × 70 cm

TYPOGRAPHY/ DESIGN	TYPOGRAPHIC SUPPLIER	AGENCY	CLIENT	PRINCIPAL TYPE	DIMENSIONS
Brian Boyd Dallas, Texas	Typographics	Richards, Brock, Miller, Mitchell & Associates	Williamson Printing Corporation	Bauer Text Initials	22¾ × 37½ in. 57.8 × 95.3 cm

TYPOGRAPHY/ DESIGN	CLIENT	PRINCIPAL TYPE	DIMENSIONS
Christof Gassner *Frankfurt,* *West Germany*	*Zanders Feinpapiere* *AG*	*Lubalin Graph/* *Benguiat Gothic*	*9²⁄₃ × 9²⁄₃ in.* *24.5 × 24.5 cm*

TYPOGRAPHY/ DESIGN	TYPOGRAPHIC SUPPLIER	STUDIO	CLIENT	PRINCIPAL TYPE	DIMENSIONS
Minoru Morita New York City	Nassau Typographers	Creative Center, Inc.	Creative Center, Inc.	American Typewriter	30 × 40 in. 76.2 × 101.6 cm

TYPOGRAPHY/ DESIGN	TYPOGRAPHIC SUPPLIER	AGENCY	STUDIO	CLIENT	PRINCIPAL TYPE	DIMENSIONS
Jack Anderson Seattle, Washington	*The Type Gallery, Inc.*	*The Type Gallery, Inc.*	*Hornall/Anderson Design Works*	*Pierce Art Gallery*	*Avant Garde*	*8½ × 11 in. 21.6 × 27.9 cm*

TYPOGRAPHY/ DESIGN	CALLIGRAPHERS	TYPOGRAPHIC SUPPLIER	AGENCY	STUDIO	CLIENT	PRINCIPAL TYPE
Linda Eissler Dallas, Texas	Linda Eissler/ Mark Drury/ Eisenberg Inc.	Jaggars Chiles Stovall	The Oakley Company	Eisenberg Inc.	Chow Catering	Bodoni

DIMENSIONS

8½ × 11 in.
21.6 × 27.9 cm

THE METROPOLITAN MEDICAL CENTER FOUNDATION

In Pursuit of Excellence...
Through the Promotion of Hope
And the Prevention of Despair

KNAPP REHABILITATION CENTER

With the assistance of MMC staff and
equipment, patients with severe injur-
ies are making miracles happen daily.

Would you like to see a miracle in action? Then, visit the Knapp Rehabilitation Center at Metropolitan Medical Center. With the assistance of MMC staff and equipment, patients with severe injuries or disabilities are making miracles happen daily.

The Knapp Rehabilitation Center, named in honor of Miland E. Knapp, M.D., recently received the maximum three-year accreditation for Comprehensive Inpatient Rehabilitation from the Commission on Accreditation of Rehabilitation Facilities (CARF). The Center is one of only three facilities in the state to receive full accreditation from the prestigious Commission for a broad range of rehabilitation services.

Dr. Knapp is a member of the MMC Medical Staff and he is widely considered Minnesota's pioneer in physical medicine and rehabilitation.

Services offered through the Knapp Rehabilitation Center program include physical therapy, occupational therapy, speech pathology, rehabilitation nursing, social services and vocational rehabilitation. The Center also offers clinical and neuropsychological services and therapeutic recreation. In addition, a special program has been developed to meet the unique needs of patients with traumatic head injuries.

Because of the previous commitment and support shown for the Knapp Rehabilitation Center through the MMC partnership, what was once a miracle is now commonplace. People are walking when once told they would never walk again. People with traumatic head injuries are learning to speak and communicate again through their own hard work and the love and encouragement offered by the MMC rehabilitation staff. And people are returning to productive and happy lives to once again contribute to the success and vitality of their communities.

With your support of The Metropolitan Medical Center Foundation, we can turn today's miracles into tomorrow's realities. Together, we can enjoy watching the miracles happen.

7

TYPOGRAPHY/ DESIGN	TYPOGRAPHIC SUPPLIER	STUDIO	CLIENT	PRINCIPAL TYPE	DIMENSIONS
Pamela Hovland Minneapolis, Minnesota	Alphagraphics One	Krogtad Design Associates	Metropolitan Medical Center	Times Roman	7⅛ × 10⅞ in. 18 × 27.6 cm

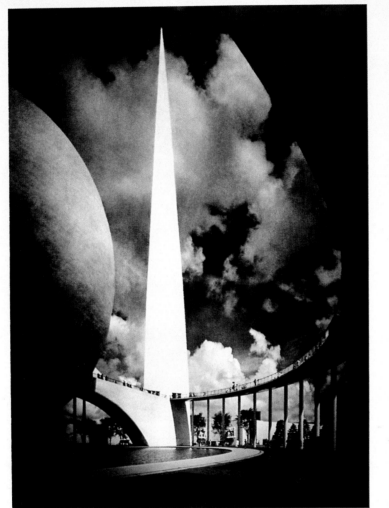

125

TYPOGRAPHY/ DESIGN	TYPOGRAPHIC SUPPLIER	AGENCY	CLIENT	PRINCIPAL TYPE	DIMENSIONS
Julia Wyant *Rochester, New York*	*Rochester Mono/* *Headliners*	*Robert Meyer Design* *Inc.*	*International* *Museum of* *Photography* *at George Eastman* *House*	*Stark Debonair* *Semibold*	*19 × 32 in.* *48.3 × 81.3 cm*

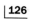

TYPOGRAPHY/ DESIGN	TYPOGRAPHIC SUPPLIER	STUDIO	CLIENT	PRINCIPAL TYPE	DIMENSIONS
Neal Cox Pittsburgh, Pennsylvania	*Davis & Warde, Inc.*	*Neal Cox Design*	*Carnegie-Mellon University Children's School*	*Novarese Book*	*8 × 8 in. 20.3 × 20.3 cm*

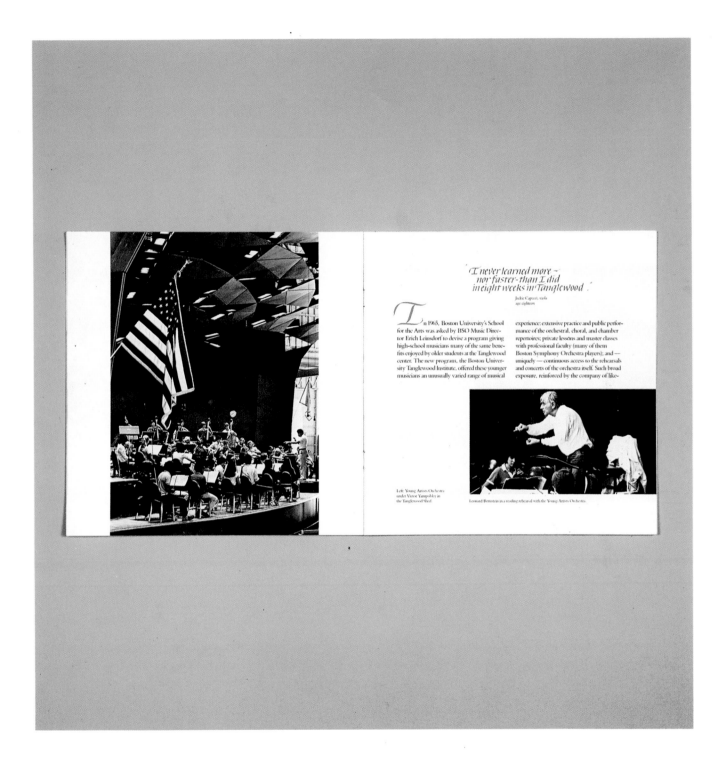

TYPOGRAPHY/ DESIGN	CALLIGRAPHER	TYPOGRAPHIC SUPPLIER	STUDIO	CLIENT	PRINCIPAL TYPE	DIMENSIONS
Janice Wheeler Boston, Massachusetts	Colleen	Litho Comp	Boston University Graphic Design Office	The Boston University Tanglewood Institute	Bembo	9 × 9 in. 22.9 × 22.9 cm

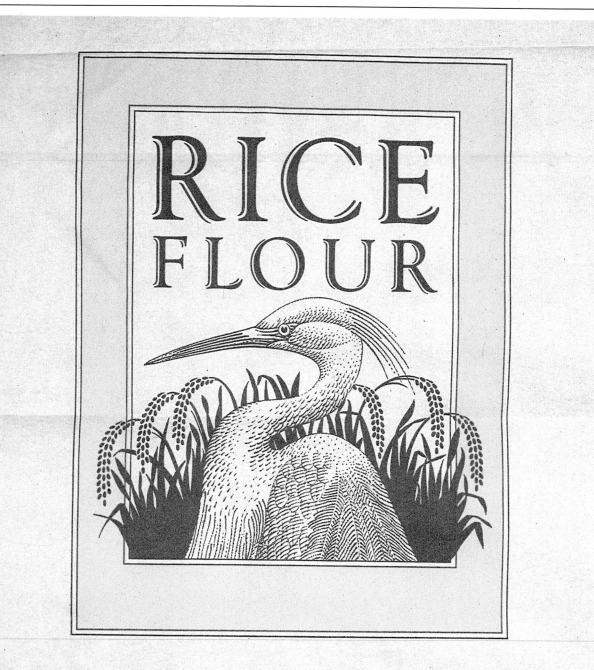

PACIFIC RICE PRODUCTS, INC.
WOODLAND, CALIFORNIA 95695 U.S.A.

NET WT. 100 LBS. 45.36 kg.

TYPOGRAPHY/ DESIGN	CALLIGRAPHER	TYPOGRAPHIC SUPPLIER	STUDIO	CLIENT	PRINCIPAL TYPE	DIMENSIONS
Michael Mabry/ Noreen Fukumori San Francisco, California	Noreen Fukumori	Petrographics	Michael Mabry Design	Pacific Rice Products	Goudy	22 × 29 in. 55.9 × 73.7 cm

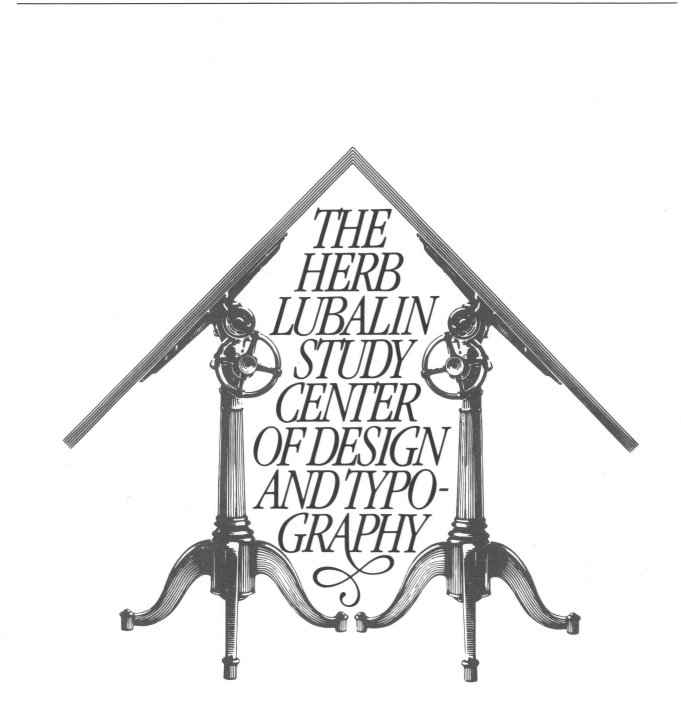

THE HERB LUBALIN STUDY CENTER OF DESIGN AND TYPO- GRAPHY

TYPOGRAPHY/ DESIGN	CALLIGRAPHER	TYPOGRAPHIC SUPPLIER	STUDIO	CLIENT	PRINCIPAL TYPE	DIMENSIONS
Alan Peckolick New York City	Tony Di Spigna	Pushpin Lubalin Peckolick	Pushpin Lubalin Peckolick	Herb Lubalin Study Center	ITC Garamond	5½ × 5 in. 14 × 12.7 cm

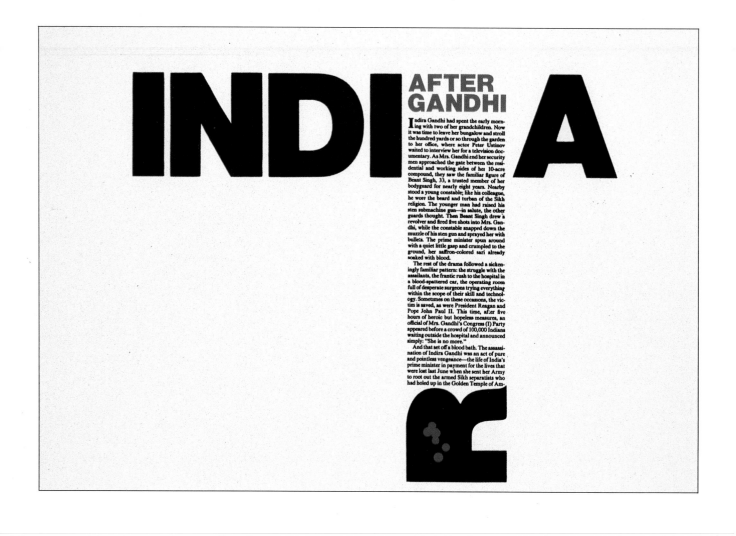

TYPOGRAPHY/ DESIGN	TYPOGRAPHIC SUPPLIER	AGENCY	CLIENT	PRINCIPAL TYPE	DIMENSIONS
Jay Sylvester Newtown, Connecticut	*ITC*	*Right Mind Design*	*Pratt Institute*	*Helvetica Bold*	*11 × 17 in. 27.9 × 43.2 cm*

Digital Typeface Library

Complete displays of more
than 1350 digital typefaces.
6 thru 36 point settings.
Character count for all sizes.

TYPOGRAPHY/ DESIGN	TYPOGRAPHIC SUPPLIER	CLIENT	PRINCIPAL TYPE	DIMENSIONS
Harvey Karp/ Steve Haines New York City	*Characters Typographic Services*	*Digital Typeface Library Company*	*1350 digitized faces*	*9 × 12 in. 22.9 × 30.5 cm*

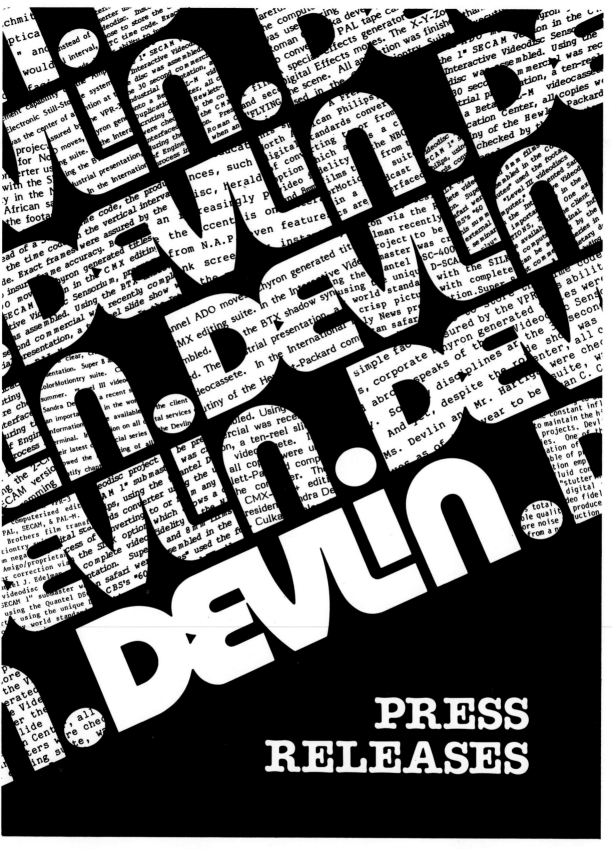

TYPOGRAPHY/ DESIGN	TYPOGRAPHIC SUPPLIER	STUDIO	CLIENT	PRINCIPAL TYPE	DIMENSIONS
Mark Eckstein/ Arthur Eckstein Roslyn Heights, New York	Scarlett Letters	Arthur Eckstein & Associates	Devlin Productions Inc.	Devlin Logo/ American Typewriter	9 × 12 in. folded 22.9 × 30.5 cm

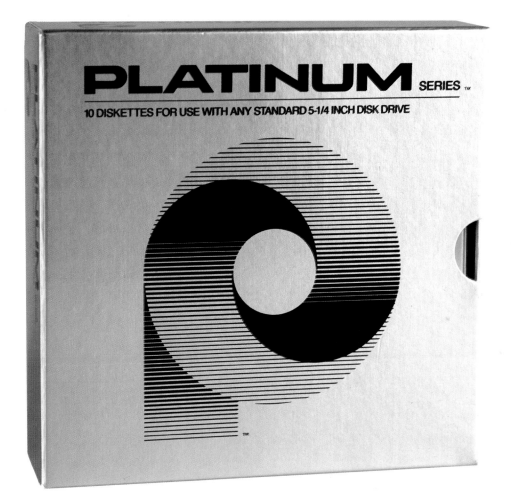

TYPOGRAPHY/ DESIGN	STUDIO	CLIENT	DIMENSIONS
Saul Bass/ Art Goodman Los Angeles, California	*Saul Bass/ Herb Yager and Associates*	*Capitol Data Systems*	*6¼ × 6¼ × 1¾ in. 15.8 × 15.8 × 4.4 cm*

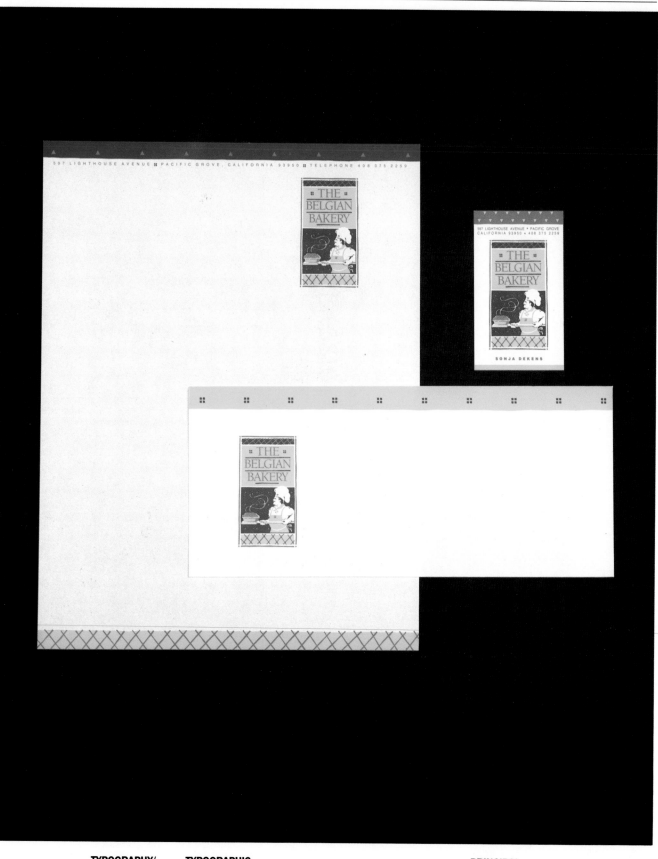

TYPOGRAPHY/ DESIGN	TYPOGRAPHIC SUPPLIER	STUDIO	CLIENT	PRINCIPAL TYPE	DIMENSIONS
Lindy Dunlavey Sacramento, California	Ad Type Graphics	The Dunlavey Studio, Inc.	The Belgian Bakery	Berkeley Old Style/ Helvetica Medium	8½ × 11 in. 21.6 × 27.9 cm

TYPOGRAPHY/ DESIGN	TYPOGRAPHIC SUPPLIER	STUDIO	CLIENT	PRINCIPAL TYPE	DIMENSIONS	
Daniel Ruesch Salt Lake City, Utah	Whipple & Associates	Tandem Studios	Holt Communications	Mixed	8½ × 11 in. 21.6 × 27.9 cm	

TYPOGRAPHY/ DESIGN	TYPOGRAPHIC SUPPLIER	AGENCY	CLIENT	PRINCIPAL TYPE	DIMENSIONS
Leslee Ladds/ Takaaki Matsumoto New York City	*Susan Schechter*	*Knoll Graphics*	*Knoll International*	*Helvetica Condensed*	*11½ × 11½ × 3 in. 29.2 × 29.2 × 7.6 cm*

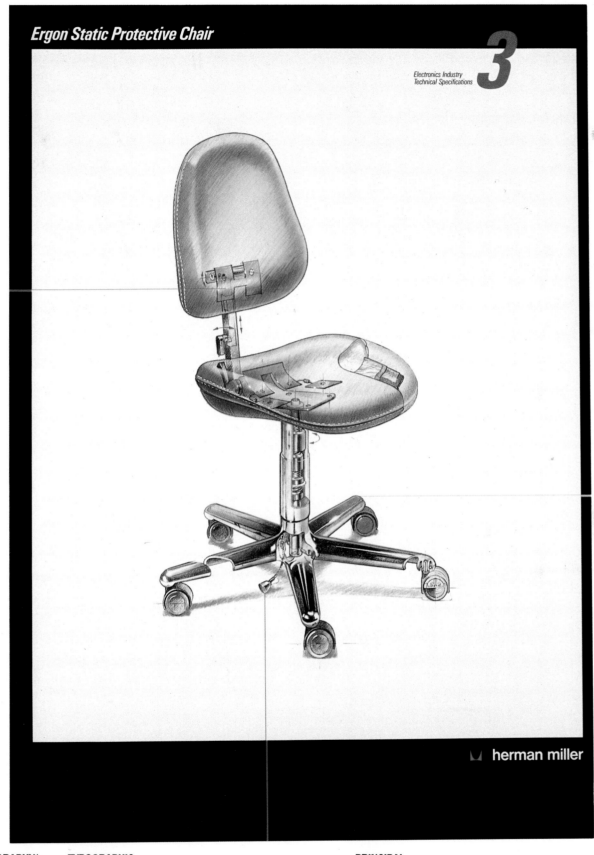

Ergon Static Protective Chair

Electronics Industry
Technical Specifications

3

herman miller

TYPOGRAPHY/ DESIGN	TYPOGRAPHIC SUPPLIER	STUDIO	CLIENT	PRINCIPAL TYPE	DIMENSIONS
Mitchell Mauk/ Mark Anderson Palo Alto, California	*Spartan Typographers*	*Mark Anderson Design*	*Herman Miller, Inc.*	*Univers 48/ Univers 68*	*20 × 28 in. 59.8 × 71 cm*

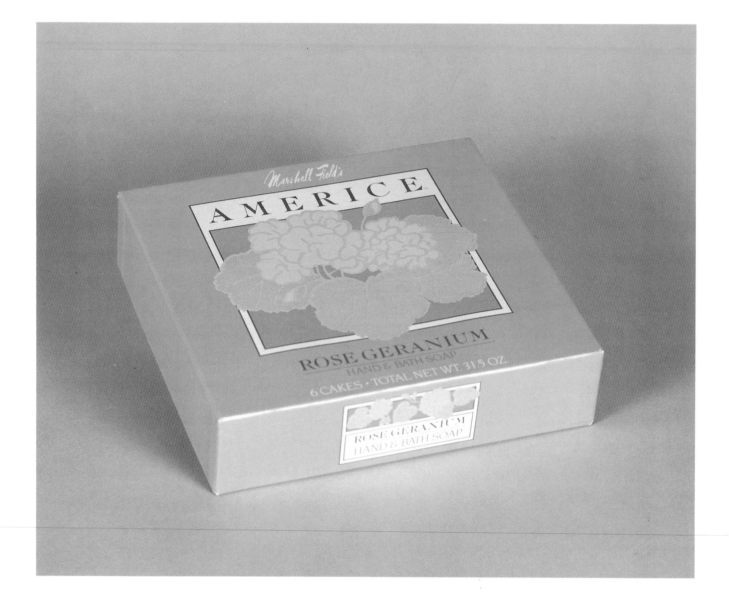

TYPOGRAPHY/ DESIGN	ILLUSTRATOR	TYPOGRAPHIC SUPPLIER	AGENCY/ STUDIO	CLIENT	PRINCIPAL TYPE	DIMENSIONS
Linda Voll Chicago, Illinois	Linda Voll	The Typesmiths	Murrie, White, Drummond, Lienhart & Associates	Marshall Field's	Caslon/ ITC Novarese	7⅞ × 7¼ × 1⅞ in. 20 × 18.3 × 4.7 cm

TYPOGRAPHY/ DESIGN	CALLIGRAPHER	TYPOGRAPHIC SUPPLIER	AGENCY	CLIENT	PRINCIPAL TYPE	DIMENSIONS
Steve Snider/ Tom Neville Boston, Massachusetts	*George Mack*	*Typographic House*	*Arnold and Company Design Team*	*Ris Paper Company*	*Centaur*	*28 × 15 in. 71.1 × 38.1 cm*

TYPOGRAPHY/ DESIGN	PHOTOGRAPHER	TYPOGRAPHIC SUPPLIER	AGENCY/ STUDIO	CLIENT	PRINCIPAL TYPE	DIMENSIONS
Ernie Perich/ Wayne Pederson/ Jeanette Dyer/ Mathew Thornton Ann Arbor, Michigan	Ann DeLaVergne	Group 243 Design, Inc.	Group 243 Design, Inc.	Domino's Pizza, Inc.	Typewriter	8½ × 11 in. 21.6 × 27.9 cm

TYPOGRAPHY/ DESIGN	TYPOGRAPHIC SUPPLIER	AGENCY	CLIENT	PRINCIPAL TYPE	DIMENSIONS
Ronn Harsh/ Tom Suiter Cupertino, California	*Vicki Takla*	*Apple Computer, Inc.*	*Apple Computer, Inc.*	*ITC Garamond Light Roman (condensed to 80% of Roman)*	*2 × 8¾ × 11⅝ in. 5.1 × 22.2 × 29.5 cm Page: 7 × 11 in. 17.8 × 27.9 cm*

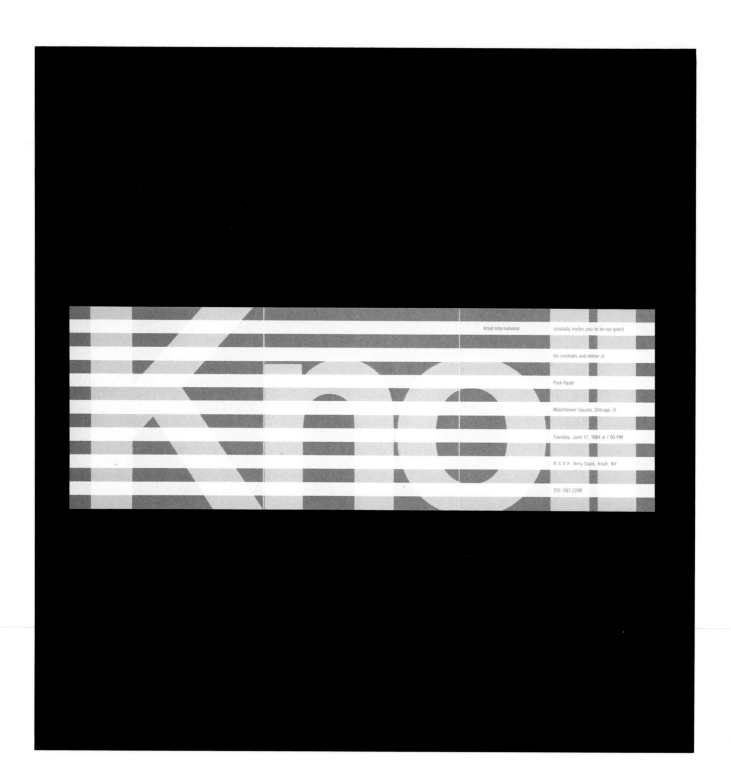

Knoll International

cordially invites you to be our guest

for cocktails and dinner at

Park Hyatt

Watchtower Square, Chicago, IL

Tuesday, June 12, 1984 at 7:00 PM

R.S.V.P. Terry Stack, Knoll, NY

212/207-2200

	TYPOGRAPHY/ DESIGN	TYPOGRAPHIC SUPPLIER	AGENCY	CLIENT	PRINCIPAL TYPE	DIMENSIONS
	Takaaki Matsumoto/ Bernard Reynoso New York City	Susan Schechter	Knoll Graphics	Knoll International	Bodoni/ Bodoni Bold/ Bodoni Italic/ Helvetica Condensed/ Helvetica Bold/ Helvetica Italic	10 × 10 in. 25.4 × 25.4 cm

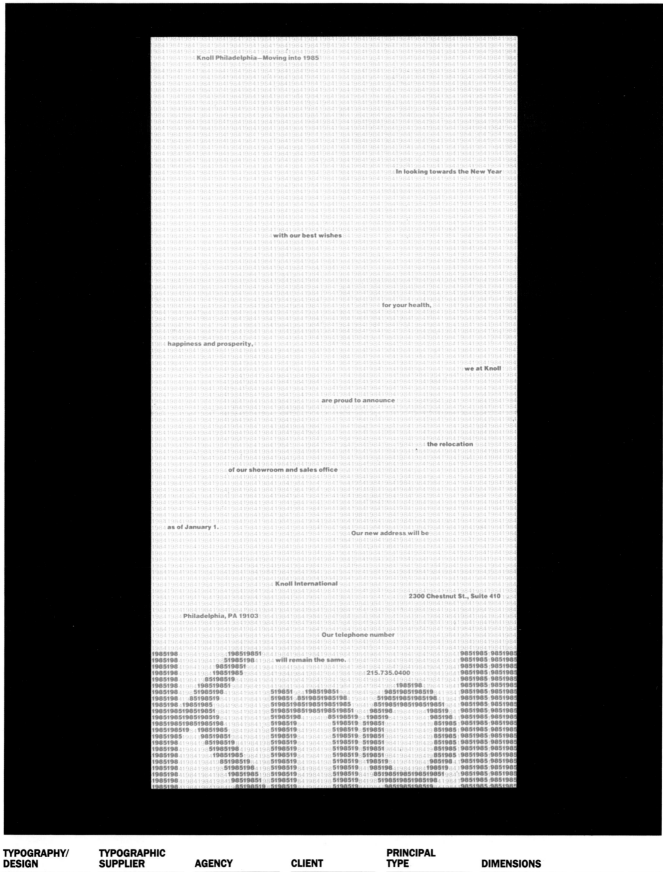

The invitation text, woven into a field of repeating "1984" and "1985" numbers, reads:

Knoll Philadelphia—Moving into 1985

In looking towards the New Year

with our best wishes

for your health,

happiness and prosperity,

we at Knoll

are proud to announce

the relocation

of our showroom and sales office

as of January 1.

Our new address will be

Knoll International

2300 Chestnut St., Suite 410

Philadelphia, PA 19103

Our telephone number

will remain the same.

215.735.0400

TYPOGRAPHY/ DESIGN	TYPOGRAPHIC SUPPLIER	AGENCY	CLIENT	PRINCIPAL TYPE	DIMENSIONS
Carrie Berman/ Takaaki Matsumoto New York City	Susan Schechter	Knoll Graphics	Knoll International	Helvetica Bold/ Helvetica Regular	5 × 10 in. 12.7 × 25.4 cm

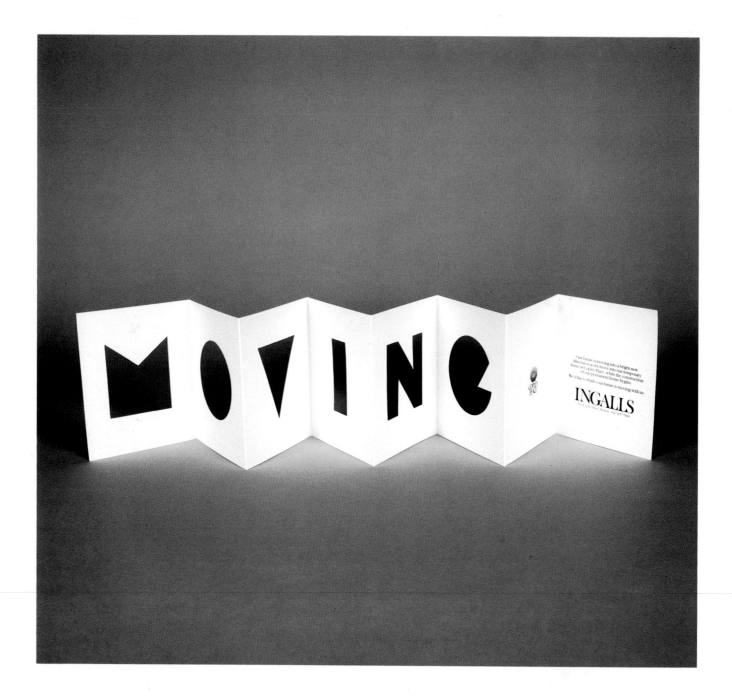

144

TYPOGRAPHY/ DESIGN	TYPOGRAPHIC SUPPLIER	AGENCY	CLIENT	PRINCIPAL TYPE	DIMENSIONS
Bill Gustat Boston, Massachusetts	*Wrightson*	*Ingalls Associates*	*Ingalls Associates*	*Garamond*	*4¾ × 5¾ in. 12.1 × 14.6 cm*

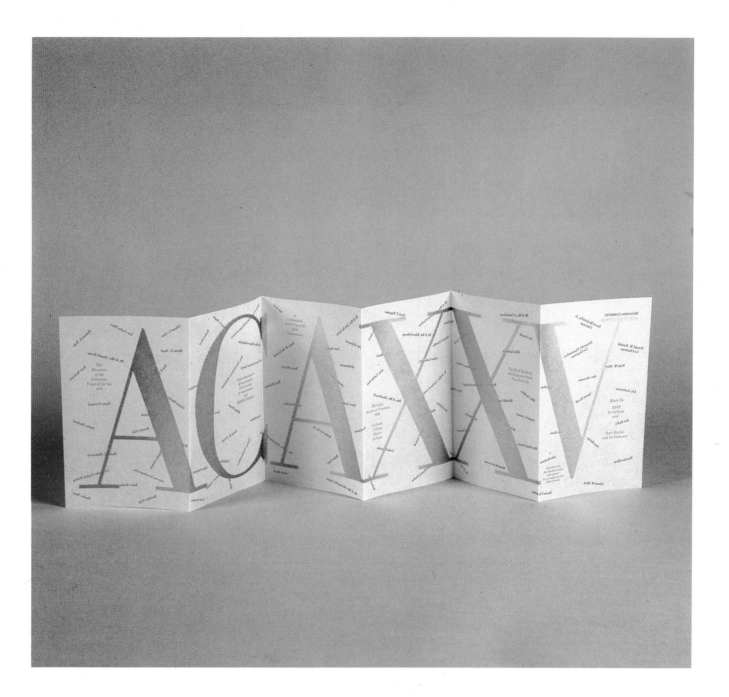

TYPOGRAPHY/ DESIGN	TYPOGRAPHIC SUPPLIER	AGENCY	STUDIO	CLIENT	PRINCIPAL TYPE	DIMENSIONS
Stephen Doyle/ Tibor Kalman New York City	Trufont	M & Co.	M & Co.	American Council for the Arts	Firmin Didot	6¾ × 27 in. 17.1 × 68.6 cm

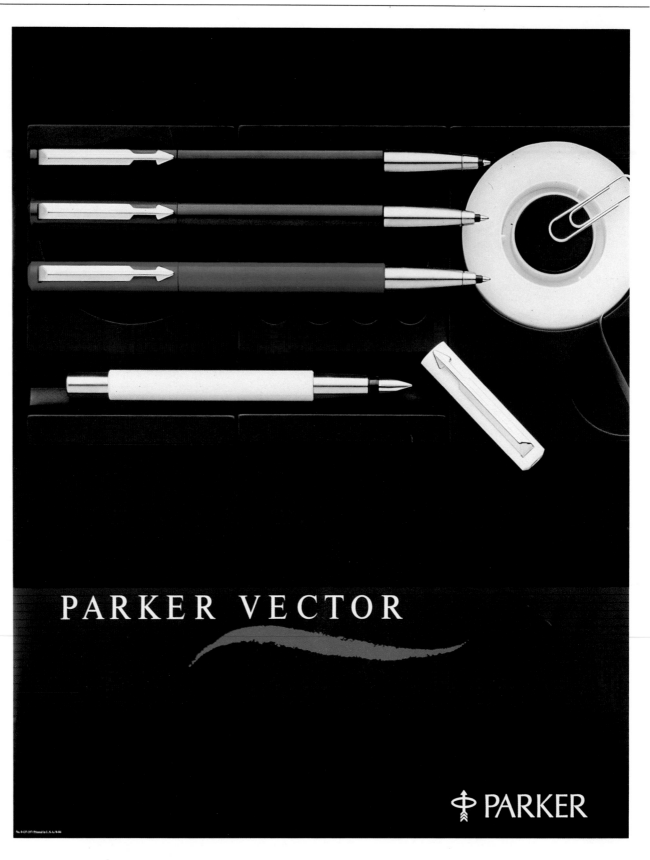

TYPOGRAPHY/ DESIGN	TYPOGRAPHIC SUPPLIER	STUDIO	CLIENT	PRINCIPAL TYPE	DIMENSIONS
Pat & Greg Samata *Dundee, Illinois*	*Ryder Types*	*Samata Associates*	*The Parker Pen* *Company*	*Times Roman*	*22 × 28 in.* *55.9 × 71.1 cm*

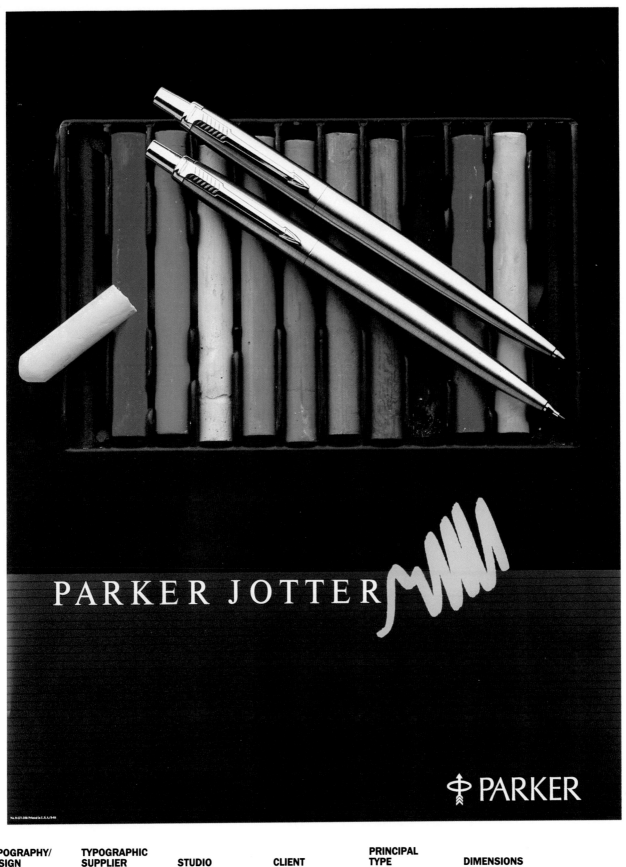

TYPOGRAPHY/ DESIGN	TYPOGRAPHIC SUPPLIER	STUDIO	CLIENT	PRINCIPAL TYPE	DIMENSIONS	
Pat & Greg Samata Dundee, Illinois	*Ryder Types*	*Samata Associates*	*The Parker Pen Company*	*Times Roman*	*22 × 28 in. 55.9 × 71.1 cm*	

TYPOGRAPHY/ DESIGN	TYPOGRAPHIC SUPPLIER	STUDIO	CLIENT	PRINCIPAL TYPE	DIMENSIONS
Pat & Greg Samata Dundee, Illinois	Ryder Types	Samata Associates	The Parker Pen Company	Times Roman	22 × 28 in. 55.9 × 71.1 cm

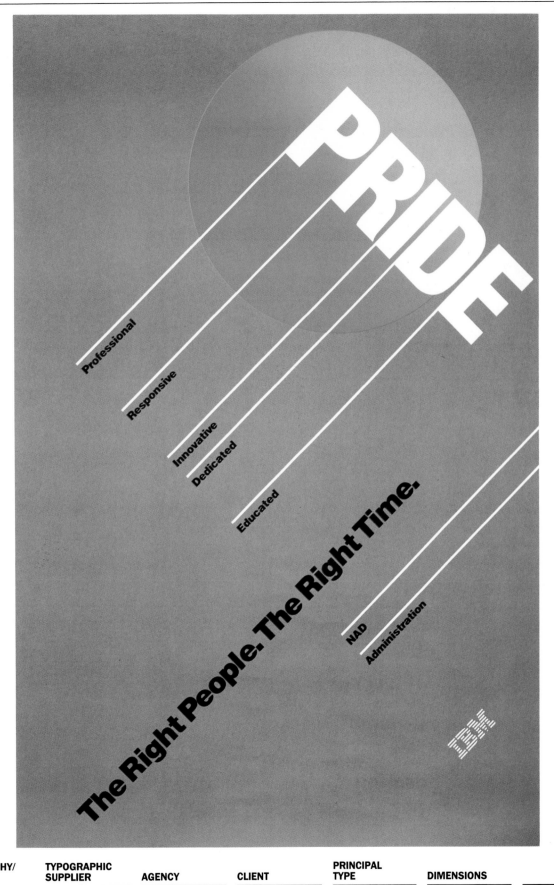

TYPOGRAPHY/ DESIGN	TYPOGRAPHIC SUPPLIER	AGENCY	CLIENT	PRINCIPAL TYPE	DIMENSIONS
Richard Rogers New York City	TypoVision Plus, Inc.	Richard Rogers Inc.	IBM	Helvetica Extra Bold/Helvetica Extra Bold Condensed	22 × 34 in. 55.9 × 86.4 cm

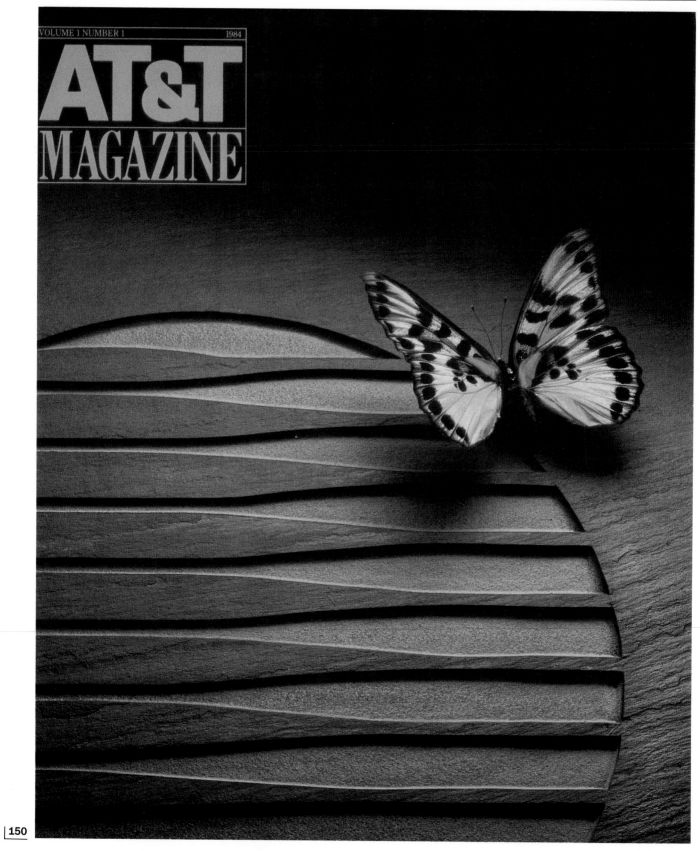

AT&T MAGAZINE

TYPOGRAPHY/ DESIGN	TYPOGRAPHIC SUPPLIER	AGENCY	CLIENT	PRINCIPAL TYPE	DIMENSIONS
Peter Deutsch/ Mark Ulrich New York City	Franklin Typographers	Anthony Russell, Inc.	AT&T	Century Bold Condensed/ Century Old Style/ ITC Century Book/ Futura Extended Condensed	8½ × 11 in. 21.6 × 27.9 cm

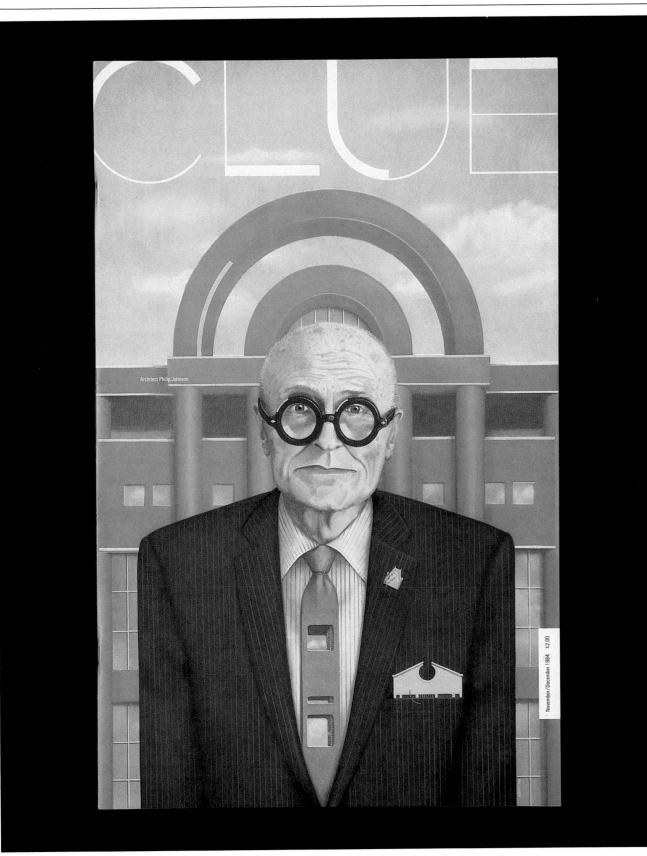

TYPOGRAPHY/ DESIGN	TYPOGRAPHIC SUPPLIER	STUDIO	CLIENT	PRINCIPAL TYPE	DIMENSIONS
Meredith Davis/ Robert Meganck Richmond, Virginia	*Type Time/ Boardwalk, Inc.*	*Communication Design, Inc.*	*Company Corporation, Publisher of Clue Magazine*	*Garamond/ Univers*	*10¾ × 16¾ in. 27.3 × 42.5 cm*

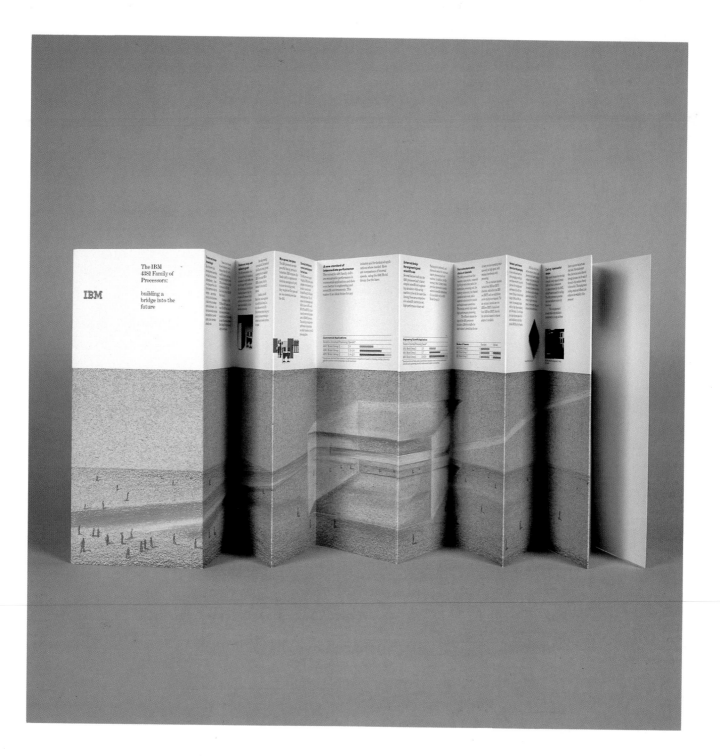

TYPOGRAPHY/ DESIGN	TYPOGRAPHIC SUPPLIER	AGENCY	CLIENT	PRINCIPAL TYPE	DIMENSIONS
Bob Salpeter New York City	Gerard Associates	Salpeter-Paganucci Inc.	IBM World Trade Corp.	Century Expanded/ Univers 75	5 × 11 in. 12.7 × 27.9 cm

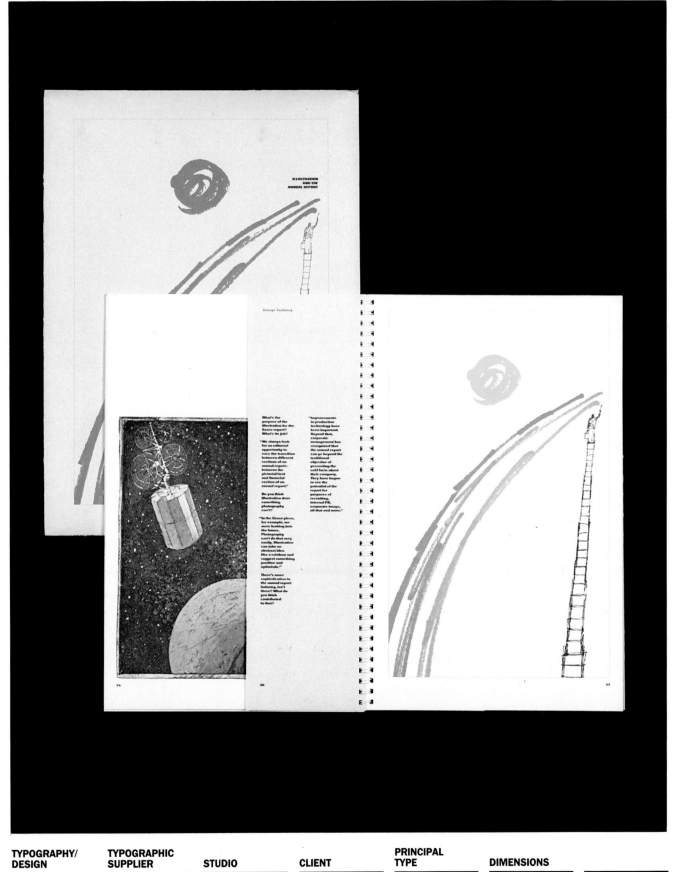

TYPOGRAPHY/ DESIGN	TYPOGRAPHIC SUPPLIER	STUDIO	CLIENT	PRINCIPAL TYPE	DIMENSIONS
Bennett Robinson New York City	*Typographic Resources*	*Corporate Graphics Inc.*	*Simpson Paper Company*	*Imago*	*13¼ × 8½ in. 33.6 × 21.6 cm*

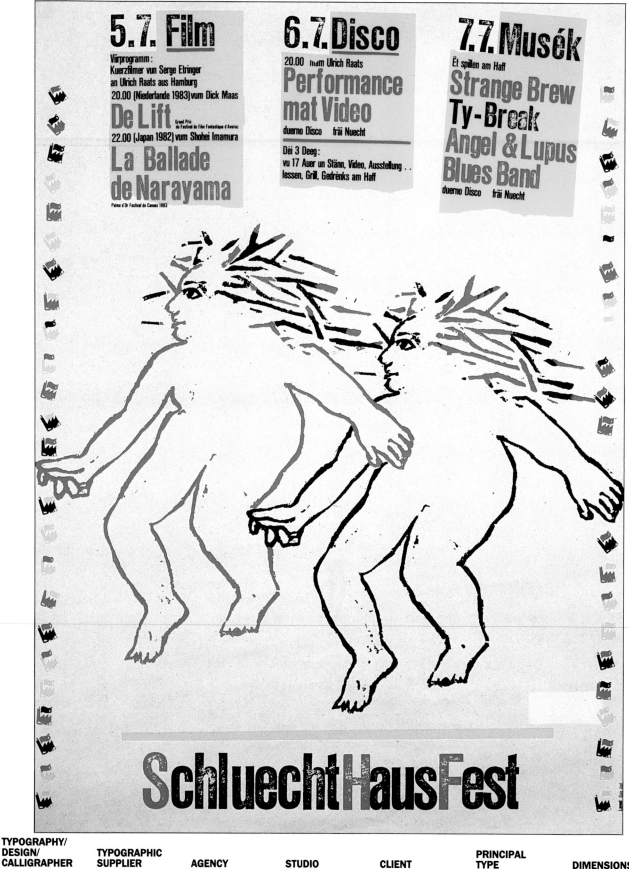

5.7. Film
Viirprogramm:
Kuerzfilmer vun Serge Etringer
an Ulrich Raats aus Hamburg
20.00 (Niederlande 1983) vum Dick Maas
De Lift Grand Prix
du Festival de Film Fantastique d'Avoriaz
22.00 (Japan 1982) vum Shohei Imamura
**La Ballade
de Narayama**
Palme d'Or Festival de Cannes 1983

6.7. Disco
20.00 mam Ulrich Raats
**Performance
mat Video**
duerno Disco fräi Nuecht

Dëi 3 Deeg:
vu 17 Auer un Stänn, Video, Ausstellung . .
Iessen, Grill, Gedrénks am Haff

7.7. Musék
Ët spillen am Haff
**Strange Brew
Ty-Break
Angel & Lupus
Blues Band**
duerno Disco fräi Nuecht

SchluechtHausFest

TYPOGRAPHY/ DESIGN/ CALLIGRAPHER	TYPOGRAPHIC SUPPLIER	AGENCY	STUDIO	CLIENT	PRINCIPAL TYPE	DIMENSIONS
Guig Jost Esch-Sur-Alzette, Luxembourg	Guig Jost	Verlag Am Schluechthaus	Guig Jost/ Willy Simon	Kulturfabrik A.S.B.L.	Helvetica/ Rubberstamp Alphabet	21⅔ × 29½ in. 55 × 75 cm

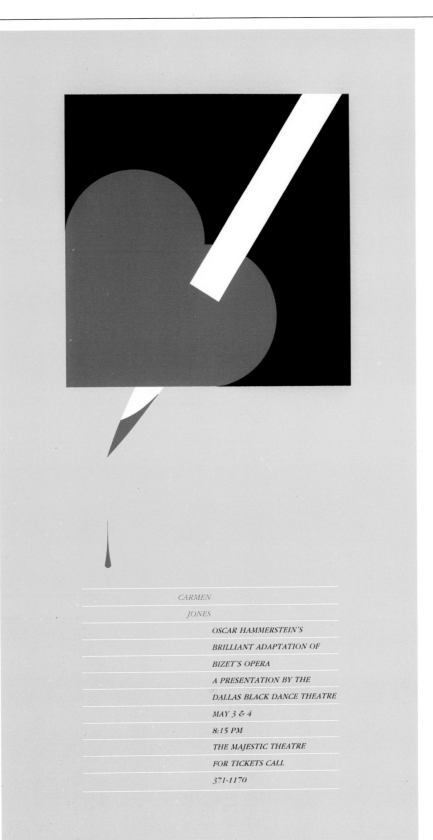

TYPOGRAPHY/ DESIGN	TYPOGRAPHIC SUPPLIER	AGENCY	STUDIO	CLIENT	PRINCIPAL TYPE	DIMENSIONS
Mark Steele Dallas, Texas	Dallas Times Herald (in-house)	Dallas Times Herald Promotion Department	Dallas Times Herald Promotion Department	Dallas Black Dance Theatre	Garamond Light Italic	13½ × 26 in. 34.3 × 66 cm

Henry Art Gallery
University of Washington
Seattle

An exhibition of paintings and photographs
that confront our notions of racism, war, urban life,
aggression and death.

GRÉGOIRE **müller**

LEONARD **koscianski**

ROBERT **birmelin**

JOEL-PETER **witkin**

ROBERT **colescott**

LEON **golub**

September 14 - November 11, 1984

CONFRONTations
confrontATIONS

TYPOGRAPHY/ DESIGN	TYPOGRAPHIC SUPPLIER	STUDIO	CLIENT	PRINCIPAL TYPE	DIMENSIONS
Douglas Wadden Seattle, Washington	Thomas and Kennedy Typographers	Design Collaborative	Henry Art Gallery, University of Washington	Helvetica	23 × 35 in. 58.4 × 88.9 cm

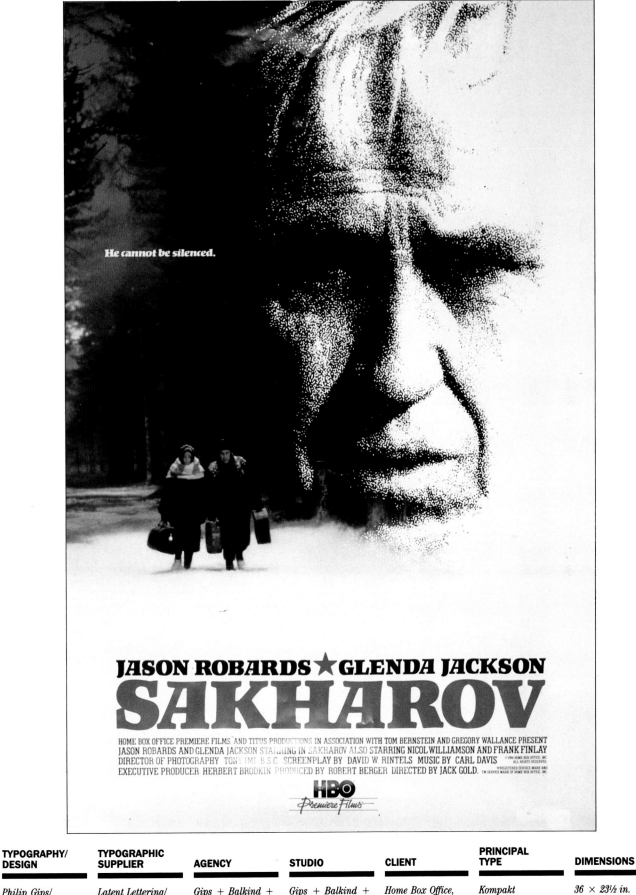

TYPOGRAPHY/ DESIGN	TYPOGRAPHIC SUPPLIER	AGENCY	STUDIO	CLIENT	PRINCIPAL TYPE	DIMENSIONS
Philip Gips/ Gina Stone New York City	Latent Lettering/ JCH Graphics	Gips + Balkind + Associates	Gips + Balkind + Associates	Home Box Office, Inc.	Kompakt	36 × 23½ in. 91.4 × 59.7 cm

TYPOGRAPHY/ DESIGN	CALLIGRAPHER	TYPOGRAPHIC SUPPLIER	STUDIO	CLIENT	PRINCIPAL TYPE	DIMENSIONS
Knut Hartmann/ Roland Mehler Frankfurt, West Germany	Knut Hartmann	Team '80 GmbH	Knut Hartmann Design	Knut Hartmann Design	Futura/ Helvetica	9⅓ × 11 in. 23.5 × 28 cm

Express-Service zu jeder Zeit
Eilzustellung überallhin
Erfahrene langjährige Mitarbeiter
Erstklassiger Satz
Einfach echter Englersatz

Englersatz AG

Weinbergstrasse 145 | Postfach | 8042 Zürich | Telefon 01 362 88 28

TYPOGRAPHY/ DESIGN	TYPOGRAPHIC SUPPLIER	STUDIO	CLIENT	PRINCIPAL TYPE	DIMENSIONS
Rosmarie Tissi Zurich, Switzerland	Englersatz AG	Odermatt & Tissi	Englersatz AG	Gill Sans Light	23⁵/₁₆ × 16⁵/₈ in. 59 × 42 cm

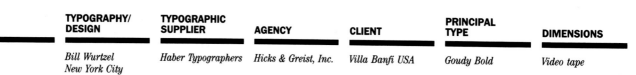

TYPOGRAPHY/ DESIGN	TYPOGRAPHIC SUPPLIER	AGENCY	CLIENT	PRINCIPAL TYPE	DIMENSIONS
Bill Wurtzel New York City	Haber Typographers	Hicks & Greist, Inc.	Villa Banfi USA	Goudy Bold	Video tape

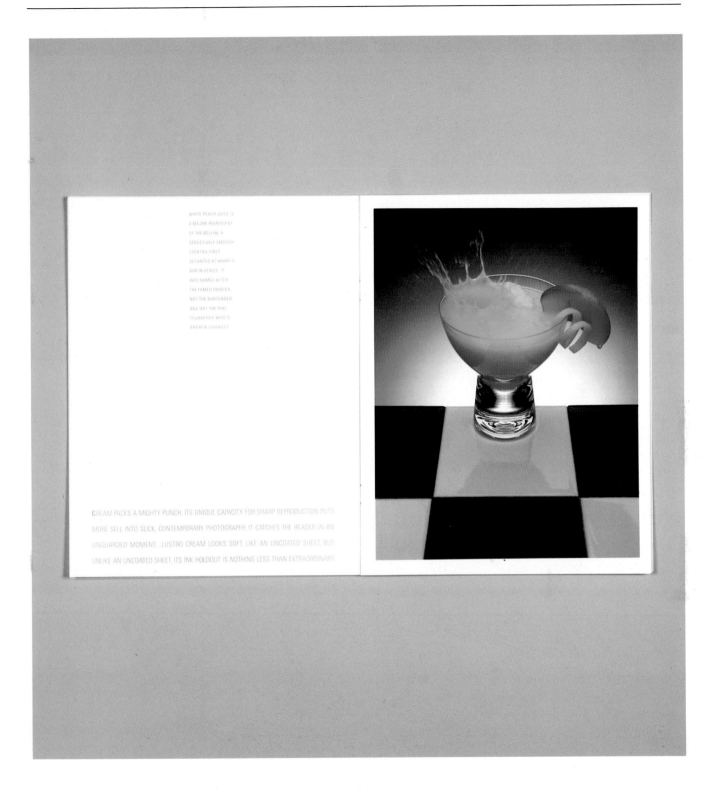

TYPOGRAPHY/ DESIGN	TYPOGRAPHIC SUPPLIER	AGENCY	STUDIO	CLIENT	PRINCIPAL TYPE	DIMENSIONS
Cheryl Heller Boston, Massachusetts	Typographic House	HBM/Creamer, Inc., Advertising	HBM/Creamer Design Group	S. D. Warren Paper Company	Univers Condensed	8 × 10 in. 20.3 × 25.4 cm

Aesthetics of Progress

Forms of the Future in
American Design 1930s/1980s

Hayden Gallery and Hayden
Corridor Gallery
Hayden Memorial Library Building
Massachusetts Institute of
Technology
160 Memorial Drive
Cambridge, Massachusetts

May 19 through June 24, 1984
Public preview
Friday May 18, 5 to 7 pm

Installation by
Tod Williams and Associates,
Architects, New York
Illustrated catalogue available

Gallery hours
Weekdays 10-4, Weekends 1-5
Telephone
Gallery 253-4680, Office 253-4400

Organized by the MIT Committee
on the Visual Arts

Exhibition and publication
supported in part by the
National Endowment for the Arts,
a Federal agency, Washington,D.C.

TYPOGRAPHY/ DESIGN	ILLUSTRATOR	TYPOGRAPHIC SUPPLIER	AGENCY	CLIENT	PRINCIPAL TYPE	DIMENSIONS
Jacqueline Casey Cambridge, Massachusetts	Joseph Durkin	Typographic House/ Xanadu	MIT Design Services	MIT Committee on the Visual Arts	Helvetica/ Helios Light	20¼ × 30¾ in. 51.4 × 78.1 cm

TYPOGRAPHY/ DESIGN	TYPOGRAPHIC SUPPLIER	AGENCY	CLIENT	PRINCIPAL TYPE	DIMENSIONS
Jeff A. Barnes Chicago, Illinois	Barnes Design Office	Barnes Design Office	Kieffer-Nolde, Inc.	1913 Underwood Typewriter	8½ × 11 in. 21.6 × 27.9 cm

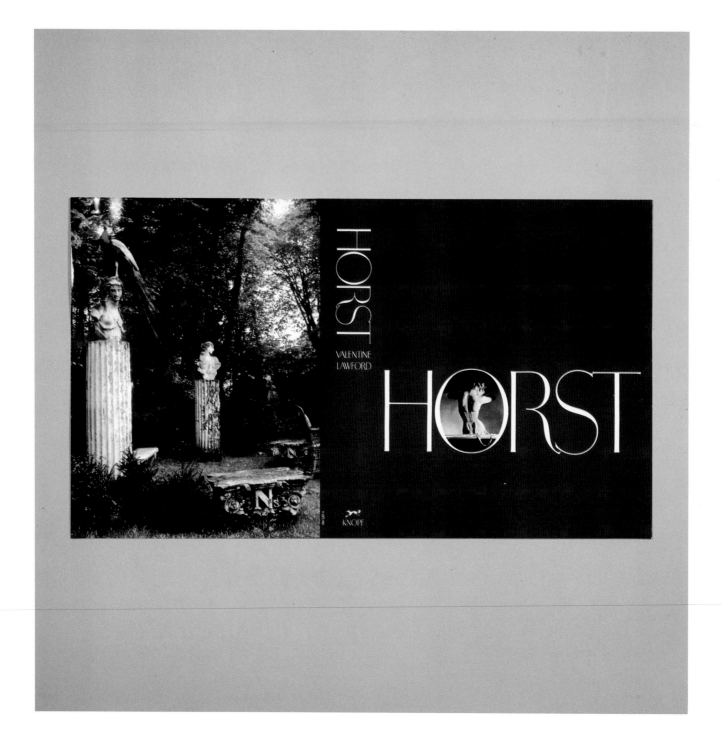

TYPOGRAPHY/ DESIGN	TYPOGRAPHIC SUPPLIER	CLIENT	PRINCIPAL TYPE	DIMENSIONS
Sara Eisenman *New York City*	*Images*	*Alfred A. Knopf*	*Stark Debonair*	*9⅞ × 11¹¹/₁₆ in.* *25.1 × 29.6 cm*

TYPOGRAPHY/ DESIGN	CALLIGRAPHER	CLIENT	DIMENSIONS
Gun Larson Klagstorp, Sweden	Gun Larson	Alfred A. Knopf	6⁵⁄₁₆ × 9⁷⁄₁₆ in. 16 × 24 cm

TYPOGRAPHY/ DESIGN	TYPOGRAPHIC SUPPLIER	STUDIO	CLIENT	PRINCIPAL TYPE	DIMENSIONS
Colleen Abrams/ Elizabeth Henry Palo Alto, California	Spartan Typographers	Mark Anderson Design	IBM	Bodoni Book/ Bodoni Bold Condensed	12 × 24 in. 30.5 × 61 cm

A Message from Ian Wilson

Over the past year, senior management has placed major emphasis on developing strategies to focus our energy and resources on those opportunities offering our Company the highest potential for long-term profitability. Three areas emerged as the most promising for our future:

□ Fresh produce
□ Packaged foods
□ Real estate

We are strongly positioned in all three, and all three have histories of profitability.

This year's annual report is devoted principally to fresh produce and packaged foods because they offer major opportunities for future growth and profit.

Consumers worldwide have created a freshness revolution in the food industry. Their increasing demand for healthier foods is inspired by a growing awareness of the importance of nutrition in maintaining fitness and good health. The traditional meat-and-potatoes diet has been replaced by lighter, healthier meals featuring more fresh produce.

In response, food markets worldwide are expanding and modernizing their fresh produce departments. New and sometimes exotic fruit and vegetables that were unknown to most consumers a decade ago are now available at the local market. And the highest premium is placed on freshness and quality.

The family dinner table will never be the same. Neither will the food business. And neither will Castle & Cooke.

We are moving to capitalize on this freshness revolution with an aggressive, consumer-driven marketing strategy. It emphasizes supplying a comprehensive range of fresh fruit and vegetables under brand names that already have gained consumer confidence: Dole and Bud of California.

We are making a significant investment in consumer advertising and promotions in fiscal 1985 to further strengthen our brands and increase consumer demand for all products from "A Sunny Place Called Dole."

Our strategy includes bringing to market new, value-added food products that meet the rising consumer demand for quality packaged foods. These products also will carry the trusted Dole name.

With the most diverse product line and worldwide fresh food sales of over $1 billion last year, we are starting from a position of strength as the world's leading supplier of fresh produce. Our research and development in the past year yielded several successful new packaged products. Five have now been placed in national distribution, including Dole chilled juice and frozen pineapple juice concentrate. Six more new products are being test marketed for introduction in the coming year, and more are in the development stage.

Studies show that the Dole brand name is an internationally recognized promise of quality to consumers. We will continue to keep that promise with global sourcing and state-of-the-art, field-to-table control for our branded products, and with unmatched service to our wholesalers and retailers.

The theme of our new advertising campaign, "A Sunny Place Called Dole," reflects our view of Castle & Cooke as a supplier and producer of light, healthful Dole brand foods that consumers associate with freshness and sunshine.

TYPOGRAPHY/ DESIGN	TYPOGRAPHIC SUPPLIER	AGENCY	CLIENT	PRINCIPAL TYPE	DIMENSIONS
Linda Hinrichs/ Carol Kramer San Francisco, California	Spartan	Jonson Pedersen Hinrichs & Shakery Inc.	Castle & Cooke	Trump	8½ × 11 in. 21.6 × 27.9 cm

TYPOGRAPHY/ DESIGN	TYPOGRAPHIC SUPPLIER	STUDIO	CLIENT	PRINCIPAL TYPE	DIMENSIONS
Malcolm Waddell Toronto, Canada	*Cooper & Beatty, Ltd.*	*Eskind Waddell*	*Yuri Dojc/ Eskind Waddell/ Cooper & Beatty, Ltd./ Empress Litho Plate Ltd./ Arthurs-Jones Lithographing Ltd.*	*Univers*	*17 × 23 in. 43.2 × 58.4 cm*

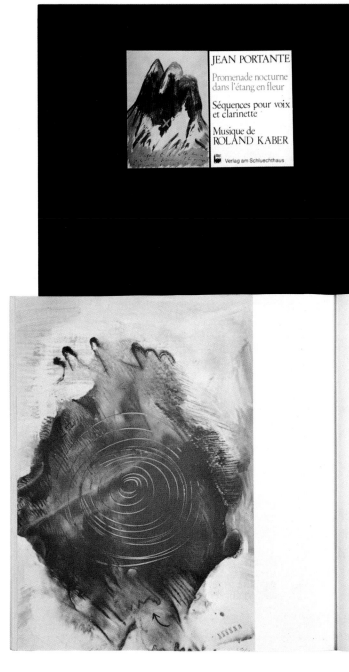

TYPOGRAPHY/ DESIGN CALLIGRAPHER	TYPOGRAPHIC SUPPLIER	AGENCY	STUDIO	CLIENT	PRINCIPAL TYPE	DIMENSIONS
Guig Jost *Esch-Sur-Alzette,* *Luxembourg*	*Guig Jost*	*Verlag AM* *Schluechthaus*	*Guig Jost/* *Kremer-Müller*	*Jean Portante/* *Roland Kaber*	*Garamond/* *Rubberstamp* *Alphabet*	*8¼ × 8¼ in.* *20.9 × 20.9 cm*

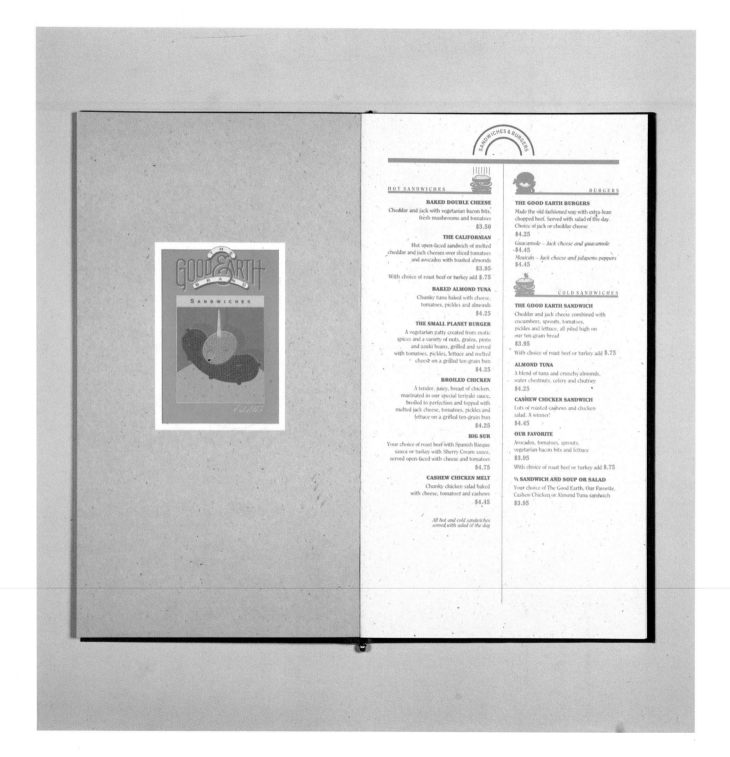

TYPOGRAPHY/ DESIGN	CALLIGRAPHER	TYPOGRAPHIC SUPPLIER	STUDIO	CLIENT	PRINCIPAL TYPE	DIMENSIONS
Rex Peteet Dallas, Texas	Rex Peteet	Southwestern Typographics	Sibley/Peteet Design, Inc.	Good Earth Restaurants	ITC Clearface/ ITC Cheltenham Ultra	7 × 14 in. 17.8 × 35.6 cm

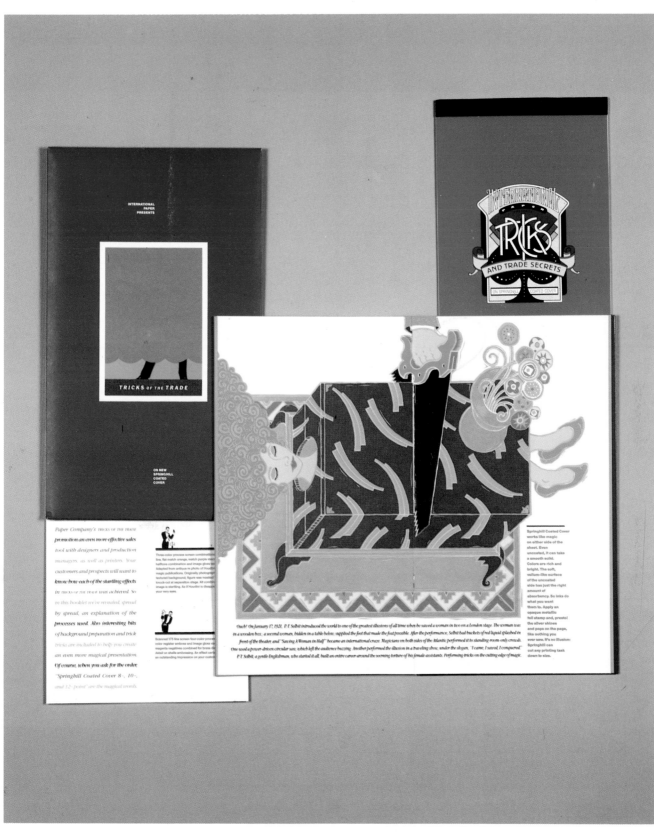

TYPOGRAPHY/ DESIGN	CALLIGRAPHERS	TYPOGRAPHIC SUPPLIER	STUDIO	CLIENT	PRINCIPAL TYPE	DIMENSIONS
Rex Peteet Dallas, Texas	Rex Peteet/ Walter Horton	Robert J. Hilton Typographers	Sibley/Peteet Design, Inc.	International Paper	Helvetica	7 × 11 in. 17.8 × 28 cm

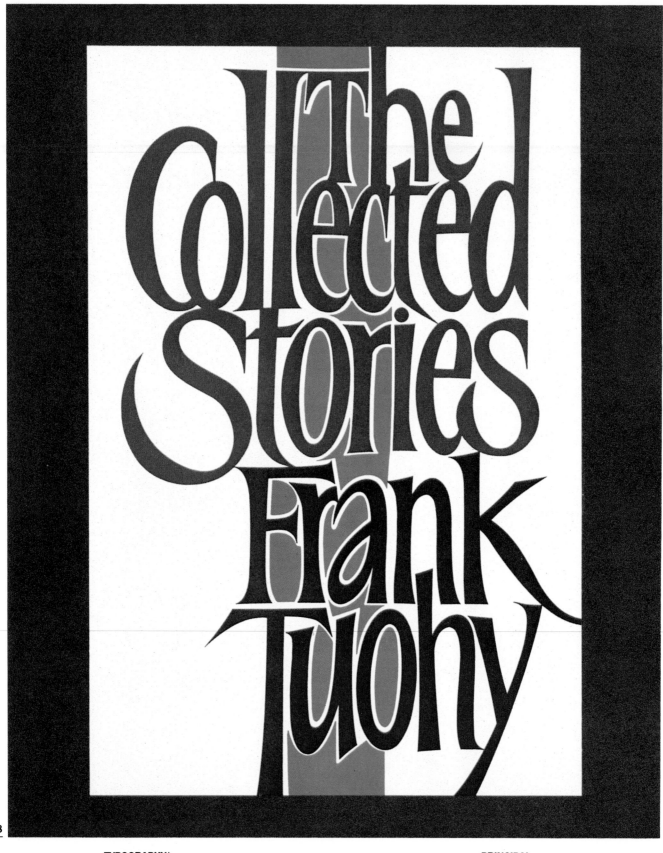

TYPOGRAPHY/ DESIGN	CALLIGRAPHER	STUDIO	CLIENT	PRINCIPAL TYPE	DIMENSIONS
David Gatti *New York City*	*David Gatti*	*David Gatti* *Graphic Design*	*Holt Rinehart* *Winston*	*Handlettering*	*6⅛ × 9¼ in.* *15.5 × 23.5 cm*

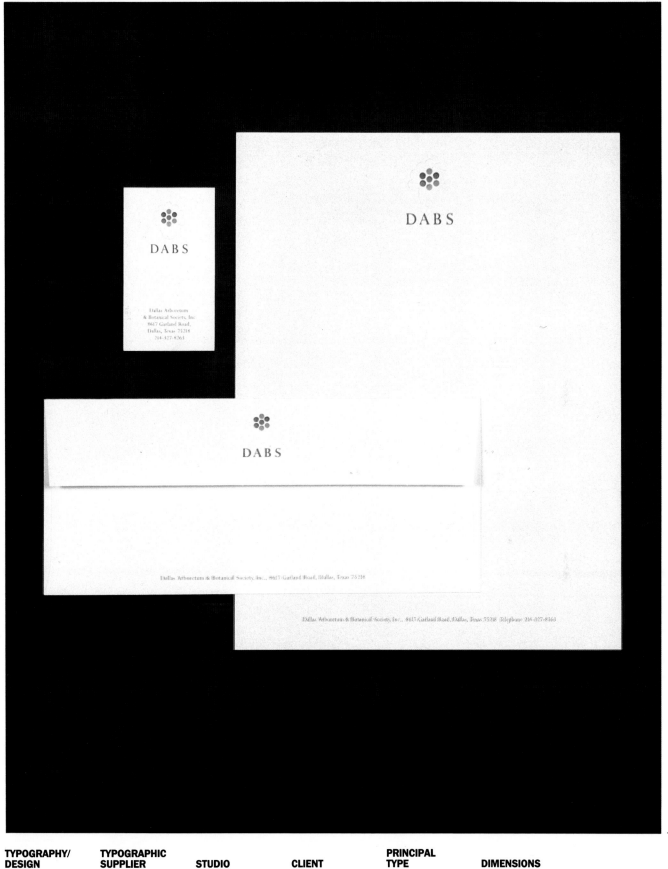

TYPOGRAPHY/ DESIGN	TYPOGRAPHIC SUPPLIER	STUDIO	CLIENT	PRINCIPAL TYPE	DIMENSIONS
Dick Mitchell/ Douglas May Dallas, Texas	Southwestern Typographics	Richard, Brock, Miller, Mitchell & Associates	Dallas Arboretum and Botanical Society, Inc.	Perpetua	8½ × 11 in. 21.6 × 27.9 cm Envelope: 4⅛ × 9½ in. 10.5 × 22.2 cm

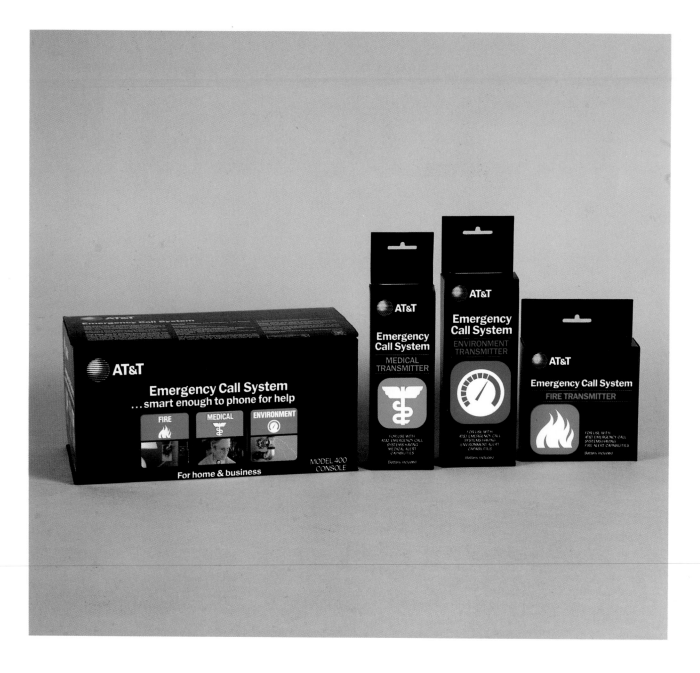

TYPOGRAPHY/ DESIGN	STUDIO	CLIENT	PRINCIPAL TYPE	DIMENSIONS
Saul Bass/ G. Dean Smith Los Angeles, California	Saul Bass/ Herb Yager and Associates	AT&T	Designed by Saul Bass	Various

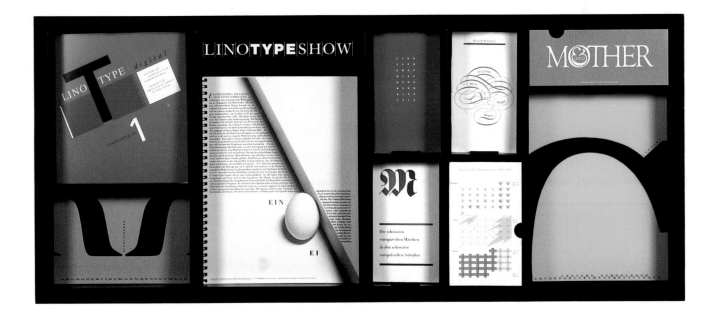

TYPOGRAPHY/ DESIGN	TYPOGRAPHIC SUPPLIER	STUDIO	CLIENT	PRINCIPAL TYPE	DIMENSIONS
Olaf Leu Frankfurt, West Germany	Fotosatz Hoffman/ Stempel AG	Olaf Leu Design & Partner	Mergenthaler Linotype GmbH	Typefaces from Mergenthaler Linotype/Stempel/ Haas	34¼ × 14⅝ in. 87 × 37 cm

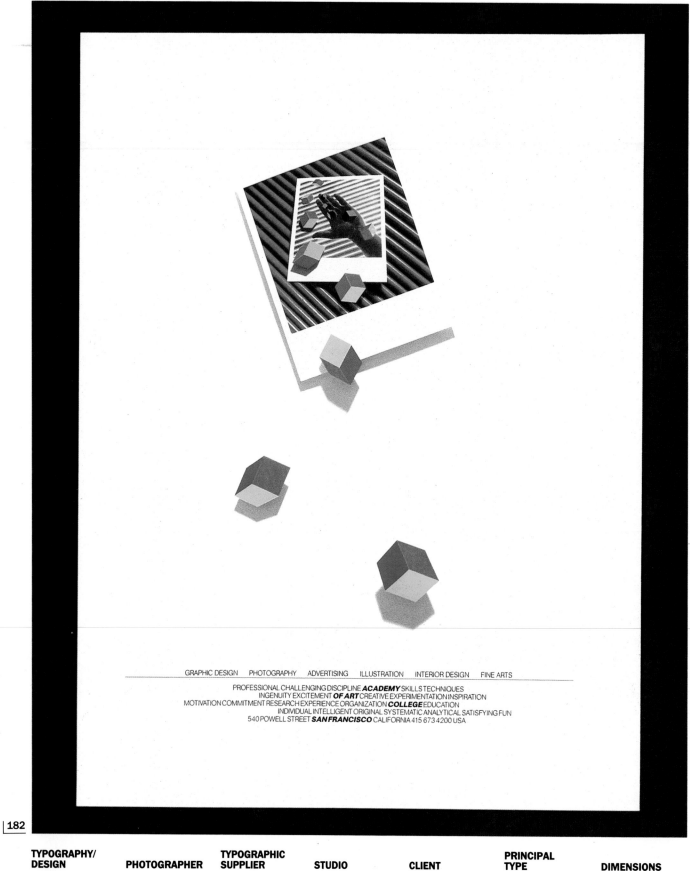

GRAPHIC DESIGN PHOTOGRAPHY ADVERTISING ILLUSTRATION INTERIOR DESIGN FINE ARTS

PROFESSIONAL CHALLENGING DISCIPLINE **ACADEMY** SKILLS TECHNIQUES
INGENUITY EXCITEMENT **OF ART** CREATIVE EXPERIMENTATION INSPIRATION
MOTIVATION COMMITMENT RESEARCH EXPERIENCE ORGANIZATION **COLLEGE** EDUCATION
INDIVIDUAL INTELLIGENT ORIGINAL SYSTEMATIC ANALYTICAL SATISFYING FUN
540 POWELL STREET **SAN FRANCISCO** CALIFORNIA 415 673 4200 USA

TYPOGRAPHY/ DESIGN	PHOTOGRAPHER	TYPOGRAPHIC SUPPLIER	STUDIO	CLIENT	PRINCIPAL TYPE	DIMENSIONS
Henry Brimmer San Francisco, California	*Henry Brimmer*	*Reardon & Krebs*	*Henry Brimmer Design*	*Academy of Art College, San Francisco*	*Helvetica Light/ Helvetica Bold Italic*	*9½ × 12 in. 24.2 × 30.5 cm*

THIS CERTIFICATE OF RECOGNITION IS
GIVEN TO THOSE OF YOU WHO
HAVE PLAYED A MAJOR ROLE IN THE BUILDING
OF APPLE'S PHENOMENAL SUCCESS.
DURING THE PAST FIVE YEARS YOU HAVE
GIVEN TO APPLE YOUR TALENTS, ENTHUSIASM
AND ENERGY. WE HOPE YOU FEEL AS
WE DO, THAT THE JOURNEY HAS BEEN AND
WILL CONTINUE TO BE THE REWARD.

President and
Chief Executive Officer

Chairman of the Board

FIVE

TYPOGRAPHY/ DESIGN	TYPOGRAPHIC SUPPLIER	AGENCY	CLIENT	PRINCIPAL TYPE	DIMENSIONS
Lindy Cameron/ Tom Suiter/ Clement Mok Cupertino, California	Vicki Takla	Apple Creative Services	Apple Computer, Inc.	ITC Garamond Light Condensed	7¼ × 10 in. 18.4 × 25.4 cm

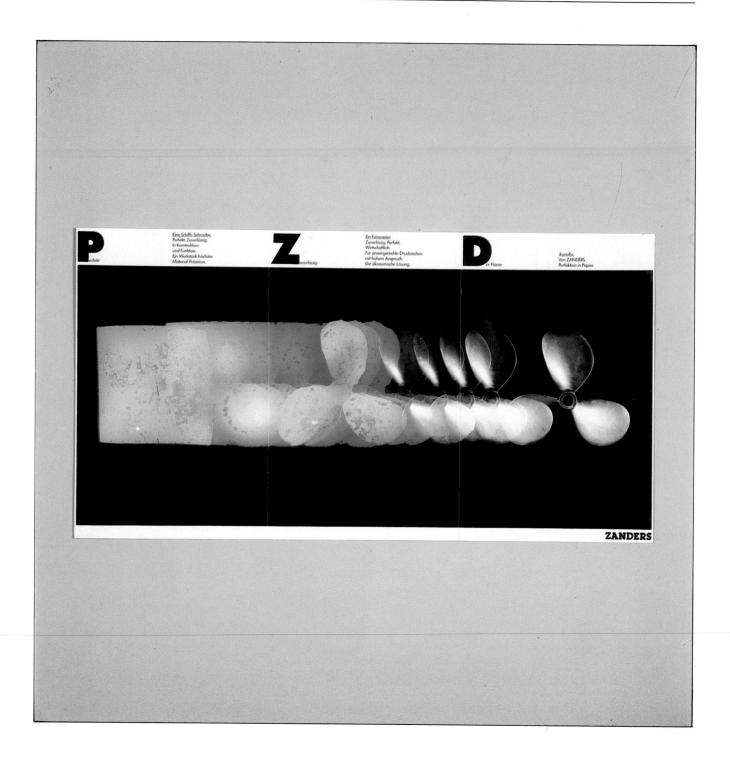

TYPOGRAPHY/ DESIGN	TYPOGRAPHIC SUPPLIER	AGENCY	STUDIO	CLIENT	PRINCIPAL TYPE	DIMENSIONS
Harald Schlüter Essen, West Germany	Workshop	Harald Schlüter Werbeagentur	Harald Schlüter Werbeagentur	Zanders Feinpapiere AG	Gill Extrafett/ Futura Book	Open: 21⅞ × 11⅓ in. 55.5 × 28.6 cm Folded: 7⅓ × 11⅓ in. 18.5 × 28.6 cm

TYPOGRAPHY/ DESIGN	TYPOGRAPHIC SUPPLIER	STUDIO	CLIENT	PRINCIPAL TYPE	DIMENSIONS
Kurt Gibson Tucson, Arizona	Tucson Typographic Service	IBM Tucson Design Center	IBM Tucson	Univers	37 × 23 in. 94 × 58.4 cm

STORIES, PHOTOGRAPHS, ADVENTURES & LEGENDS

PARK CITY

A 100 YEAR HISTORY: SILVER MINING TO SKIING

TYPOGRAPHY/ DESIGN	TYPOGRAPHIC SUPPLIER	AGENCY	STUDIO	CLIENT	PRINCIPAL TYPE	DIMENSIONS
Don Weller/ Chikako Matsubayashi Los Angeles, California	Alpha Graphix, Inc.	The Weller Institute for the Cure of Design, Inc.	The Weller Institute for the Cure of Design, Inc.	The Weller Institute for the Cure of Design, Inc.	Goudy Old Style	10½ × 14½ in. 26.7 × 36.8 cm

A Bright Past,
A Shining Future

A Campaign To Celebrate
Hamilton's 175th Anniversary
1812–1987

TYPOGRAPHY/ DESIGN	TYPOGRAPHIC SUPPLIER	STUDIO	CLIENT	PRINCIPAL TYPE	DIMENSIONS
Beau Gardner *New York City*	*Concept* *Typographers*	*Beau Gardner* *Associates*	*Hamilton College*	*Bembo/* *Bembo Italic*	*9 × 11 in.* *22.9 × 27.9 cm*

Home Owners

Federal Savings &

Loan Association

1984

Annual Report

"Just as home styles and features have evolved over the years, so has the business of mortgage lending. The commitment to compete and to grow distinguishes the thrifts that will thrive in today's deregulated environment. Fiscal 1984, a year of unparalleled expansion for Home Owners, demonstrates our ability to compete as a national mortgage lender both today and in the years to come."

TYPOGRAPHY/ DESIGN	TYPOGRAPHIC SUPPLIER	STUDIO	CLIENT	PRINCIPAL TYPE	DIMENSIONS
Marjorie Greene Millyard Boston, Massachusetts	*Typographic House*	*Gunn Associates*	*Home Owners Federal Savings & Loan Association*	*Bodoni/ Bodoni Italic*	*Open: 11 × 17 in. 27.9 × 43.2 cm Folded: 8½ × 11 in. 21.6 × 27.9 cm*

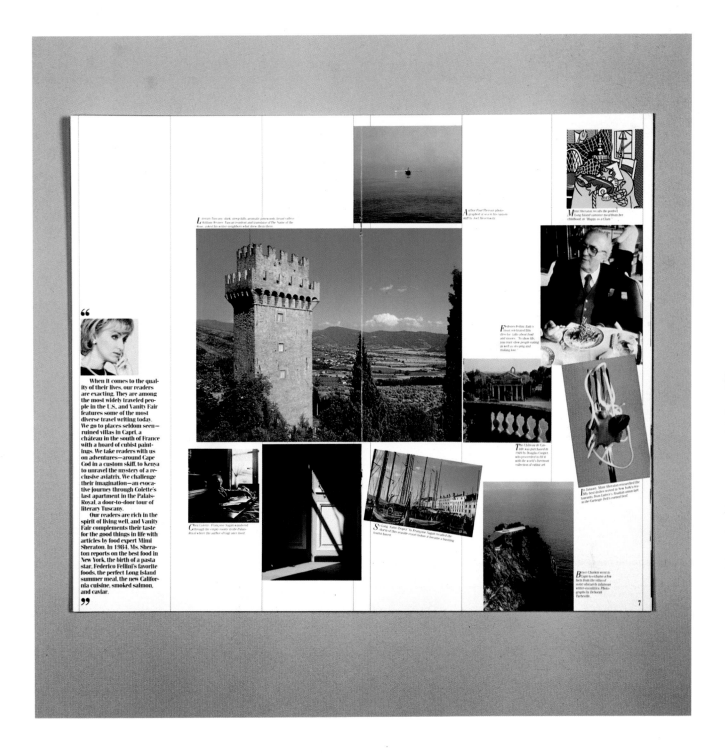

TYPOGRAPHY/ DESIGN	TYPOGRAPHIC SUPPLIER	AGENCY	CLIENT	PRINCIPAL TYPE	DIMENSIONS
Bob Barthelmes/ Young Hee Choi/ Alice Kenny New York City	Photo-Lettering, Inc.	The Condé Nast Publications, Inc.	Vanity Fair	ITC Fenice	8½ × 14 in. 21.6 × 36 cm

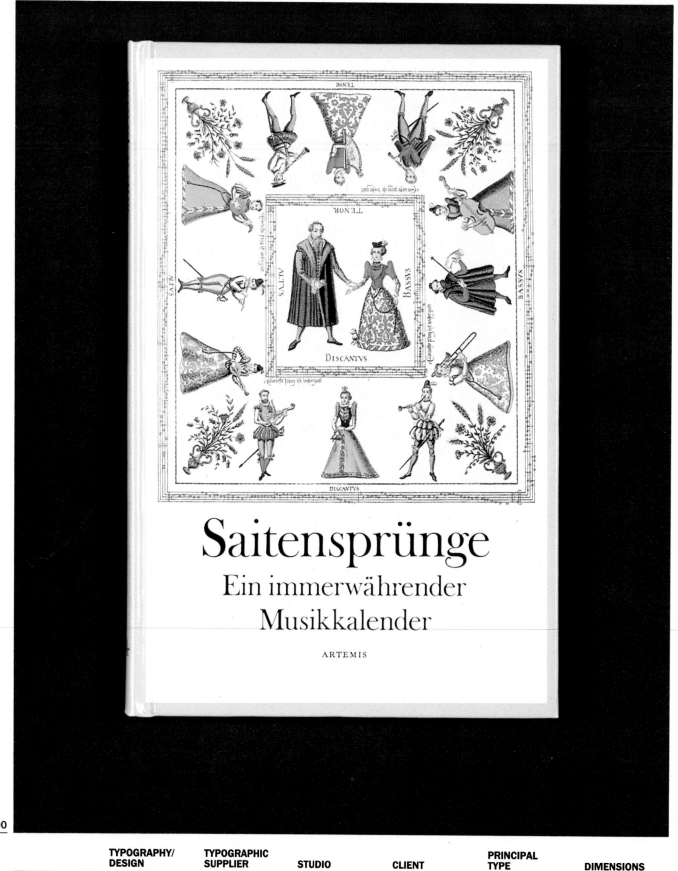

TYPOGRAPHY/ DESIGN	TYPOGRAPHIC SUPPLIER	STUDIO	CLIENT	PRINCIPAL TYPE	DIMENSIONS
Meike Harms München, West Germany	Libro-Satz, Kriftel	Artemis Verlag München	Artemis Verlag München	Mono-Photo Baskerville	4¾ × 7¹/₁₆ in. 12 × 18 cm

From Start

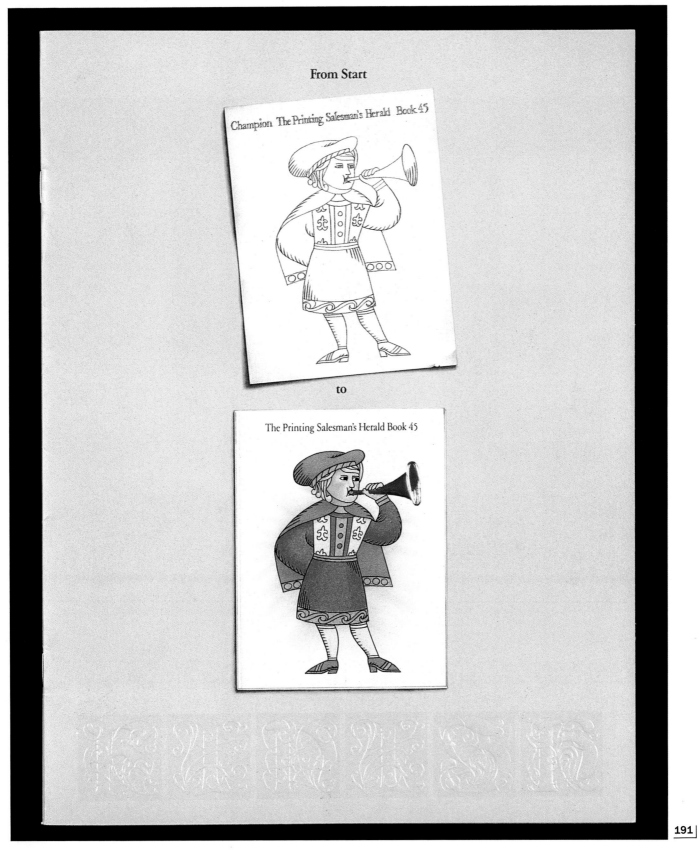

to

TYPOGRAPHY/ DESIGN	TYPOGRAPHIC SUPPLIER	AGENCY	STUDIO	CLIENT	PRINCIPAL TYPE	DIMENSIONS
Joan Wilking Newburyport, Massachusetts	Rand Typography, Inc.	Cartouche, Inc.	Cartouche, Inc.	Champion International Corporation	Garamond Antiqua	8½ × 11 in. 21.6 × 27.9 cm

TYPOGRAPHY/ DESIGN	TYPOGRAPHIC SUPPLIER	AGENCY	STUDIO	CLIENT	PRINCIPAL TYPE	DIMENSIONS
Typographics Manchester, England	Georgia Typesetting	Buchanan Company	D&A Artwork Services	Geoff Smith Photography	Hadriano	11¾ × 8¼ in. 29.8 × 21 cm

TYPOGRAPHY/ DESIGN	TYPOGRAPHIC SUPPLIER	STUDIO	CLIENT	PRINCIPAL TYPE	DIMENSIONS
Pat Sloan Fort Worth, Texas	Fort Worth Linotyping Company, Inc.	Pat Sloan Design	Andy Miracle	ITC Berkeley Old Style Book	8½ × 11 in. 21.6 × 27.9 cm

MICHAEL
OSBORNE

MICHAEL
OSBORNE

Michael Osborne Design, Inc.
105 South Park,
San Francisco CA 94107

MICHAEL
OSBORNE

Bill Reuter

Michael Osborne Design, Inc.
105 South Park
San Francisco CA 94107
415 495 4292

Michael Osborne Design, Inc.
105 South Park
San Francisco CA 94107
415 495 4292

TYPOGRAPHY/ DESIGN	TYPOGRAPHIC SUPPLIER	STUDIO	CLIENT	PRINCIPAL TYPE	DIMENSIONS
Tandy Belew San Francisco, California	Hester Typography	Michael Osborne Design, Inc.	Michael Osborne Design, Inc.	Garamond	8½ × 11 in. 21.6 × 27.9 cm

TYPOGRAPHY/ DESIGN	CALLIGRAPHER	TYPOGRAPHIC SUPPLIER	AGENCY	CLIENT	PRINCIPAL TYPE	DIMENSIONS
Patricia J. Allen Kearney, New Jersey	Patricia J. Allen	CTC	Patricia J. Allen	Patricia J. Allen	Cartier	8½ × 11 in. 21.6 × 27.9 cm

TYPOGRAPHY/ DESIGN	TYPOGRAPHIC SUPPLIER	STUDIO	CLIENT	PRINCIPAL TYPE	DIMENSIONS
Victoria Eubanks Denver, Colorado	EB Typecrafters, Inc.	Weber Design	American Society of Interior Designers, Denver Chapter	Modern #20	8 × 48 in. 20.3 × 121.9 cm

TYPOGRAPHY/ DESIGN	TYPOGRAPHIC SUPPLIER	AGENCY	CLIENT	PRINCIPAL TYPE	DIMENSIONS
Reba Sochis/ Carol Lugtu Durkel New York City	*Cardinal Type Service*	*Reba Sochis Design*	*Bulkley Dunton*	*Folkwang/ Goudy Old Style/ Goudy Bold*	*9 × 6 in. 22.9 × 15.2 cm*

TYPOGRAPHY/ DESIGN	CALLIGRAPHER	TYPOGRAPHIC SUPPLIER	AGENCY/STUDIO	CLIENT	PRINCIPAL TYPE	DIMENSIONS
Steve Martin Los Angeles, California	Tim Girvin Seattle, Washington	Central Typesetting	Cross Associates	Simpson Paper Company	Helvetica	11 × 13 in. 27.9 × 33 cm

TYPOGRAPHY/ DESIGN	CALLIGRAPHER	STUDIO	CLIENT	PRINCIPAL TYPE	DIMENSIONS
Seymour Robins *Sheffield,* *Massachusetts*	*Karole Svingala*	*Seymour Robins* *Design*	*Mohawk Paper Mills*	*Labyrinth-Logo* *(designed by* *Seymour Robins)*	*9 × 14⅝ in.* *22.9 × 37.2 cm*

TYPOGRAPHY/ DESIGN	TYPOGRAPHIC SUPPLIER	AGENCY	CLIENT	PRINCIPAL TYPE	DIMENSIONS
Lindy Cameron/ Clement Mok/ Tom Suiter Cupertino, California	*Vicki Takla*	*Apple Creative Services*	*Apple Computer*	*ITC Garamond Condensed*	*7 × 31½ in. 17.8 × 80 cm*

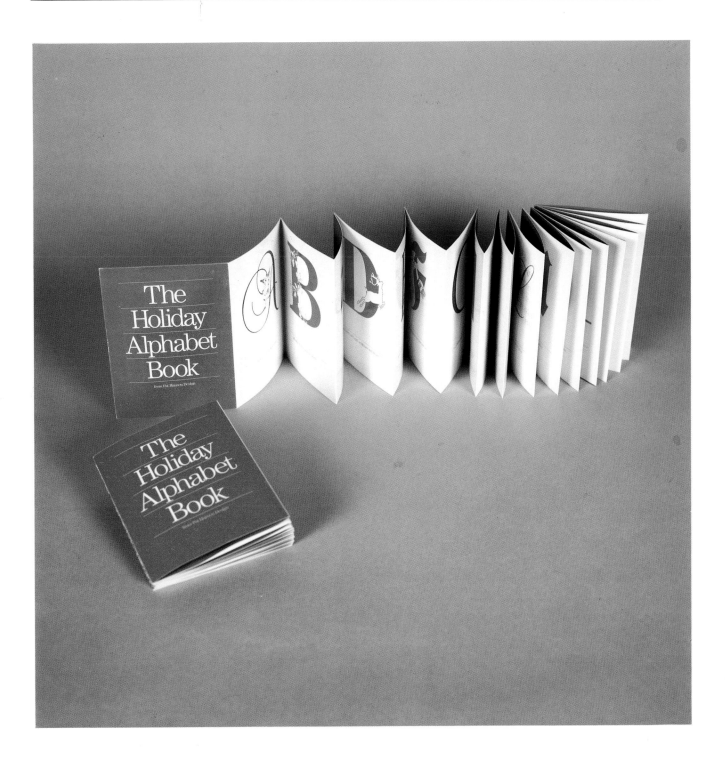

TYPOGRAPHY/ DESIGN	TYPOGRAPHIC SUPPLIER	AGENCY	STUDIO	CLIENT	PRINCIPAL TYPE	DIMENSIONS
Pat Hensen/ Paula Richards Seattle, Washington	The Type Gallery	Pat Hansen Design	Pat Hansen Design	Pat Hansen Design	Miscellaneous/ Century Light	105 × 4¾ in. 266.7 × 22.2 cm

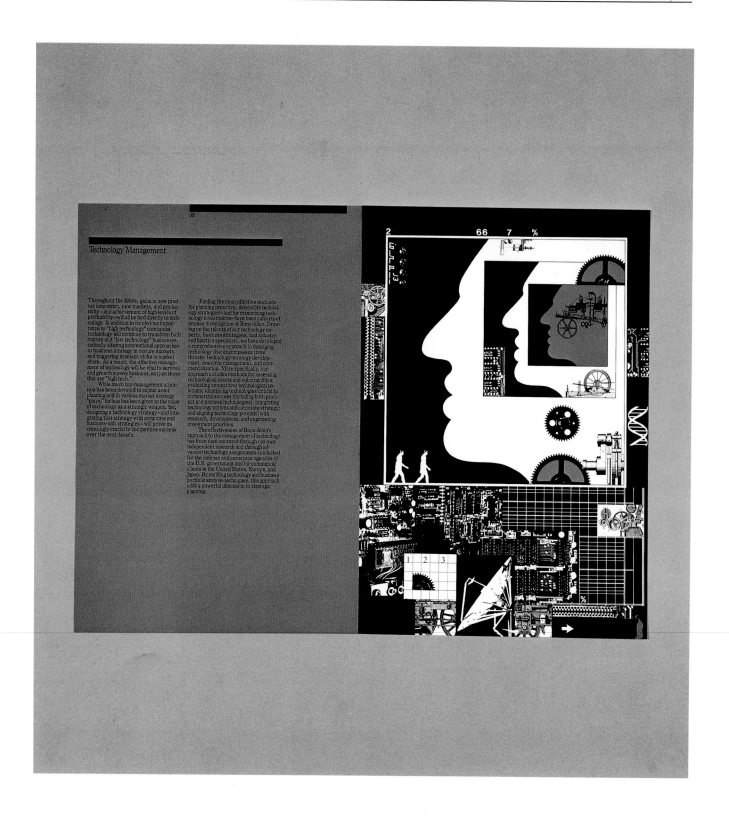

TYPOGRAPHY/ DESIGN	TYPOGRAPHIC SUPPLIER	STUDIO	CLIENT	PRINCIPAL TYPE	DIMENSIONS
Tomás Gonda New York City	Print & Design Typography	Gonda Design Inc.	Booz, Allen & Hamilton Inc.	Century Old Style	8¼ × 11¾ in. 21 × 29.8 cm

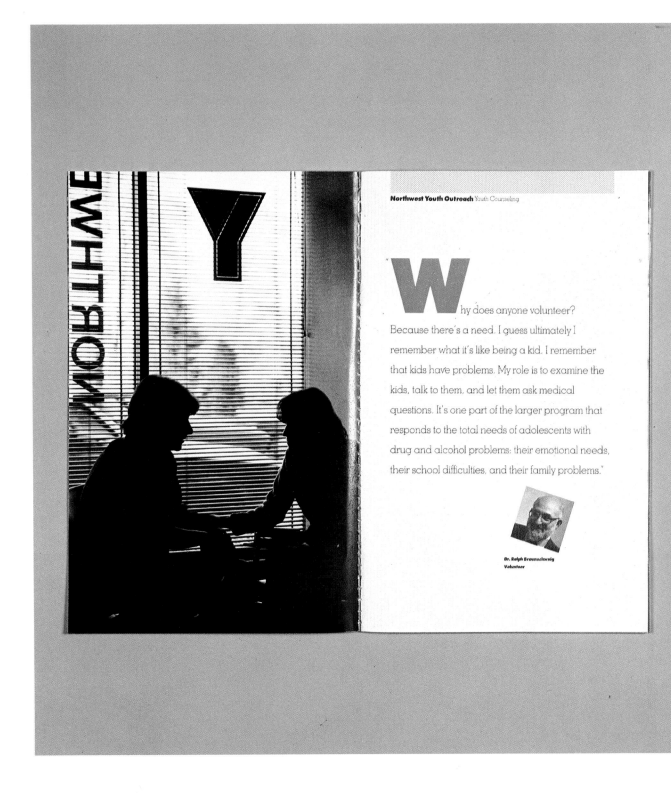

Northwest Youth Outreach Youth Counseling

"**W**hy does anyone volunteer? Because there's a need. I guess ultimately I remember what it's like being a kid. I remember that kids have problems. My role is to examine the kids, talk to them, and let them ask medical questions. It's one part of the larger program that responds to the total needs of adolescents with drug and alcohol problems: their emotional needs, their school difficulties, and their family problems."

Dr. Ralph Braunschweig
Volunteer

TYPOGRAPHY/ DESIGN	TYPOGRAPHIC SUPPLIER	STUDIO	CLIENT	PRINCIPAL TYPE	DIMENSIONS
Pat & Greg Samata Dundee, Illinois	*Ryder Types*	*Samata Associates*	*YMCA of Metropolitan Chicago*	*Futura Extra Bold/ Stymie Light*	*7½ × 11½ in. 19 × 29.1 cm*

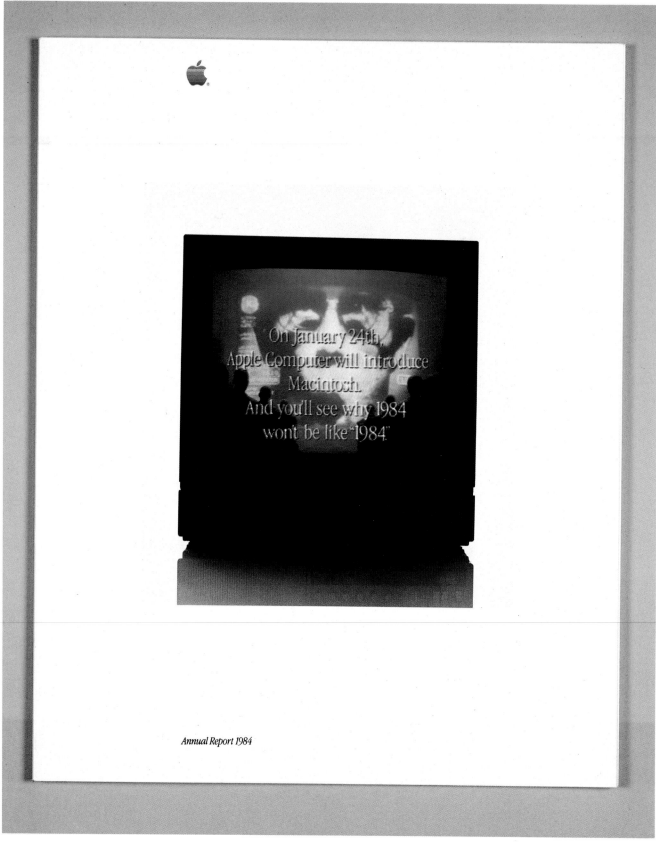

Annual Report 1984

TYPOGRAPHY/ DESIGN	TYPOGRAPHIC SUPPLIER	AGENCY	STUDIO	CLIENT	PRINCIPAL TYPE	DIMENSIONS
Clement Mok/ Tom Suiter Cupertino, California	Vicki Takla	Apple Creative Services	Corporate Group	Apple Computer	ITC Garamond Condensed	9 × 11 in. 22.9 × 27.9 cm

TYPOGRAPHY/ DESIGN	TYPOGRAPHIC SUPPLIER	AGENCY	CLIENT	PRINCIPAL TYPE	DIMENSIONS
Carrie Berman/ Takaaki Matsumoto New York City	Susan Schechter	Knoll Graphics	Knoll International	Helvetica Condensed	5 × 15 in. 12.7 × 38.1 cm

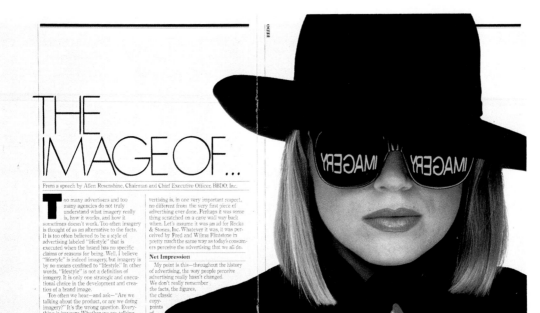

THE IMAGE OF...

From a speech by Allen Rosenshine, Chairman and Chief Executive Officer, BBDO, Inc.

Too many advertisers and too many agencies do not truly understand what imagery really is, how it works, and how it sometimes doesn't work. Too often imagery is thought of as an alternative to the facts. It is too often believed to be a style of advertising labeled "lifestyle" that is executed when the brand has no specific claims or reasons for being. Well, I believe "lifestyle" is indeed imagery, but imagery is by no means confined to "lifestyle." In other words, "lifestyle" is not a definition of imagery. It is only one strategic and executional choice in the development and creation of a brand image.

Too often we hear—and ask—"Are we talking about the product, or are we doing imagery?" It's the wrong question. Everything is imagery. Whether we are talking about the product or the people who use it or the lifestyle situations in which it is used; whether we are doing a demo or a comparative claim or a song and dance, it's all imagery. And imagery is all.

Let's talk a little history. I point is that not only is ima thing, it always has been. Th a new phenomenon. Today

vertising is, in one very important respect, no different from the very first piece of advertising ever done. Perhaps it was some thing scratched on a cave wall way back when. Let's assume it was an ad for Rocks & Stones, Inc. Whatever it was, it was perceived by Fred and Wilma Flintstone in pretty much the same way as today's consumers perceive the advertising that we all do.

Net Impression

My point is this—throughout the history of advertising, the way people perceive advertising really hasn't changed. We don't really remember the facts, the figures, the classic copy- points of

also true that with the control they possess, the networks have been able to impose the biggest increases in advertising CPM's over the past 10 years. No other medium has come close.

Nevertheless, despite those increases and the continuing erosion of audience share, for many brands network television remains the most efficient *and* effective advertising medium ever created. In some circles it's heresy to admit it, but network television can still be a bargain.

Sins of Mismanagement

However, even bargain status can't absolve the networks completely from their sins of mismanagement—the very sins which have accelerated their rate increases, driven audiences away and provoked such bitter feelings.

The cumulative effect of questionable production deals has been painful and costly.

Take production costs, which the networks usually cite as the biggest cause of rate increases. Critics agree that these costs are troublesome but lay much of the blame on the networks for paying only lip service to the problem and letting Hollywood operate virtually unchecked for years. Weekly series are now so expensive that usually only 22 or 24 episodes are produced in a year, compared with the standard 39 episodes of not long ago. The result, of course, is a higher ratio of reruns to originals—a practice which can only diminish audience loyalty.

Adding to the cost problem is the multitude of questionable production deals the networks have made. In recent years, it's been common for the networks to recruit programming executives by promising them a production deal should they be let 'go or decide to leave. Not to be outdone, the stars of many top series have demanded similar treatment. Each time the networks relented, they committed themselves to hundreds of thousands of dollars in production costs without even seeing a concept, much less a script.

For these moderates remember that network advertising helped them build the mighty national brands that are now the backbone of American consumer marketing. Still, they can only flinch when the networks demand 10, 12 even 15 percent more dollars a year to reach what is undeniably a dwindling network audience. The increases look unconscionable, and when projected over several years, they look absolutely frightening. The moderates know there is simply no way their advertising budgets can keep pace.

The Power of Supply and Demand

What makes it worse, the critics say, is the out-and-out arrogance the networks have sometimes shown. Not only do the networks expect to be paid more and more for less and less; they have, at times, announced their expectations in take-it-or-leave-it fashion. They've attempted to turn panic into an effective sales tool. In some instances, advertisers have been told they can either sign a check for the stated amount or do without network advertising. Defenders of the networks say that's nonsense and insist that what the critics call arrogance is nothing more than good business sense. After all, the networks are simply abiding by the law of supply and demand. The defenders ask, "If *you* had control of the supply in *your* business, wouldn't you demand what the market would bear?"

The cumulative effect has been painful, to say the least. The quality of programming that's come from these deals has often been below what the networks otherwise would have approved. And, just as damaging, budgets for normal program development have to be restricted while the backlog of deals is worked off.

Under Pressure

A far more publicized source of criticism against the networks is the decline of their audiences, both in share and in absolute numbers. Again, critics have assigned most of the blame to network mismanagement. Regardless of just how completely the networks are at fault, there certainly is irony in the fact that many of the steps the networks took to strengthen their ratings actually precipitated their decline.

And in the networks' business—which is largely the business of delivering national audiences to mass merchandisers for advertising purposes—the big three broadcasters still retain overwhelming control of the supply. No other medium comes close. It's

TYPOGRAPHY/ DESIGN	TYPOGRAPHIC SUPPLIER	AGENCY	STUDIO	CLIENT	PRINCIPAL TYPE	DIMENSIONS
Philip Gips/ Gina Stone New York City	R. C. Communication	Gips + Balkind + Associates	Gips + Balkind + Associates	Batten Barton Durstine & Osborne	Century Old Style	8½ × 11 in. 21.6 × 27.9 cm

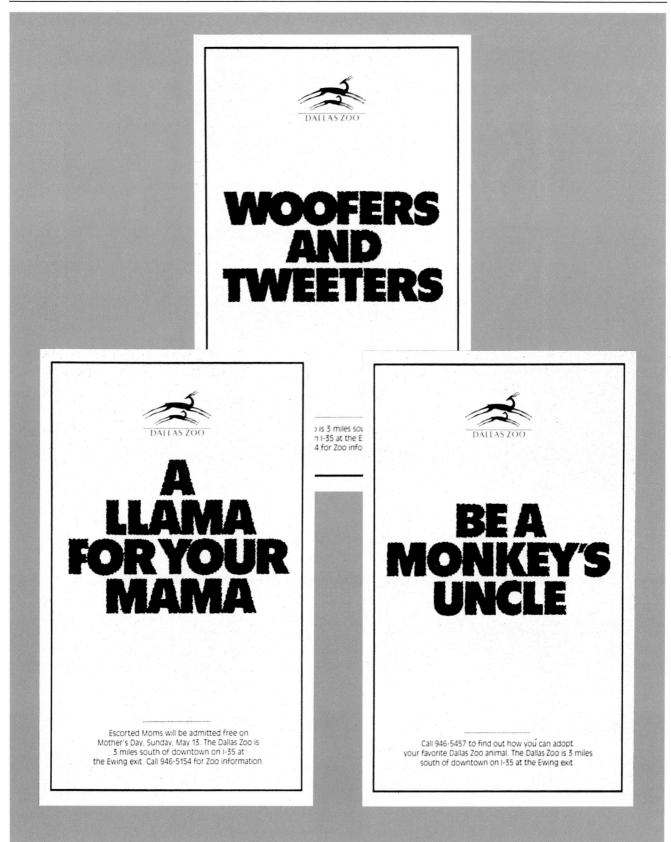

207

TYPOGRAPHY/ DESIGN	TYPOGRAPHIC SUPPLIER	STUDIO	CLIENT	PRINCIPAL TYPE	DIMENSIONS
Scott Eggers Dallas, Texas	Southwestern Typographics	Richards, Brock, Miller, Mitchell & Associates	Dallas Zoo	Quota	4 × 6¾ in. 10.2 × 17.1 cm

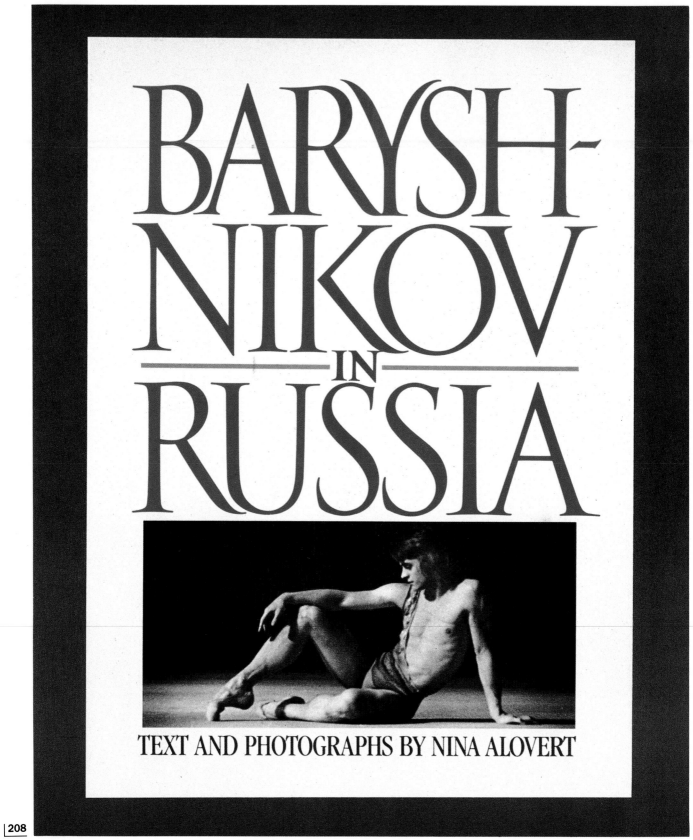

BARYSH-
NIKOV
IN
RUSSIA

TEXT AND PHOTOGRAPHS BY NINA ALOVERT

TYPOGRAPHY/ DESIGN	CALLIGRAPHER	TYPOGRAPHIC SUPPLIER	STUDIO	CLIENT	PRINCIPAL TYPE	DIMENSIONS
David Gatti New York City	David Gatti	Expertype	David Gatti Graphic Design	Holt Rinehart Winston	Handlettering	9 × 12¼ in. 22.8 × 31.1 cm

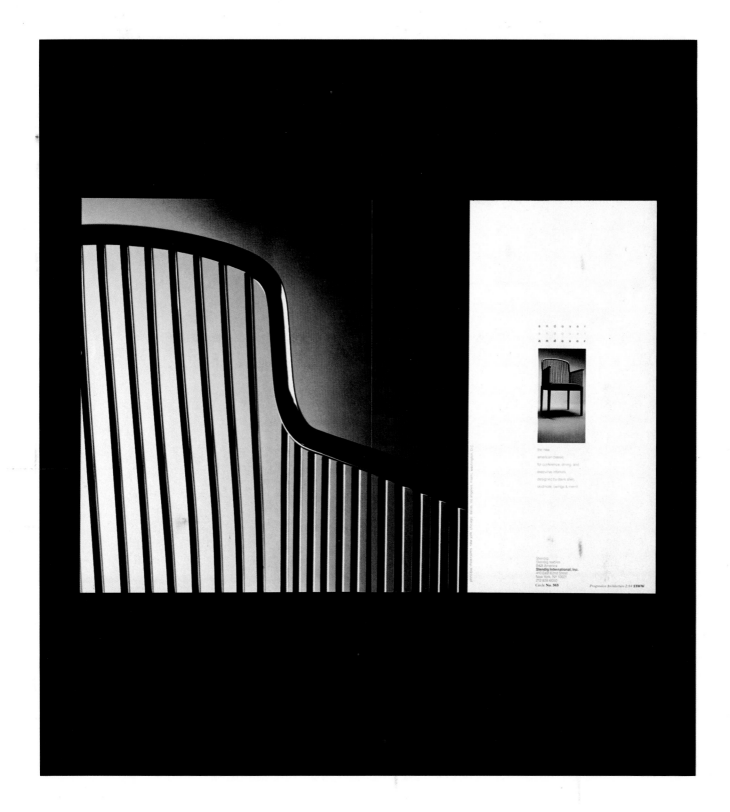

TYPOGRAPHY/ DESIGN	TYPOGRAPHIC SUPPLIER	CLIENT	PRINCIPAL TYPE	DIMENSIONS
Bridget DeSocio *New York City*	*Nassau* *Typographers*	*Stendig* *International*	*Helvetica*	*½ × 1½ in.* *1.3 × 3.8 cm*

H. J. Heinz Company 1984 Annual Report

Dale Chihuly

"**W**e discovered the technique for our cylinders in the summer of 1974 at Pilchuck, our farm north of Seattle, and I remember how thrilled we were to find we could lay out a drawing with bits of glass which, when we came down on it with molten glass, would fuse and mold together as it was blown out. I began a series of cylinders to further explore the idea of drawing into glass. I go back to the series now and then because the process is still unpredictable and continues to stimulate me.

"I saw some Northwest Coast Indian blankets in the Tacoma Historical Society and thought I would try blowing some very thin basketlike forms which would appear crumpling and collapsing under their own weight. I didn't want them symmetrical. It was quite a discovery to see what I could do with just air, fire and gravity using hardly any tools. In the summer of 1977, I made about 100 baskets, all the same color (tabak), and they were shown on a steel table at the Seattle Art Museum.

"**A**t one point, I went to Murano to study. Strange, I and others are still carrying on the Venetian tradition. They're losing it over there because of modern technology. There doesn't seem to be the desire for handmade glasses when glasses made by machines are available at less cost. People would rather drive a Porsche, which is made by machine, than a more expensive Rolls-Royce, which is primarily made by hand.

"We start blowing at 4 a.m. and work straight through with no breaks. The blowing just seems to go better on the early schedule. It's quieter and the shop is cooler and the glass is at its best in the morning. I don't know why. And we have more privacy. We then stop for a big lunch—lots of Italian style. This has a pull on my social life. Maybe that's why I never got married.

The last few years I've been a kind of nomad, working with my traveling team in many different universities and shops around the United States and in Europe.

"**W**hen I'm not traveling for my work, I'm often traveling for pleasure. Every year or two, I visit some unusual archipelago of islands—most recently the Orkneys and the Scilly Islands off Great Britain and the coast of Brittany. I love islands. I'm fascinated by the fact that, being isolated, they develop uniquely."

210

TYPOGRAPHY/ DESIGN	TYPOGRAPHIC SUPPLIER	STUDIO	CLIENT	PRINCIPAL TYPE	DIMENSIONS
Bennett Robinson/ Paula Zographos New York City	Davis & Warde	Corporate Graphics Inc.	H J Heinz Company	Helvetica/ Horley/Bookman	9 × 11 in. 22.9 × 27.9 cm

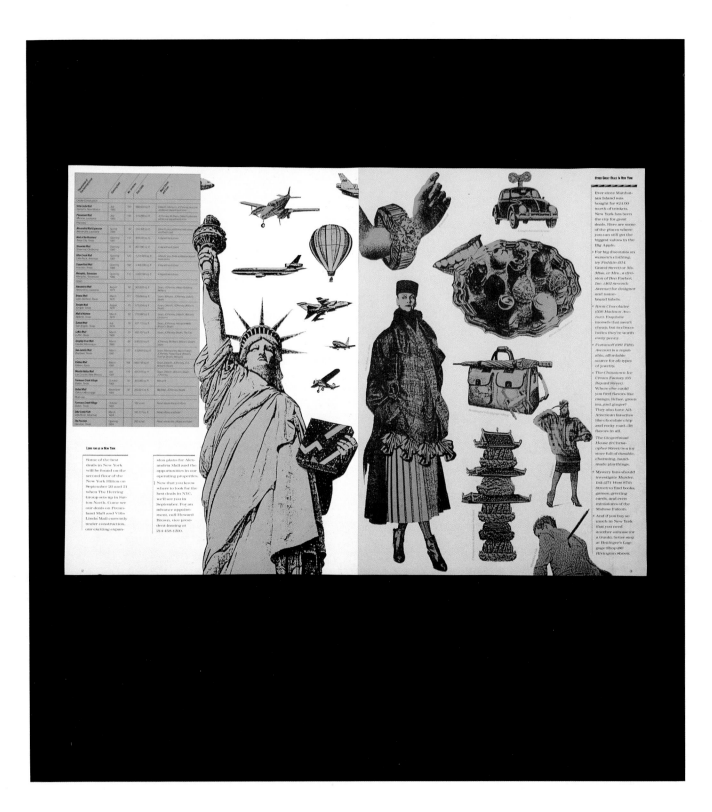

TYPOGRAPHY/ DESIGN	ILLUSTRATORS	TYPOGRAPHIC SUPPLIER	STUDIO	CLIENT	PRINCIPAL TYPE	DIMENSIONS
Glyn Powell/ Bob Dennard/ Dallas, Texas	Jan Wilson/ Glyn Powell/ Chuck Johnson/ Paul von Heeder/ John Evans	Typeworks, Inc.	Dennard Creative, Inc.	The Herring Group	Craw Modern	11¹⁵⁄₁₆ × 15 in. 30.3 × 38.1 cm

TYPOGRAPHY/ DESIGN	TYPOGRAPHIC SUPPLIER	AGENCY	STUDIO	CLIENT	PRINCIPAL TYPE	DIMENSIONS
Simha Fordsham/ Nancy Leung/ Jonas Tse Toronto, Canada	Canadian Composition	Olympic & York Developments Limited	Olympic & York Developments Limited	Queen's Quay Residences	T. S. Martin Gothic	8½ × 11 in. 22 × 28 cm

TYPOGRAPHY/ DESIGN	ILLUSTRATORS	TYPOGRAPHIC SUPPLIER	STUDIO	CLIENT	PRINCIPAL TYPE	DIMENSIONS
Jan Wilson/ Bob Dennard Dallas, Texas	*Jan Wilson/ Ken Koester/ Terry Widner/ Lee Lee Braezal*	*Southwestern Typographics*	*Dennard Creative, Inc.*	*The Herring Group*	*ITC Century Light/ Compacta Light*	*11 × 15 in. 27.9 × 38.1 cm*

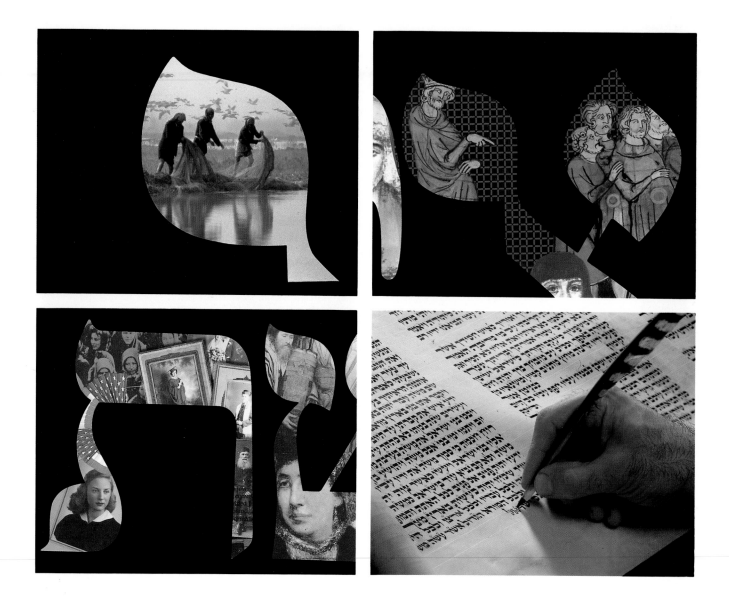

TYPOGRAPHY/ DESIGN	TYPOGRAPHIC SUPPLIER	AGENCY	STUDIO	CLIENT	PRINCIPAL TYPE	DIMENSIONS
Eileen Boxer/ Sandra Imhoff New York City	*Spectrum*	*Donovan & Green*	*First Editions Composite*	*WNET 13 "Civilization and the Jews"*	*Hebrew (Traditional)*	*Video tape*

TYPE DIRECTORS CLUB

**TYPE DIRECTORS CLUB OFFICERS
1984/1985**

PRESIDENT
Klaus Schmidt

VICE PRESIDENT
John Luke

SECRETARY/TREASURER
Jack Odette

DIRECTORS-AT-LARGE

Ed Benguiat	*Marilyn Marcus*
Ed Brodsky	*Vic Spindler*
Freeman Craw	*Ed Vadala*
Tom Kerrigan	

CHAIRMAN BOARD OF DIRECTORS
Jack George Tauss

**TYPE DIRECTORS CLUB OFFICERS
1985/1986**

PRESIDENT
Klaus Schmidt

VICE PRESIDENT
John Luke

SECRETARY/TREASURER
Jack Odette

DIRECTORS-AT-LARGE

Ed Benguiat	*Marilyn Marcus*
Ed Brodsky	*Vic Spindler*
Ed Colker	*Ed Vadala*
Freeman Craw	

CHAIRMAN BOARD OF DIRECTORS
Jack George Tauss

COMMITTEE FOR TDC-31

CHAIRPERSON
Marilyn Marcus

DESIGN
Olaf Leu

COORDINATOR
Carol Wahler

PRINTING
EM Graphics

CALLIGRAPHY
Robert Boyajian

RECEIVING FACILITIES
Cardinal Type Services, Inc.

ASSISTANTS TO JUDGES

Gladys Barton	*Elissa Querzé*
Jane Blomquist	*Beverly Rothberg*
Kathie Brown	*Ena Schmidt Solomon*
Laurie Burns	*Klaus Schmidt*
Cheryl Donovan	*Jerry Singleton*
Josh Field	*Gertrude Spindler*
Sloan Friedman	*Victor Spindler*
David Gatti	*Walter Stanton*
Bonnie Hazelton	*Juliet Travison*
John Johnston	*Allan R. Wahler*
Harry Marcus	*Samantha Wahler*
Minoru Morita	*Cameron Williams*
Richard Mullen	*Roy Zucca*

**INTERNATIONAL LIAISON
CHAIRPERSONS**

*Japan Typography Association
Kanamori Bldg. 4th Floor
12-9, Sendagaya 1-chrome
Shibuya-ku, Tokyo 151
JAPAN*

*Jean Larcher
16 Chemin des Bourgognes
95000 Cergy
FRANCE*

*German Liaison Committee
Leipziger Str. 3
D-6000 Frankfurt am Main 90
WEST GERMANY*

*Oswaldo Miranda (MIRAN)
Av. Centenario, 2000
Curitiba—PR.
80.000 BRAZIL*

*Keith Murgatroyd
Royle Murgatroyd
Design Associates Limited
24/41 Wenlock Road
London N1 7SR
ENGLAND*

*STV/AST
Swiss Typographic Association
Bahnhofweg 6
CH-8157 Dielsdorf
SWITZERLAND*

TYPE DIRECTORS CLUB
*545 West 45 Street
New York, NY 10036
212-245-6300
Carol Wahler, Executive Director*

*For membership information please contact the
Type Directors Club office.*

MEMBERSHIP

George Abrams
Mary Margaret Ahern
Kelvin J. Arden
Leonard F. Bahr
Don Baird
Aubrey Balkind
Arnold Bank†
Gladys Barton
Clarence Baylis
Edward Benguiat
Peter Bertolami
Emil Biemann
Godfrey Biscardi
Roger Black
Art Boden
Friedrich Georg Boes
Garrett Boge
David Brier
Ed Brodsky
Kathie Brown
William Brown
Werner Brudi
Bernard Brussel-Smith*
Bill Bundzak
Aaron Burns
Joseph Buscemi
Daniel Canter
Tom Carnase
Alan Christie
Robert Cipriani
Travis Cliett
Mahlon A. Cline*
Tom Cocozza
Barbara Cohen
Ed Colker
Freeman Craw*
James Cross
Ray Cruz
Derek Dalton
Ismar David
Whedon Davis
Saundra De Geneste
Cosimo De Maglie
Robert Defrin
Claude Dieterich
Ralph Di Meglio
Cheryl Donovan
Lou Dorfsman
Charles Dozier
John Dreyfus†
Christopher Dubber
William Duevell
Curtis Dwyer
Rick Eiber
Leon Einzig
Penny Ellis
Joseph Michael Essex
Eugene Ettenberg*
Leon Ettinger
Bob Farber
Sidney Feinberg*
Joseph A. Fielder
Blanche Fiorenza
Holley Flagg
Norbert Florendo

Glenn Foss
Dean Franklin
Elizabeth Frenchman
Adrian Frutiger†
David Gatti
Stuart Germain
John Gibson
Lou Glassheim*
Howard Glener
Jeff Gold
Edward Gottschall*
Norman Graber
Austin Grandjean
Kurt Haiman
Allan Haley
Edward A. Hamilton
Mark L. Handler
William Paul Harkins
Sherri Harnick
Horace Hart
Knut Hartmann
Bonnie Hazelton
Fritz Hofrichter
Gerard Huerta
Donald Jackson†
Mary Jaquier
Allen Johnston
R.W. Jones
Judith Teener Kahn
R. Randolph Karch
Rachel Katzen
Louis Kelley
Michael O. Kelly
Scott Kelly
Tom Kerrigan
Lawrence Kessler
Peggy Kiss
Zoltan Kiss
Robert Knecht
Steve Kopec
Linda Kosarin
Gene Krackehl
Bernhard J. Kress
Walter M. Kryshak
Jim Laird
Guenter Gerhard Lange
Jean Larcher
Mo Lebowitz
Alan Leckner
Arthur B. Lee*
Judith Kazdym Leeds
Louis Lepis
Robert Leslie†
Professor Olaf Leu
Mark Lichtenstein
Wally Littman
Sergio Liuzzi
John Howland Lord*
John Luke
Ed Malecki
Sol Malkoff
Marilyn Marcus
Stanley Markocki
John S. Marmaras
Frank B. Marshall III

Rogério Martins
Donna Marxer
James Mason
Les Mason
Jack Matera
John Matt
Frank Mayo
Fernando Medina
Professor Frédéric Metz
Douglas Michalek
R. Hunter Middleton†
Lawrence Miller
John Milligan
Michael Miranda
Oswaldo Miranda
Deborah Mix
Barbara Montgomery
Richard Moore
Ronald Morganstein
Minoru Morita
Patti Morrone
Tobias Moss*
Leslie Mullen
Richard Mullen
Keith Murgatroyd
Louis A. Musto
Rafael Navarro
Alexander Nesbitt
Paschoal Fabra Neto
Jack Odette
Thomas D. Ohmer
Motoaki Okuizumi
Brian O'Neill
Gerard J. O'Neill*
Jane Opiat
Vincent Pacella
Zlata W. Paces
Bob Paganucci
Luther Parson
Charles Pasework
Eugene Pattberg
Ray Pell
Ronald Pellar
Roma Plakyda
Roy Podorson
Louis Portuesi
Janice Prescott
Richard Puder
David Quay
Elissa Querzé
Erwin Raith
John Rea
Bud Renshaw
Ed Richman
Jack Robinson
Edward Rondthaler*
Robert M. Rose
Herbert Rosenthal
Joseph E. Rubino
Gus Saelens
Fred Salamanca
Bob Salpeter
David Saltman
John N. Schaedler
Hermann Schmidt

Klaus Schmidt
Robert Scott
Michael G. Scotto
David Seager
William L. Sekuler*
Ellen Shapiro
Julie Silverman
Jerry Singleton
Janet Slowik
Martin Solomon
Jan Solpera
Jeffrey Spear
Vic Spindler
Rolf Staudt
Walter Stanton
Murray Steiner
William Streever
Doug Stroup
Ken Sweeny
William Taubin
Jack George Tauss
Pat Taylor
Anthony J. Teano
Bradbury Thompson
Susan B. Trowbridge
Professor Georg Trump†
Lucile Tuttle-Smith
Edward Vadala
Jan Van Der Ploeg
Jurek Wajdowicz
Robert Wakeman
Herschel Wartik
Professor Kurt Weidemann
Ken White
Cameron Williams
John F. Williamson
Alan Wood
Stanley Yates
Hal Zamboni*
Professor Hermann Zapf†
Roy Zucca

*Charter Member
†Honorary Member

SUSTAINING MEMBERS

Ad Agencies/Headliners
Allied Linotype
Arrow Typographers
Cardinal Type Service, Inc.
Characters Typographic Services, Inc.
International Typeface Corporation
Pastore DePamphilis Rampone
Photo-Lettering, Inc.
Royal Composing Room
Techni-Process Lettering
Typographic Designers
Typographic House
TypoGraphic Innovations, Inc.
TypoVision Plus

INDEX

Corporate Graphics, Inc., 101, 153, 210
Corporate Groups, 204
Creamer Design Group, 161
Creative Center, Inc., 121
Crouch & Fuller, Inc., 110
Dallas Times Herald Promotion Department, 94, 95, 155
D&A Artwork Services, 192
David Gatti, 178
Dennard Creative, Inc., 44, 208, 211
Design Collaborative, 156
Design Group West, 110
The Dunlavey Studio, Inc., 134
Ear/Say, 38
Eclectic Design, 84
Eisenberg, Inc., 123
Emerson Wajdowicz Studios, Inc., 30
Eskind Wadell, 168
Esprit Graphic Design Studio, 90
Fernando Medina Design, 88
Fiorentino Reinitz Leibe, 78
First Editions Composite, 218
Gips + Balkind + Associates, 157, 206
Glazer & Kaleyjian, Inc., 39
Gonds Design, Inc., 80, 202
Gunn Associates, 188
Hafenbrack Graphic Design, 45
Harald Schlüter Werbeagentur, 184
HBM, 161
Henry Brimmer Design, 182
Herb Yager and Associates, 133, 180
Hornall, 122
IBM Tucson Design Center, 185
Igarashi Studio, 47
Jean Evans Design, 103
John Stevens Calligraphy & Lettering Design, 18, 25
Jonson Pedersen Hinrichs & Shakery Inc., 57, 68, 69, 76, 100, 169
Jost, Guig, 154
The J. Paul Getty Museum Design, 56
J. Walter Thompson, 98, 99
KCSM Communications, 72
Klaus Richter, 12
Knut Hartmann Design, 158
Koppel & Scher, 33
Kremer-Müller, 175
Krogstad Design Associates, 79, 124
Mark Anderson Design, 137
Meadows & Wiser, 60
Michael Mabry, 10, 128
Michael Osborne Design, Inc., 194
Miller Judson and Ford, Inc., 31
Neal Cox Design, 126
The North Charles Street Design Organization, 40
Odermatt & Tissi, 36, 159
Olaf Leu Design & Partner, 170, 181
Olympic & York Developments Limited, 105, 212
Parsons Publication Design Office, 50
Paul Davis Studio, 34
Pat Hansen Design, 201
Pat Sloan Design, 193
Peteet Design, Inc., 176, 177
Photo-Lettering, Inc., 85
Pushpin Lubalin Peckolick, 129
P Vron Visual Communication

Design, 32
Raymond Machura Design, 214
Richards, Brock, Miller, Mitchell & Associates, 71, 106, 113, 118, 179, 207
Rick Cusick Design, 17, 124
Robert Conover Graphic Design, 28
RZA Werberealisierung GmbH, 89, 93
Salpeter-Paganucci Inc., 41
Samata Associates, 146, 147, 148, 203
Saul Bass, 133, 180
Seymour Robins Design, 199
Sibley, 176, 177
Sibley/Peteet Design, Inc., 15, 92
Sidjakov, Berman, & Gomez, 65
Second Hand Press, 97
Steven Jacobs, Fulton and Green, 108
Tandem Studios, 135
Tim Girvin Design, Inc., 48
Weber Design, 196
The Weller Institute for the Cure of Design, Inc., 186
The Whelan Design Office, Inc., 111
Willy, Simon, 154

CLIENTS

Abilene Christian College, 113
Academy of Art College, 182
Alfred A. Knopf, 67, 164, 165
Allen, Patricia J., 195
American Council for the Arts, 145
American Society of Interior Designers, Denver Chapter, 196
Anton Schöb Buchdruck—Offset, 36
Apple Computer, Inc., 141, 183, 200, 204
Arthur Jones Lithographing Ltd., 168
AT&T, 150, 180
Artemnis Verlag Müchen, 190
Batten Barton Durstine & Osborne, 206
The Belgian Bakery, 134
The Bieler Press, 58
Bloomingdale's, 48
Bölling, Offizen für Pragedruck, 63
Booz, Allen & Hamilton Inc., 202
Borg-Warner, 86, 87
The Boston Globe, 83
The Boston Globe Magazine, 54
125 Broad Street, 104
Bulkley Dunton, 197
Canton, 61
Capital Data Systems, 133
Carnegie-Mellon University Children's School, 126
Castle & Cooke, 167
Centre de Création et de Diffusion en Design, 49
Champion International Corporation, 191
Chow Catering, 123
Cockburns Port, 98, 99
Company Corporation, Publishers of *Clue* Magazine, 151
Concord Assets Group, Inc., 111
Control Data Corporation, 79
Cooper & Beatty, Ltd., 168
Criterion Financial Corp., 71
Dallas Aboretum and Botanical Society, Inc., 179

Dallas Black Dance Theatre, 155
Dallas Society of Visual Communications, 118
Dallas Symphony Orchestra, 94, 95
Dallas Zoo, 207
Dana-Farber Cancer Institute, 115
Design Student Associations, California State University, 32
Devlin Productions, Inc., 132
Digital Typeface Library Company, 131
Dojc, Yuri, 168
Domaine de la Berriere, 20
Dominos' Pizza, Inc., 140
Ear/Say, 38
Empress Litho Plate Ltd., 168
Englersatz AG, 159
The Equitable Life Assurance Society of the U.S., 101
Esprit De Corps, 90
Exclam Comunicacões, 14
Fernando Medina Design, 88
Forum Typografic, 93
The Franklin Library, 59
Gebr. Schmidt Druckfarben, 170
Geoff Smith Photography, 192
Georgia Pacific, 57, 68, 69, 70
Good Earth Restaurants, 176
Gráfica, 91
Haavikko & Pietilainen & Co. OY, 76
Hallmark Cards, 19, 96
Hamilton College, 187
Hand Workshops, 82
Pat Hansen Design, 201
Harvard University Library, 103
Henry Art Gallery, University of Washington, 156
Herb Lubalin Study Center, 129
Herman Miller, Inc., 109, 137, 174
The Herring Group, 211, 217
Hills Bros. Coffee, Inc., 65
H.J. Heinz Company, 210
Holt Communications, 135
Holt Rinehart Winston, 178
Home Box Office, Inc., 157
Home Owners Federal Savings & Loan Association, 188
Howard Paper Mills, Inc., 45
IBM, 41, 80, 149, 166
IBM Tucson, 185
IBM World Trade Corp., 152, 169
Ingalls Associates, 144
International Auschwitz Committee, 51
International Museum of Photography at George Eastman House, 125
International Paper, 177
Jesperson Construction Co., 31
Johannes-Gutenberg-Schule, 27
Jöllenbeck & Schlieper, 26, 52
The J. Paul Getty Museum, 56
Kaher, Roland, 175
Kent State University, 21
Kieffer-Nolde, Inc., 163
Knoll International, 136, 142, 143, 205
Knut Hartmann Design, 158
Koppel & Scher, 33
Kremer, Gunter H., 89
Kulturfabrik A.S.B.L., 154

425 Lexington Avenue, New York, 105
The Lowell Press, 17
59 Maiden Lane, 104
The March of Dimes Gourmet Gala, 106
Marinko, Fondação Robert, 107
Marshall Fields, 138
Master Eagle Gallery, 18
Mayor's Office of Film, Theatre & Broadcasting, 30
Mead Paper Corporation, 73
Mercantile Trust Company, 114
Mergenthaler Linotype GmbH, 181
The Meridian Company, Ltd., 110
Methodist Hospital of Indiana, 205
Metropolitan Medical Center, 124
Michael Osborne Design, Inc., 194
Miracle, Andy, 193
MIT Committee on the Visual Arts, 162
Mobil, 34
Mohawk Paper Mills, 199
The Museum of Modern Art, 13, 47
Napoli 99 Foundation, 216
National Trust for Historic Preservation, 60
Neiman Marcus, 92
New York Philharmonic Tour of Asia, 23
New York Society of Scribes, 24
New York Telephone, 30
Nikosey Design, 173
Northwest Paper Company, 81
Oberlin College, 40
Ottobach Repro GmbH, 22
Overseas Printing Corporation, 10
Pacific Rice Products, 128
Pantheon Books, 66
320 Park Avenue, 104
The Parker Pen Company, 146, 147, 148
Parsons School of Design, 50
Peat Marwick International, 74
Petrographics, 110
Photo-Lettering, 85
Pierce Art Gallery, 122
Plinc, 64
Pori Jazz Festival, 46
Portante, Jean, 175
Potlatch, 100
Pratt Institute, 72, 130
Preservation Press, 60
Queens' Quay Developments Limited, 212
Richter, Klaus, 12
Ris Paper Company, 139
Rites & Reason/Brown University, 42
Roosevelt University, 214
Royal Viking Line, 213
Royal Zenith, 78
The San Francisco Symphony, 77
Schlieper & Co., 26
S.D. Warren Paper Company, 161
Sears Roebuck and Company, 112
Select Magazine, 84
Simon & Schuster, 55
Simpson Paper Company, 153, 198
Society of Publication Designers, 53
Society of Scribes, 18
Stendig International, 209
Teacher/Student Journal, 16
Technische Hochschule Darmstadt, 62
Time Inc., 171

PRINCIPAL TYPE